POSTCARD

Rye

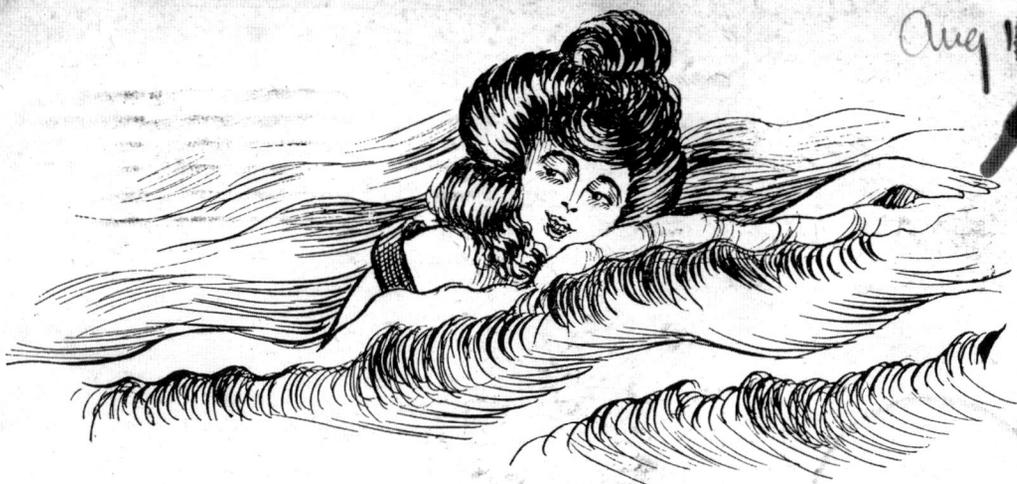

Come and Take "A Dip" with Me at Rye Beach

Reynold,

The above beats your lake

Papa

This drawing is on perhaps the earliest postcard in this book, dated 1905. After having a pleasant day at Rye Beach, "Papa" wrote his son in Long Eddy. Rye Beach is the subject of several chapters in this book. Cards such as this were frequently made generically, and the name of the beach was filled in. (Author's collection.)

On the front cover: Please see page 14. (Author's collection.)

On the back cover: Please see page 100. (Author's collection.)

POSTCARD HISTORY SERIES

Rye

Paul D. Rheingold

ARCADIA
PUBLISHING

Published by Arcadia Publishing
Charleston SC, Chicago IL, Portsmouth NH, San Francisco CA

Printed in the United States of America

Library of Congress Control Number: 2009926093

For all general information contact Arcadia Publishing at:
Telephone 843-853-2070
Fax 843-853-0044
E-mail sales@arcadiapublishing.com
For customer service and orders:
Toll-Free 1-888-313-2665

Visit us on the Internet at www.arcadiapublishing.com

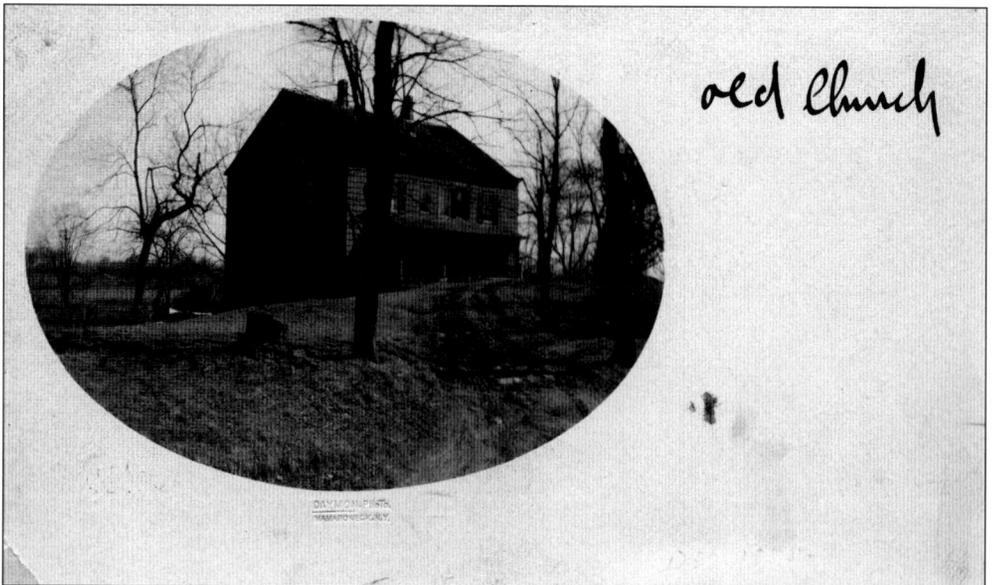

This view, dating from the dawn of the 20th century, is of the former Grace Episcopal Church, which stood where Christ's Church sits today. It was built in 1788. In 1854, it was moved down to 51 Milton Road and became a house, as illustrated. Owned by the city, in 1972 it was converted into its present use, the Rye Arts Center. Church history is covered in chapter 4. (Author's collection.)

CONTENTS

ACKNOWLEDGMENTS

The author acknowledges information provided by Richard Hourahan, archivist for the Rye Historical Society, and the advice and editing of Susan Morison, former director of the Rye Historical Society, who also drew the four maps at the end of the book showing the development of the waterfront area of Rye, based upon old maps. The author also thanks Daniel Kelly, Rye city historian, for reading the text.

Unless otherwise noted, all images are in the collection of the author. For the providing of certain images, as credited individually, the author thanks the Rye Historical Society (identified in the captions as RHS) and Steven Feeney, Rye resident and fellow postcard collector.

INTRODUCTION

Rye was founded in 1660 and has been a region, a town, a village, and now a city of some 15,000 people. It has 5.8 square miles of land (20 square miles counting the surrounding water) and borders Long Island Sound.

Rye was founded merely 40 years after the landing of the Pilgrims at what became Plymouth, Massachusetts, and the arrival of the Dutch in what is now Manhattan. Rye developed as many eastern waterfront towns did, starting with farms, mills, and boating and then developing homes and stores. With the coming of the railroad, these activities increased and led in turn to the creation of Gilded Age mansions and then subdivisions of large plots of land. The Rye of today is a suburb of New York City, but it is self-contained and a built-out community, dominated as everywhere by the automobile.

As is often the case, the advent of postcards at the dawn of the 20th century nicely coincides with the transition of Rye from a rural community to a residential community. The earliest cards, many of which are utilized here, date from 1905 and 1906.

Rye is blessed with an abundance of postcard views, due to several special features. The first is the great amount of waterfront, which over time has yielded beach use, a large town park, inns, and amusement parks. The second is the large amount of private clubs for sailing, swimming, golf, and tennis, eight of which are illustrated in this book.

The presence of mankind in Rye did not start in 1660. Native Americans of the Peningo tribe, part of the Siwanoy or Lenni Lenape family, lived and fished here. The first European settlers were Peter Disbrow, John Coe, and Thomas Studwell from nearby Greenwich, Connecticut, who purchased a portion of what is now Rye from Native American sachems, paying the proverbial eight coats and seven shirts. The three men and their families first settled and began to plant on an island separated from Rye by only a few hundred feet then called Manussing by Native Americans and now known as Manursing Island. They chose the island for the protection they felt it would give them from the Native Americans. In the second year of habitation, it is estimated there were log cabins for some 18 families.

Within two years, the early settlers ventured onto the mainland, developing a small community on Peningo Neck, which is known today as Milton Point, a large peninsula of land pointing south into the sound. This sheltered a long harbor, known today as Milton Harbor. The original development was known as Mill Town, named after a large grinding mill located on a river that flowed into the harbor. Over time, the name became contracted to Milton. And, in fact, the name of the larger area soon became Rye, named after the town in England from which several of the settlers came.

Over time, the early residents developed small farms in the Rye area. A house of one of Mill Town's early settlers, Timothy Knapp, dates back to 1667; it has been preserved by the Rye Historical Society.

Soon after the Manursing Island purchase, more land was purchased from separate Native American sachems by John Budd, also from Connecticut. This land lay west and south of Milton Harbor and down to present-day Mamaroneck. Estates illustrated in the book, owned by the Jay and Park families, were later created out of Budd's lands.

Within Rye, there are two streams, Blind Brook and Beaver Swamp Brook, the former playing a much greater role in development. Blind Brook arises in neighboring Purchase, runs through the downtown area and much residential area, and then it flows into Milton Harbor. It probably derives its name from the fact that it was in a deep trench with many trees on the bank and hence could not be easily seen. Blind Brook was the situs of several of the grinding mills, which played a major role in the early community. The first were built by Budd and Chapman. And by harnessing the tidal change on Long Island Sound, the Kirby Mill began around 1770.

Milton Harbor, a protected natural harbor behind Milton Point, has a history as old as Rye. Docks were built as early as 1679. It was used by the colonists as a sailing port and then by merchants carrying produce and cattle from farms to New York City. Fishing and oystering were also commercial activities. Rye's history for shipbuilding goes back to the 1600s as well. The area was also used for graving—the beaching of boats to clean and repair them. In the 1850s, David Kirby Jr., the son of the man who ran Kirby Mill, began to build boats. In the 1870s, he produced a boat that won the America's Cup—the *Madeline*.

Ferry service began early in Rye's history and lasted into well into the 20th century. As early as 1739, there was a ferry across Long Island Sound to Oyster Bay. Various locations have been used for ferry stations. An early one was near the Port Chester line, and then the Dearborn Avenue pier was developed, as shown in illustrations here, which had a ferry to Sea Cliff on Long Island.

Land transportation began with the horse and the stage. Rye was some 25 miles from New York, often one day's travel. The history of travel is traced in this book, through the railroad, the trolley, the buses, and the private automobile.

Borders were not always clear. For awhile, Rye was deemed to be in Connecticut and then later considered to be in New York, based upon rulings of the state legislatures. Even Rye's borders varied. For awhile, it was part of a larger area called Rye Town, which encompassed what today includes the separate villages of Port Chester and Rye Brook and probably some portions of the Purchase section of Harrison.

Probably the best known and loved building in Rye is the Square House, which sits on the village green and dates back to around 1730 as a private residence. It was a tavern later in the 1700s, and it is documented that George Washington stayed there twice, as well as John and Samuel Adams. It later became the seat of village government and is today the headquarters of the Rye Historical Society. It is on the National Register of Historic Places.

During the Revolutionary War, Rye was virtually deserted and became known as the neutral district. The British were to the south, and Washington was to the north. After the war, Rye's Tory residents departed. Around 1800 it is estimated that the population was around 1,000, over 100 of which were slaves working on farms.

The Boston Post Road was laid out in 1672 as a county road, following what had been known as the Old Westchester Path, which itself followed an old Native American trail. For a period of time, it had tollgates. The Boston Post Road served as a route from New York City to Boston, cutting north and south through Rye. Benjamin Franklin, as the United States postmaster, caused milestones to be placed along the road. Three of these were in Rye and are still present: 24, at the Jay mansion; 25, on the Osborn Home property; and 26, at Christ's Church. In 1925, the Boston Post Road became a stretch of U.S. Route 1.

A momentous event in Rye, although probably only dimly understood at the time as to long-run consequences, was the advent of the railroad. The New York, New Haven and

Hartford Railroad came through Rye in 1849. One no longer needed to take the stage to New York City. Over time, Rye residents began to commute to New York to work, and wealthy New York City families built summer cottages (read: mansions) in Rye. Briefly there was a competing second railroad line, the New York, Westchester and Boston Railway, from New York City, on tracks parallel to those of the New York, New Haven and Hartford Railroad. Foundations for it are still present over Purchase Street.

Although Rye is one entity today, for a long period of time residents considered the Milton Point community as separate from the central, downtown area. Milton has its own school, fire station, and chapel. Perhaps this reflects nothing more than distances, or perhaps an isolationist attitude. Other more peripheral sections of what is Rye today played less of a role in the early days and garnered no postcard views. One is known today as Greenhaven, formerly known as Brevoort Farms, on the border with Mamaroneck. Another is West Rye or Dublin, west of the train tracks. This area developed as homes for immigrants from Ireland and Italy, who were workers—masons, caretakers, and the like—for the mansions being built.

The wealthy families who came to Rye in the summer gradually participated in the affairs of Rye. Scenes in this book involve such names as Parsons, Wainwright, Morehead, Fisk, Barron, and Sackett. This was of course in the Gilded Age, when major fortunes were being made in New York City and there were no income taxes.

Some of the major landowners made subdivisions of their properties, breaking up major areas of Rye. In the 1920s, Rye eclipsed other areas for sales volume and size due to its "quaint beauty," according to the advertisements. With a new era in the 21st century of teardowns and building mansions, Rye remains a quietly affluent town.

Much could be added about one of the most dominant families in Rye, the Wainwrights. The family at one time owned much of Milton Point, populating it with relatives and numerous homes. Some of the grandest Wainwright homes are illustrated in this book, today housing clubs, a spiritual house, and a restaurant.

Due to complaints about lack of representation, Rye in 1904 officially became a village by state act, incorporating itself as a separate entity within the Town of Rye. It established a municipal government at a time when its population was about 3,500. The Village Improvement Association was the principal force in modernizing Rye. Paving the streets and putting in sewers, gas service, schools, and proper police and fire departments were on the agenda of the town fathers and taxpayers.

The Osborn Home, illustrated in chapter 5, was the desire of Miriam Osborn, a Mamaroneck resident, to establish a home for "respectable, aged women in needy circumstances." At first she planned to use her home, but she hired New York City lawyer John William Sterling (Shearman and Sterling) to find a larger location. Osborn died, and under the provisions of her will, he purchased farmland in Rye, and the property was developed. Bruce Price was the architect; he had designed the Chateau Frontenac in Quebec, among other structures. He adopted the Georgian Renaissance style for the first building, constructed between 1902 and 1907.

The trolley came along as a means of transportation around 1900, which not only provided mobility around Rye but also between it and neighboring cities. The trolley line was owned by the New York and Stamford Railway Company. In Rye, the tracks ran down Purchase Street and on to the shorefront on Beck Avenue, where there was a turnaround. There are numerous illustrations of the tracks in the book. The lines also ran to Port Chester, entering Rye along what is now called Midland Avenue, and also to Mamaroneck via what is now called Theodore Fremd Avenue. This was part of the interurban system. The tracks and the trolleys were replaced by the bus in 1927 and then by the automobile.

The 20th century also brought several large apartment houses before World War II, followed more recently by smaller condominium developments. It brought buildings in office parks, helping with the tax base. It brought new stores to downtown, but the downtown has remained markedly unchanged. It brought Playland, the county-owned amusement park, which replaced

shorefront development. It brought two highways (Interstate 95 and Interstate 287). And it brought the clubs, new schools, and bigger church structures.

Also in the 20th century, Rye became a city in 1942, totally separating itself from the Town of Rye for political reasons. This made it the smallest city in the state. Governance was now by a mayor and city council. Other boards were created, all populated by volunteer residents. Rye created a planning commission, which produced a master plan in 1945. The Rye Historical Society was founded in 1964 and has helped preserve several major structures shown in this book.

The preservation and conservation movements have led to major blocks of land being set aside free of development. This includes the Rye Nature Center, where a Parsons estate had been (which is pictured in the book); Marshlands, a park behind the Jay mansion; the Edith Read Wildlife Sanctuary, a tract on Manursing Island carved out of Playland property; and various sports fields, including Rye Recreation and Disbrow Park.

As for cemeteries in Rye, the oldest is the one on Milton Road, with the earliest readable tombstone bearing the date of 1772. The Jay family had a cemetery on their estate, dating from 1815. Currently burials are at the Greenwood Union Cemetery on North Street. Adjacent to it is a plot known as the "colored cemetery."

Taking a retrospective view of the development and character of Rye based upon the research for this book, a major factor that emerges is the role that philanthropy has played in its development. The churches, the library, the city hall, and the Square House were built with funds from wealthy Rye citizens or donated by them. Second to them only is the county of Westchester and the state of New York, which has given the city Playland, Rye Town Park, and the Jay mansion. But the city has also prospered due to smaller but crucial acts on the part of its citizens over the years, including volunteering to work on charitable and governmental boards, committees, and councils.

The author believes that books like this one, which look back a century, also help look forward. They show the benefits of preservation of what is of historic significance. They also document the gift to historians of the postcard era in this country. Personal photography was rare in the early part of the 20th century, and but for the postcard views, one would not know today what Rye of 100 years ago looked like.

One

DOWNTOWN

Remarkably, the downtown section of Rye has not changed substantially in the century following the earliest pictures in this book. It was then and is now several blocks along Purchase Street.

It is not true that Purchase Street derived its name as a subliminal reminder of retailers along the street. It was an early route used to reach an adjoining section of Westchester named Purchase, which John Harrison bought from the Native Americans in the 1600s.

Before 1913, Rye did not have a downtown square or green, as might be found in most New England towns. However, almost by happenstance, a village green came into existence in 1913, created out of a downtown lot owned by John Parsons, which ran from the Boston Post Road to Blind Brook. On it stood the Square House, much unchanged for the past 280 years. Behind it, the library was built, the land for which was given by Sarah Ely Parsons in 1913. On the south side of the green, the city hall was built in 1964, replacing the moving-picture theater that went up in the silent-movie era. And to the north, a portion of the Parsons land was given for the fire station.

The Rye Police Department originally had its station in the old Bitz building on Purchase Street before moving to its headquarters on Elm Street. In 1904, it had four officers. Since 1936, it has been on Third Street, now named McCullough Place.

The Rye Fire Department, with headquarters on Locust Street, traces back to 1886 when the Poningoe Fire Company was established. The firefighting apparatus was a hand-drawn cart and a horse wagon, stored at the Cushion blacksmith shop on the Boston Road. The horses were stabled close by. The first stable to bring the horses was paid a bonus.

The Rye YMCA started out around 1913 in a rented room above the Guerin drugstore and then moved in 1916 to the Purdy house, both illustrated here. It moved in 1920 to its present location at 21 Locust Avenue after purchasing the Raymond property.

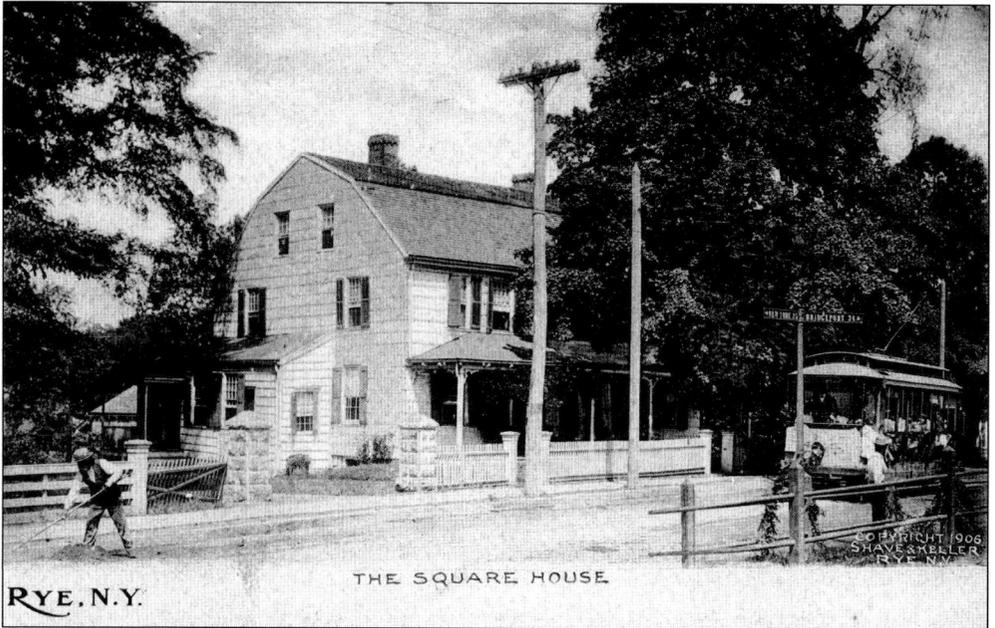

THE SQUARE HOUSE

RYE, N.Y.

The Square House is Rye's best-known and most-beloved building. While today it is the headquarters for the Rye Historical Society, previously it has been a home, an inn and tavern, a place of worship, and a municipal hall. It is documented that George Washington stayed here twice in 1789 when it was a stage stop on the Boston Post Road, one day's ride north from New York City. The building was probably constructed as a farmhouse around 1730 and was regarded as a major structure for its time. The Square House is open to the public at One Purchase Street and is decorated in some rooms to look as it did in the Colonial era. It is on the National Register of Historic Places. In the above view from around 1906, one can note the trolley and the dirt road.

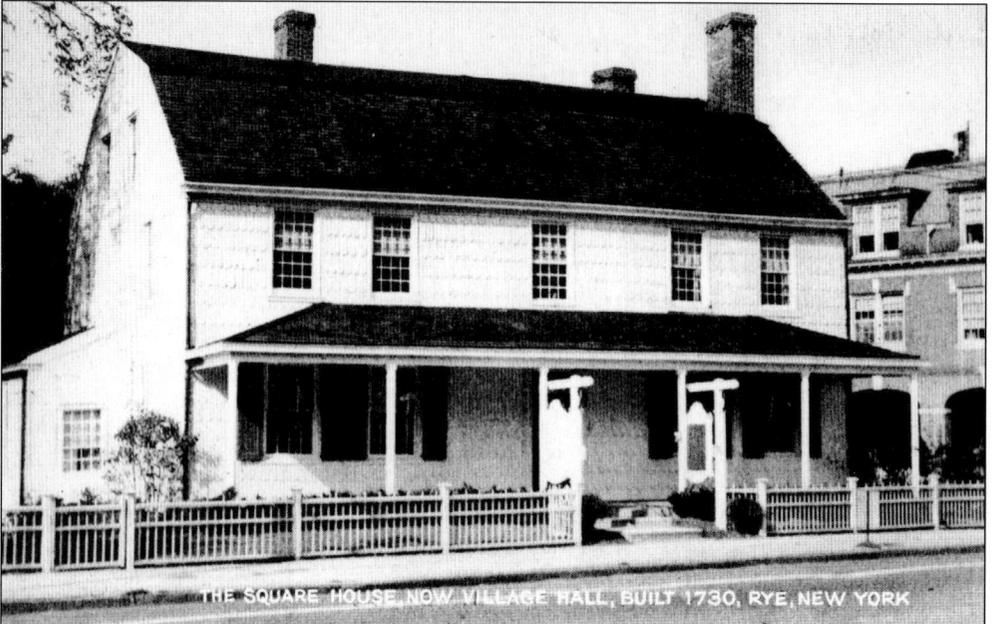

THE SQUARE HOUSE, NOW VILLAGE HALL, BUILT 1730, RYE, NEW YORK

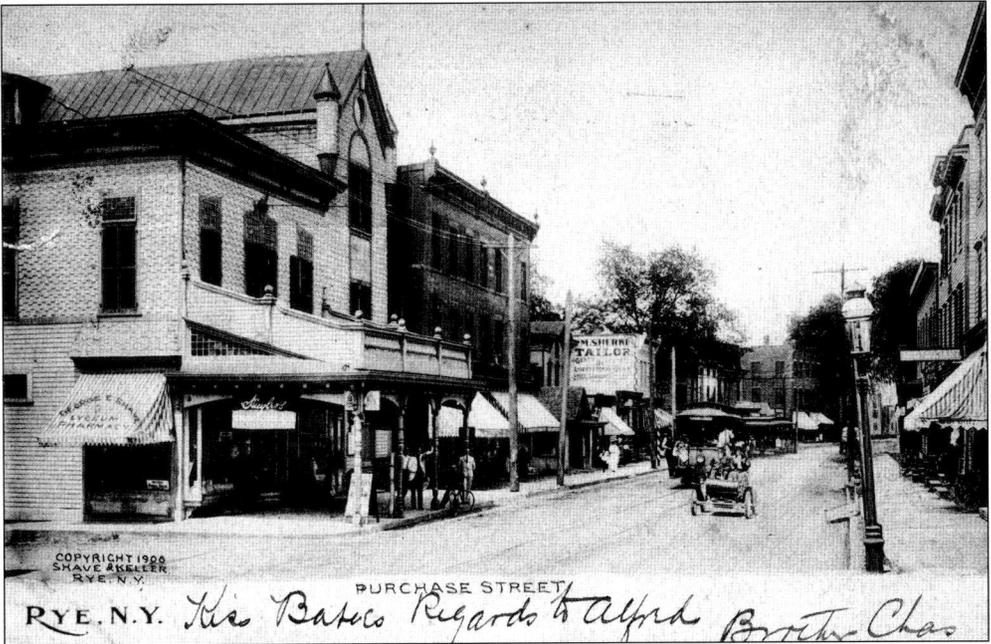

RYE. N.Y. *Kis Batso Regards to Alfred Brother Chas*

PURCHASE STREET

These two cards present views of Purchase Street looking north where Locust Street intersects. The large building on the left is the Lyceum. For years, it was one of the most notable in Rye (its present address is 33 Purchase Street). Abraham Fowler built the structure in 1883. It had a grocery store below and an unfinished second story. A decade later, John W. Gwynne, a wealthy Rye resident, purchased it, named it the Lyceum Building, and made the upstairs into an auditorium. Bands played on the porch, which is shown over the first floor. Later there was a pharmacy and in the basement a billiards room and bowling alley. Note on the awning the name of George E. Shave, who published this and other cards. It has since been remodeled.

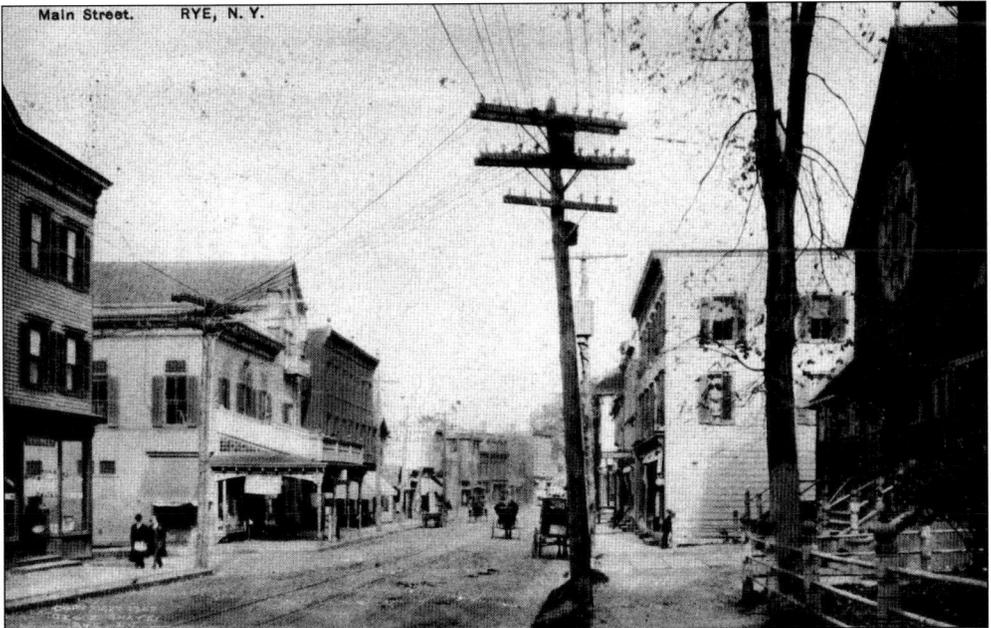

Main Street. RYE, N. Y.

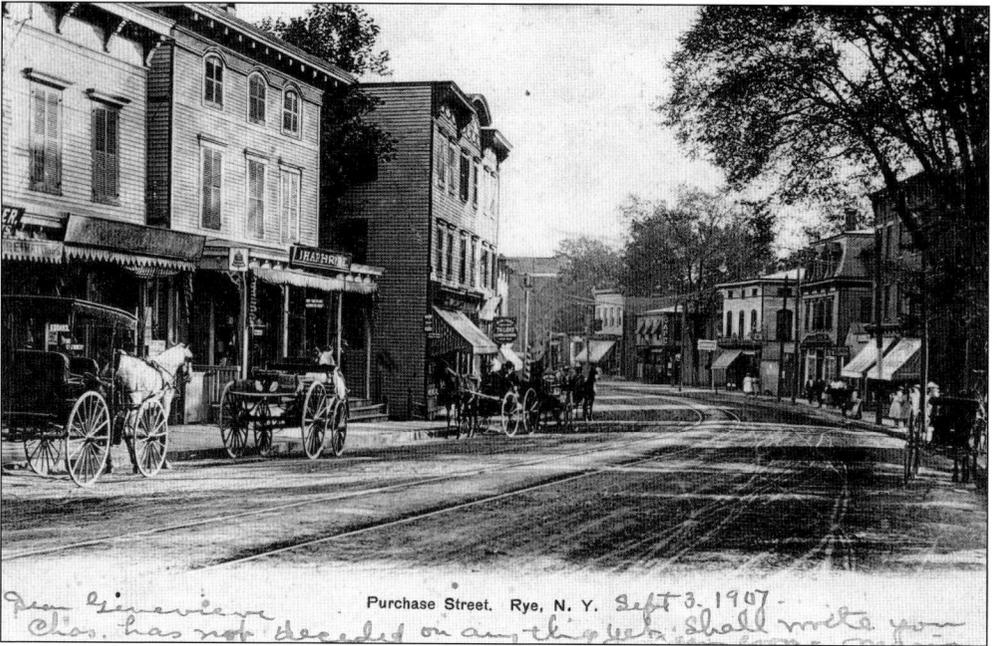

This is a beautiful scene of a section of Purchase Street in 1907 looking south toward the lower end of the street toward the Square House. The road is still dirt, and the trolley tracks can be seen. Horses and wagons brought in both products and customers to shop. The names of some of the stores can be made out, including "New York Tailors," "mattresses," and "carpets."

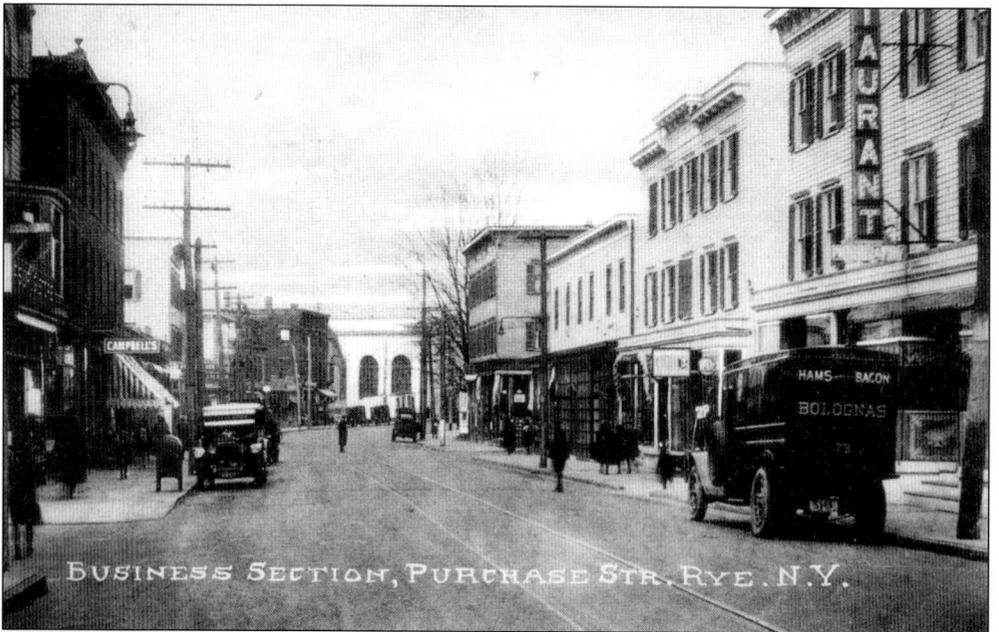

BUSINESS SECTION, PURCHASE STR. RYE. N.Y.

Time has moved on with this view from the 1920s, which looks north along Purchase Street at the corner of Elm Street. The trolley tracks are still present, but the street is paved. The automobile has replaced the carriage. A delivery van is bringing pork products to a store. At the end of the street before the turn is Rye's first bank.

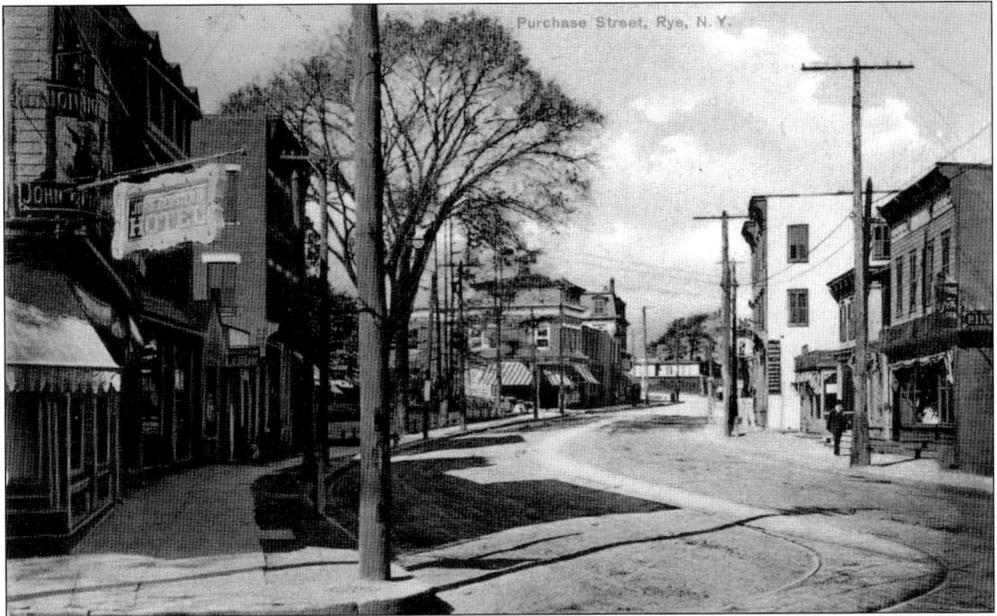

This is a 1909 view farther along Purchase Street where the New Haven train tracks cross above grade. The Union Hotel, owned by John Gerster, is on the left, and beyond that are the awnings of Guerin drugstore. Hotels were a feature of downtowns and railroad stations that do not exist today.

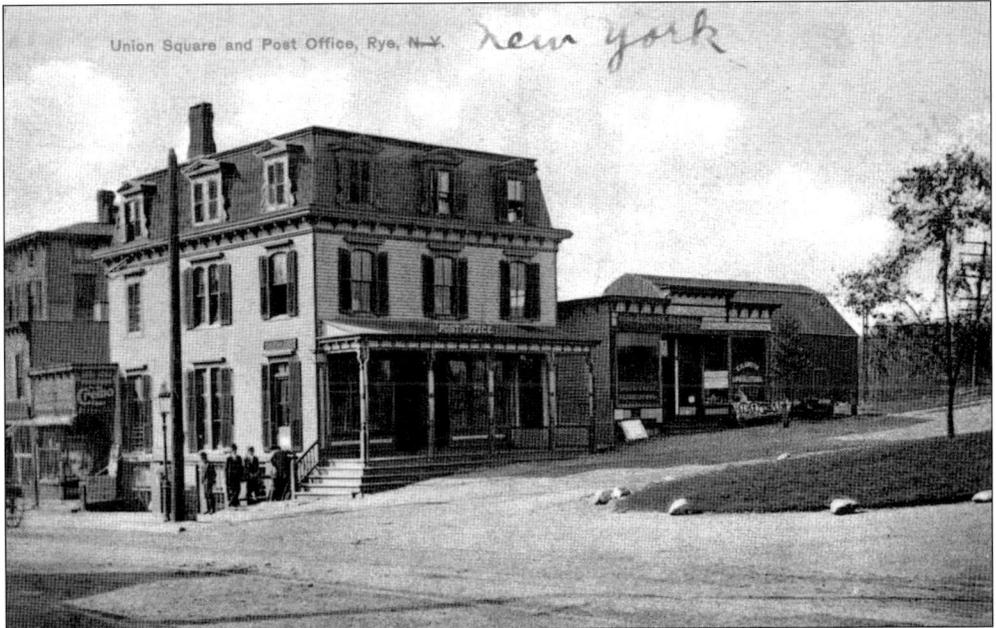

Union Square and Post Office, Rye, N.Y. *new york*

This is a view from the early 1900s of the intersection of Purchase Street and what is now Theodore Fremd Avenue, but if one stood in the same position today, it would look little changed. The large building in the center was then the post office for Rye, with a cigar store to its left. To the right are the store of upholsterer T. H. Smith and the office of Augustus G. Wilson, a land developer.

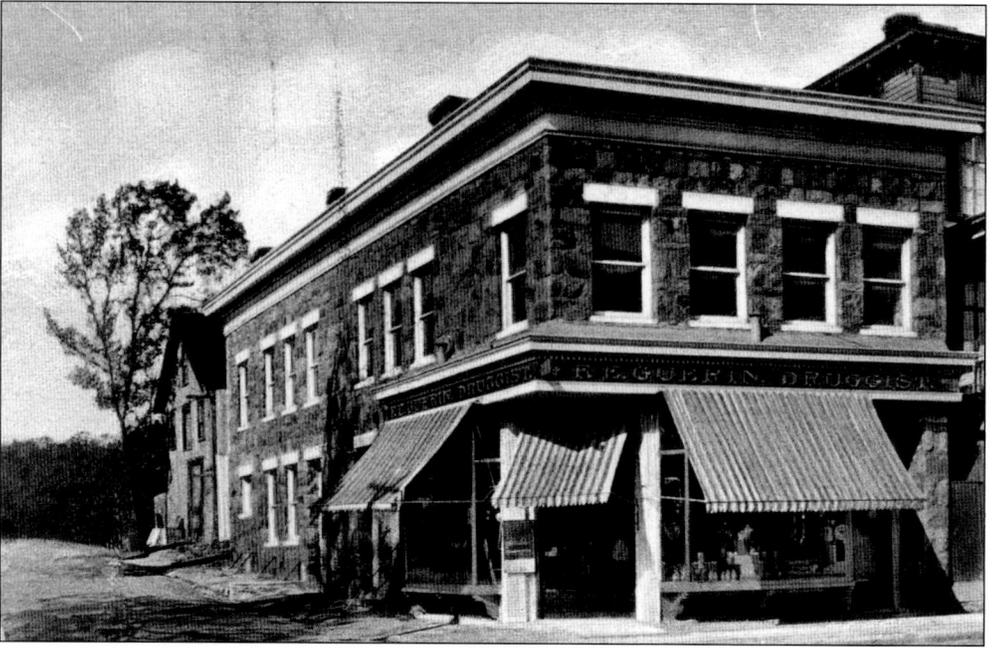

E. E. Guerin operated a drugstore on Purchase Street in the early 1900s. He properly calls himself a druggist, as he compounded many of the drugs. Also, as with other drugstores in Rye, he had postcards made, some of which are used as illustrations in this book. The building was remodeled into a bank and how houses a candy store. (RHS.)

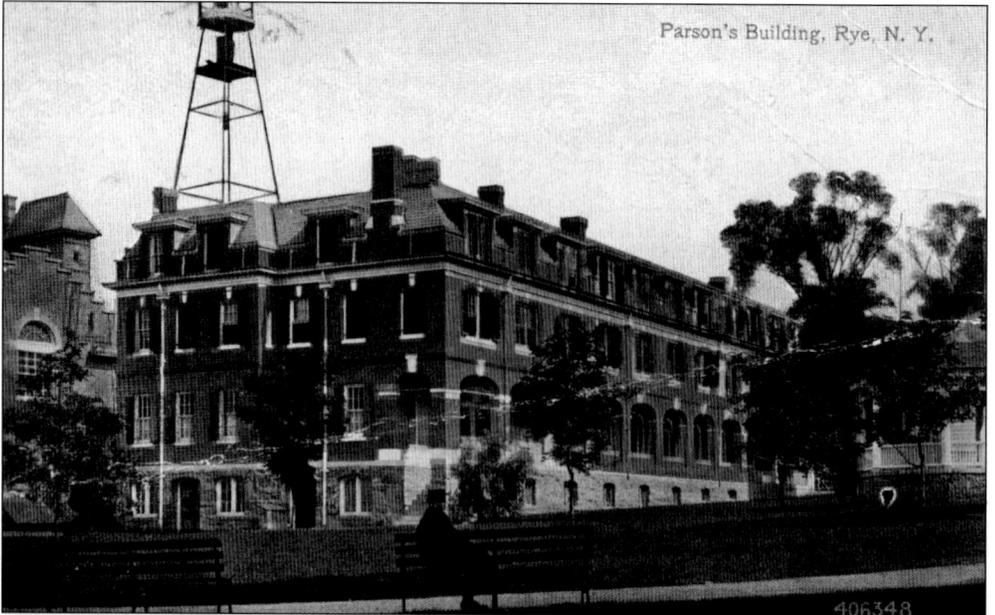

Parson's Building, Rye, N. Y.

This structure, known as the Parsons Building (after developer John E. Parsons), or the Arcade Building, was erected in 1909 at 15 Purchase Street. It was shoehorned in sideways next to the Square House and built for $50,000. There were stores on the first floor with offices and apartments on the upper floors. On the street level today are the Arcade Bookstore and an antique shop.

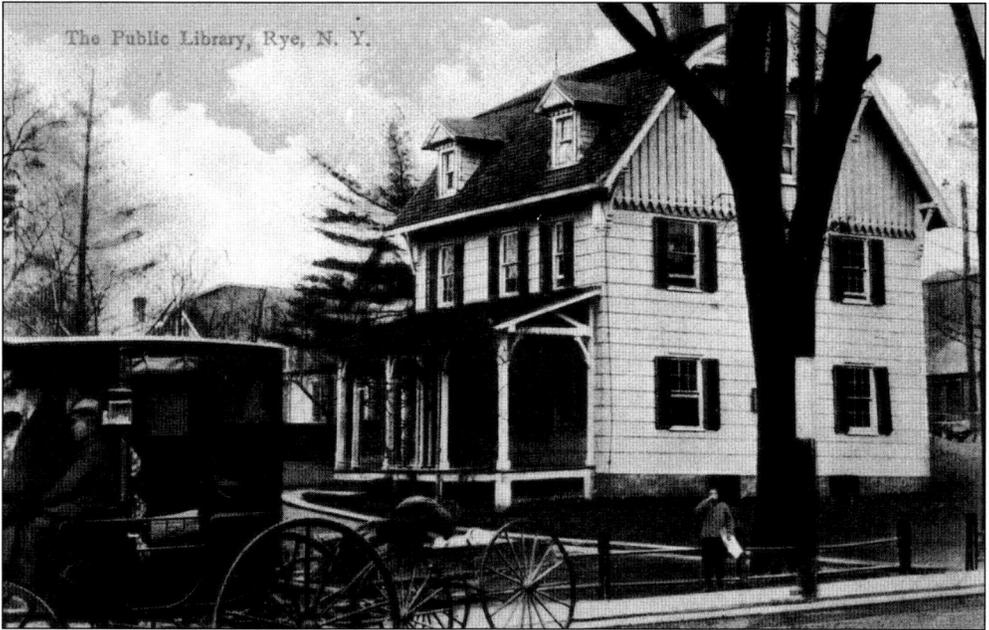

The Public Library, Rye, N. Y.

The building above was the home of the Rye Free Reading Room from 1890 to 1913. The library was established in the 1880s at the earlier illustrated post office building and continues today under the same name as a private organization with public support. The building above started as the Purdy cottage, standing back from Purchase Street, where the Rye National Bank was later built at West Purdy Street. After the library moved from Purdy cottage, the building was rented to the nascent YMCA until 1919, when it was torn down. The library moved into its new building, shown below, in 1913, where it is still today, although with some major additions. The land was donated by Sarah Ely Parsons; the primary money for construction came from wealthy Rye resident George D. Barron. The architectural firm was Upjohn and Conable.

FREE READING ROOM, FOUNDED 1884, RYE, N.Y.

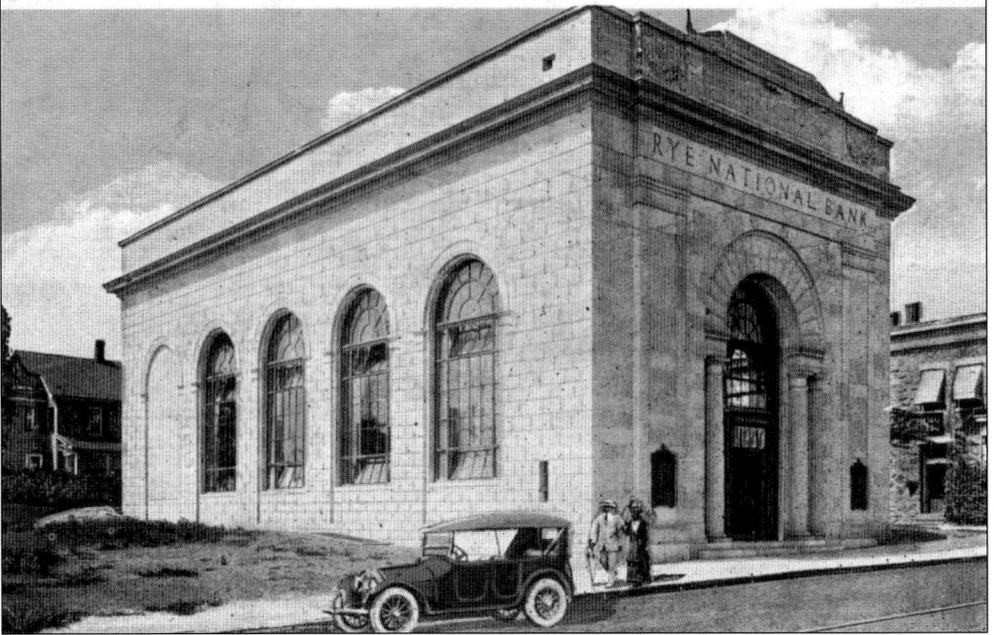

Rye's first bank, Rye National Bank, was founded in 1901 and moved to the building shown above in 1923. It had the usual marble and columns associated with stability. Marcelis Parsons, whose house is illustrated on page 40, was one of the founders. Today it is a Chase Bank at the corner of Purchase and West Purdy Streets. Shown below is the Rye Trust Company (erroneously called the national bank here), which was across the street at the corner of Purchase Street and Purdy Avenue. It was built of brick by Col. J. Mayhew Wainwright, one of Rye's gentry. Later a second story was added, and today it is a store. Today Rye has many banks, all located in storefronts, but no imposing structures except for Chase Bank. (Below, Steven Feeney.)

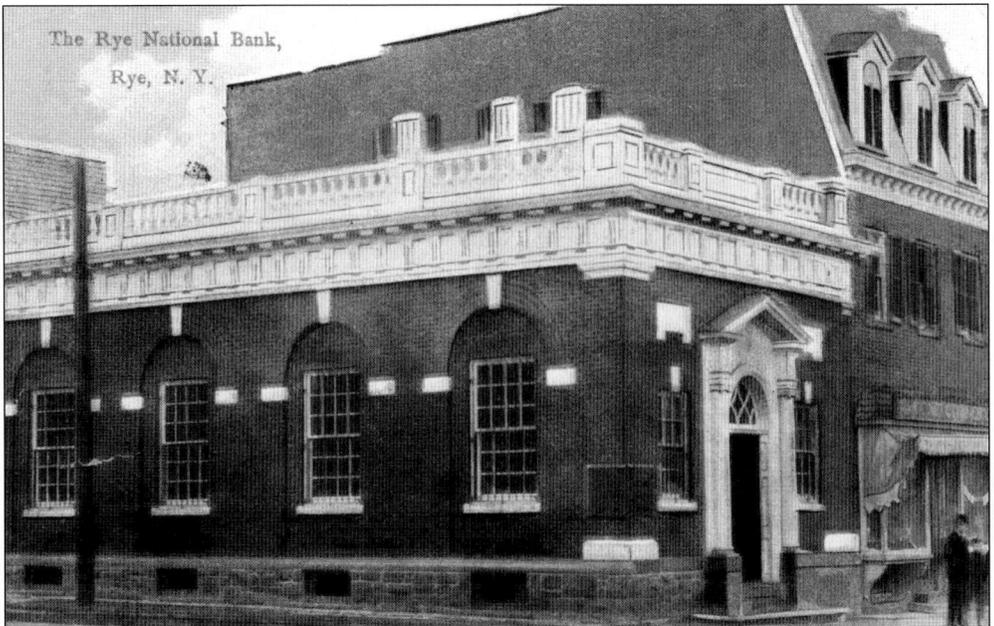

The Rye National Bank, Rye, N. Y.

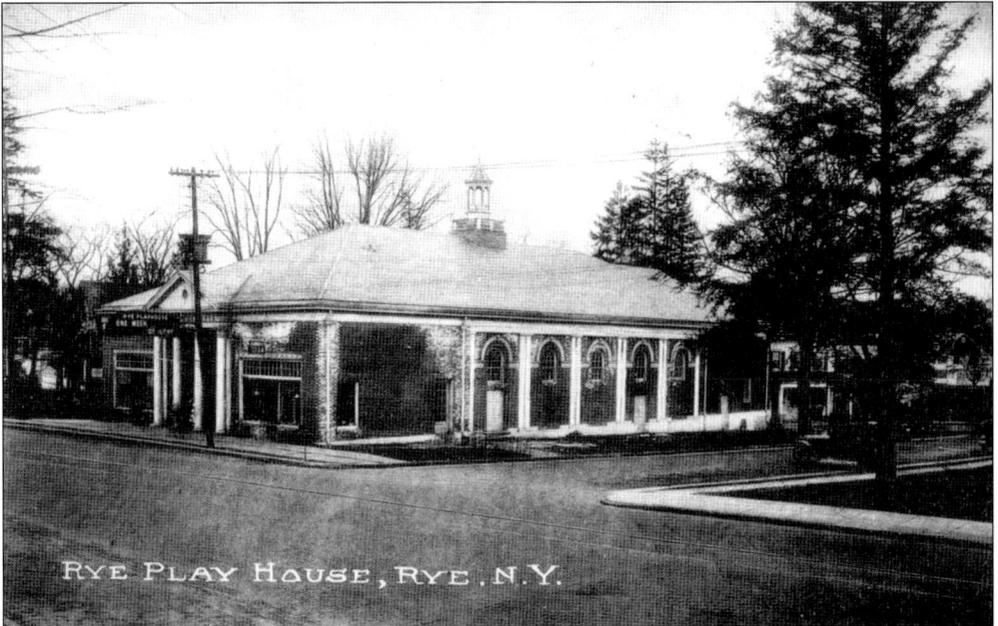

RYE PLAY HOUSE, RYE, N.Y.

The movies came to Rye in the Play House in 1921, beginning with silent films and then going to Movietone in 1928. The oral histories of old-timers recall going to the Play House as children, paying a dime on Saturdays to see such serials as the *Green Archer*. The Play House burned down in 1951 and was not rebuilt. Instead the land became the space for the new city hall.

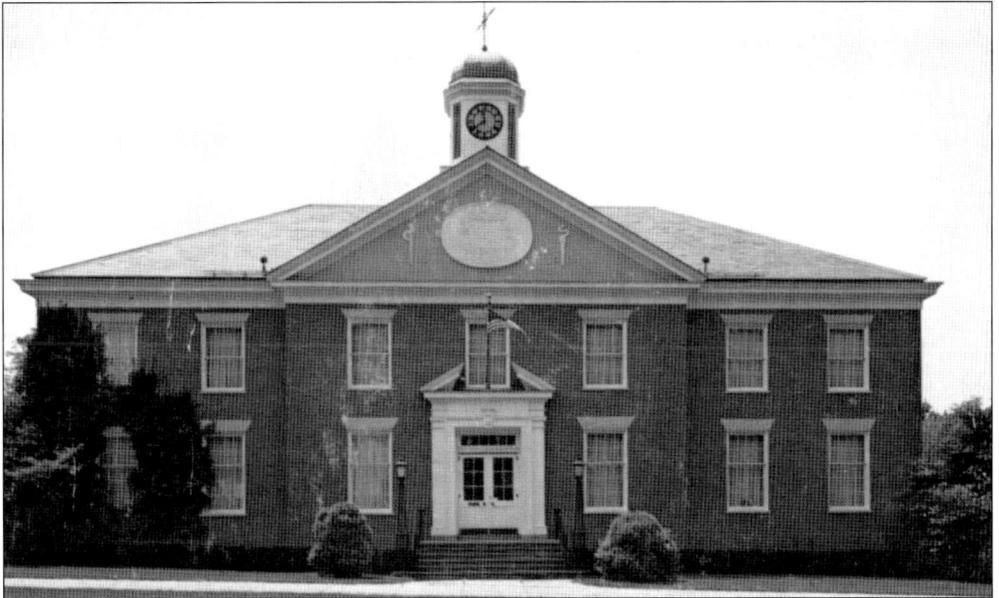

Rye City Hall was erected in 1964 on the lot of the Play House and thereby completed the third side of the current city green (1051 Boston Post Road). The architects, William and Geoffrey Platt, adopted the Colonial Revival style, perhaps a reference to Rye's Colonial history. The building was paid for by another of Rye's wealthy residents, John Motley Morehead III, a North Carolinian by birth. (RHS.)

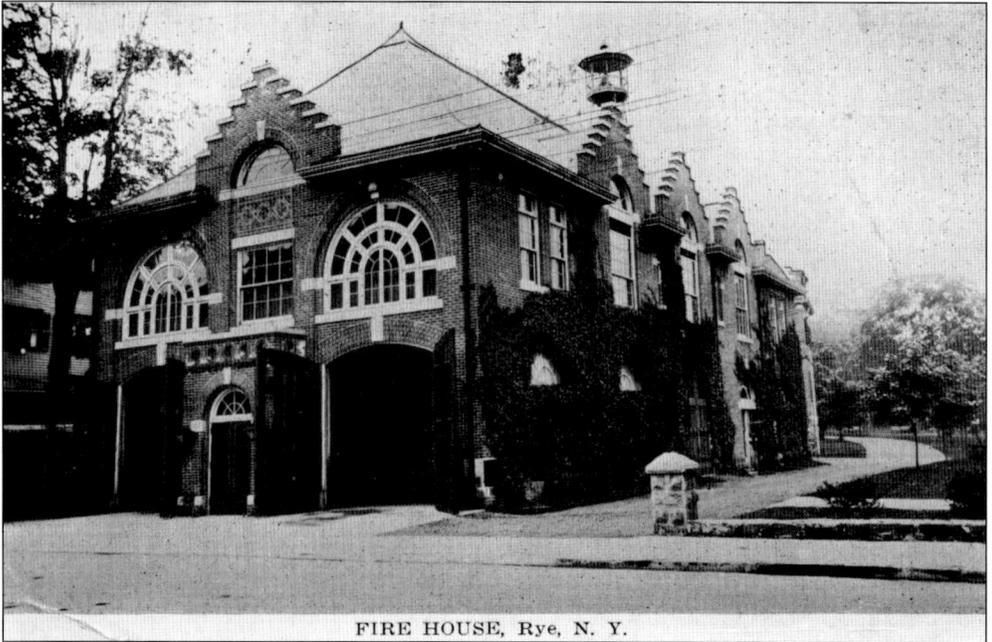

FIRE HOUSE, Rye, N. Y.

Rye's fire department dates back to 1886. The two fire stations, pictured here, have been in Rye for almost a century. The Locust Avenue one, shown above, is the headquarters. It opened in 1909 on land donated by Sarah Ely Parsons. The one glimpsed below is Milton Point Hose Company, erected in 1911. Its name was changed to Milton Point Engine and Hose Company in 1927, reflecting the replacement of horse-drawn fire wagons. Rye has had a volunteer fire department from its initiation. There are several paid employees who stay at the stations. The Milton Point station (560 Milton Road) was substantially enlarged recently. The Locust Avenue one, housing two Poningoe companies, engine and hose and hook and ladder, has only been modestly enlarged over the years but often modernized.

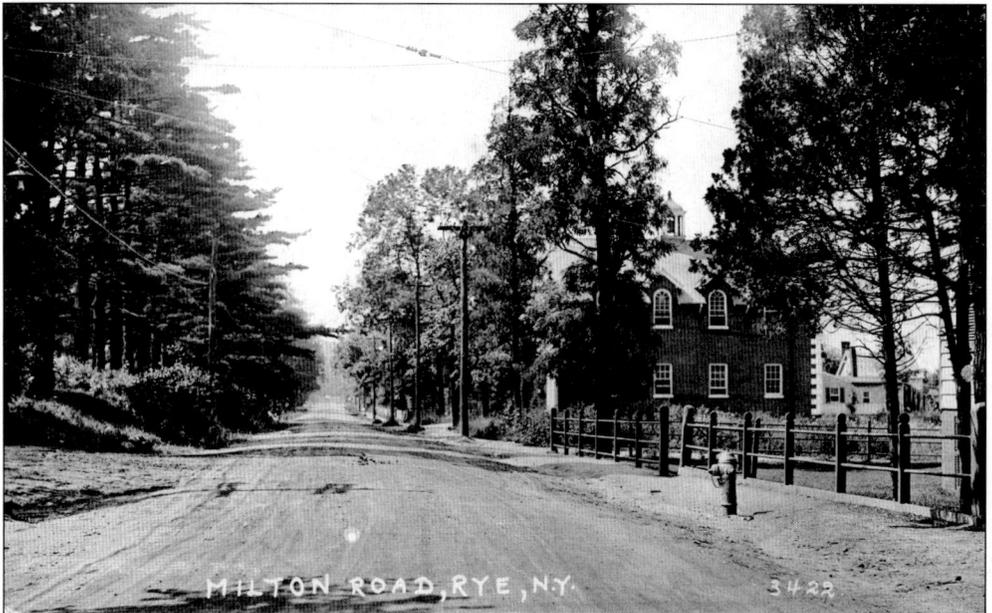

MILTON ROAD, RYE, N.Y. 3422

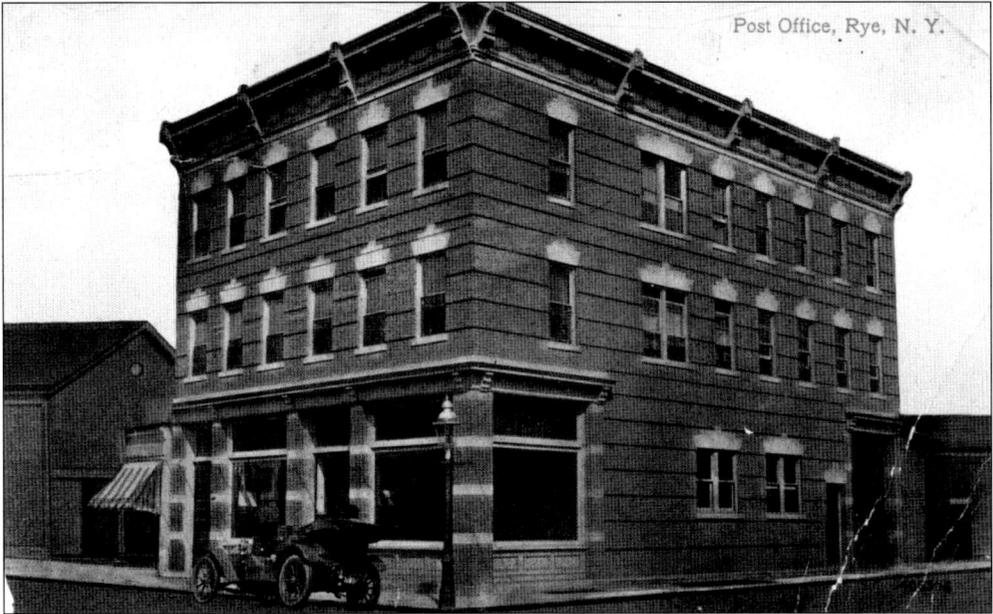

The post office has been in a number of locations in Rye. After the Purchase Street office shown on page 15, it was then located at 7 Purdy Avenue, as shown above. Today that building houses a pizza parlor. The current post office in Rye is shown below, farther up on Purdy Avenue. It was dedicated in August 1936. The architectural style might be called Grecian but with restraint and limited decorations. Arthur Howland was the director of construction, and it was built at a cost of $134,000. Inside is a notable mural done on a Works Progress Administration (WPA) commission by Guy Pene du Bois, a well-known artist. It shows John Jay at the family estate on the Boston Post Road departing on some judicial duty. (Above, RHS.)

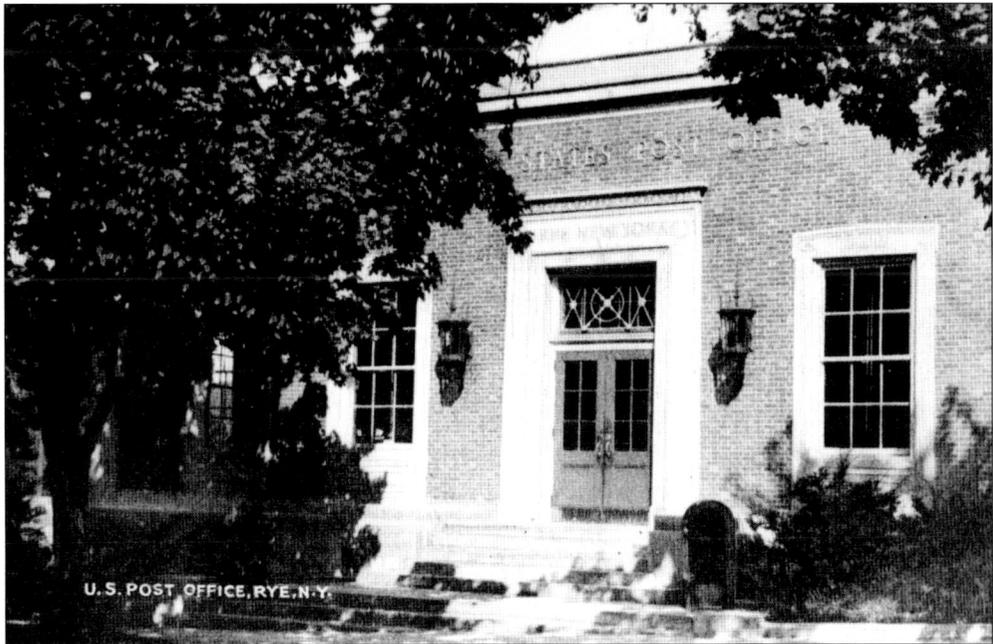

U.S. POST OFFICE, RYE, N.Y.

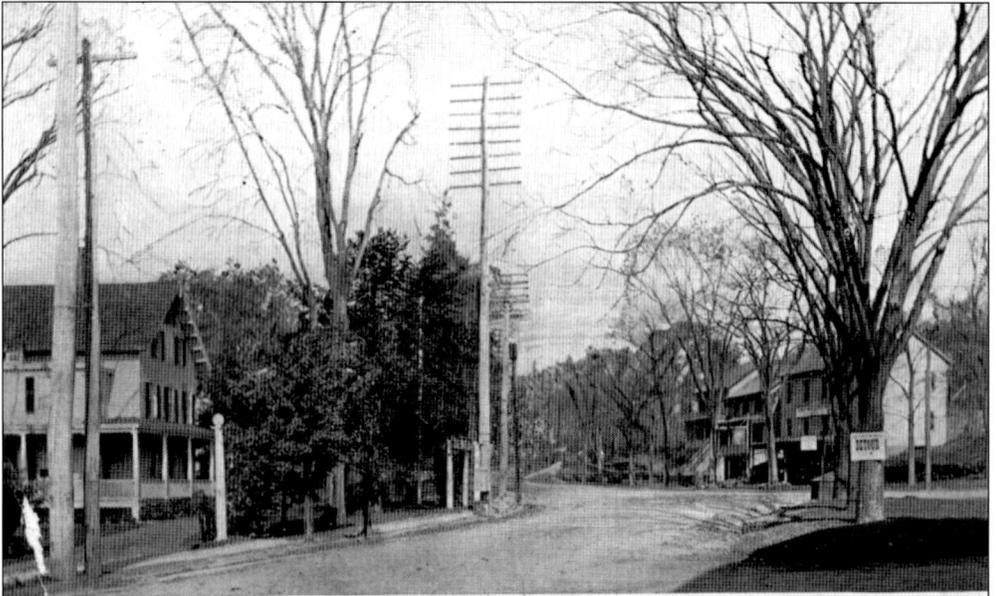

POST ROAD, NORTH FROM BAIRD SQUARE, Rye, N. Y.

These two views show the intersection of the Boston Post Road with Milton Road and Purchase Street. At the time of these pictures around 1910, the area was known as Baird Square, named in memory of Rev. Charles W. Baird, beloved minister of the Presbyterian church. Today it is a busy intersection with traffic lights. In the upper view, looking north, are the Colonial Inn on the left and the Cushion blacksmith shop (today replaced by condominiums) in the far center. The view below looks west toward the Colonial Inn. Once again, the trolley tracks are seen on the unpaved street.

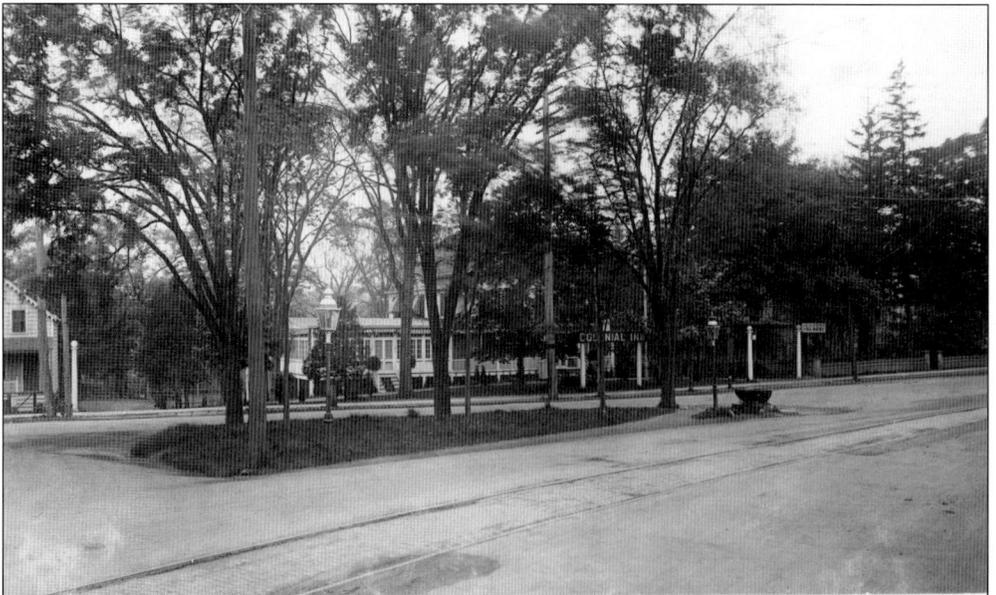

P2006 Baird's Square, Rye, N. Y.

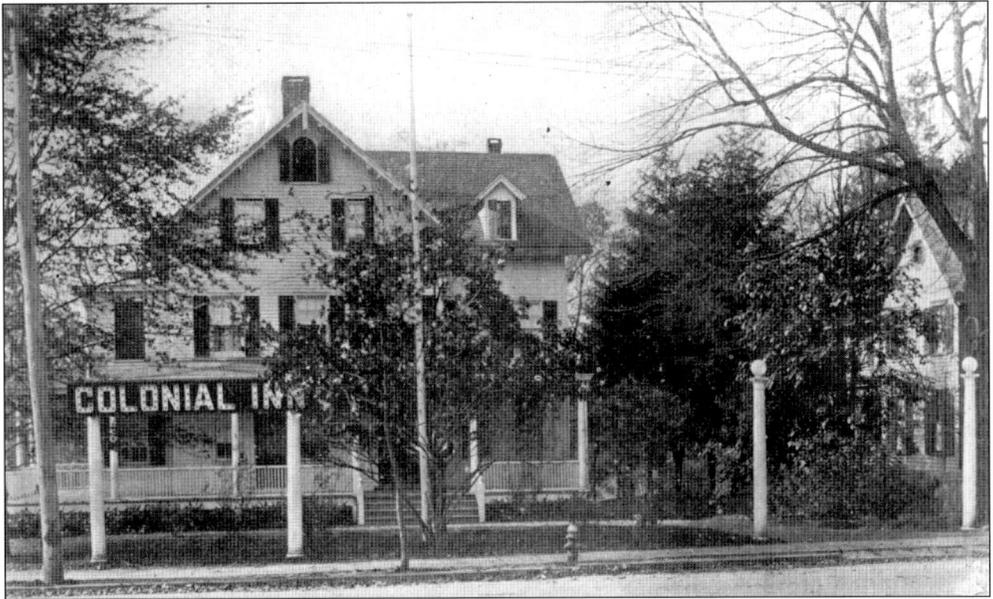

Rye's Colonial Inn, pictured above, stood on the west side of the Boston Post Road just south of where Purchase Street began. Today it has made way for a store at 1037 Boston Post Road. Pictured below is the Quilting Bee Tea Room, which was probably on Elm Street. Quilting was a major occupation of women in former days, working collectively or making a social meeting out of it. The tearoom served that function; it was founded about 1914 by local women. An old advertisement described it as "quaint environment, old time furniture and lovely quilted products—charming place to tea and to see." (Below, Steven Feeney.)

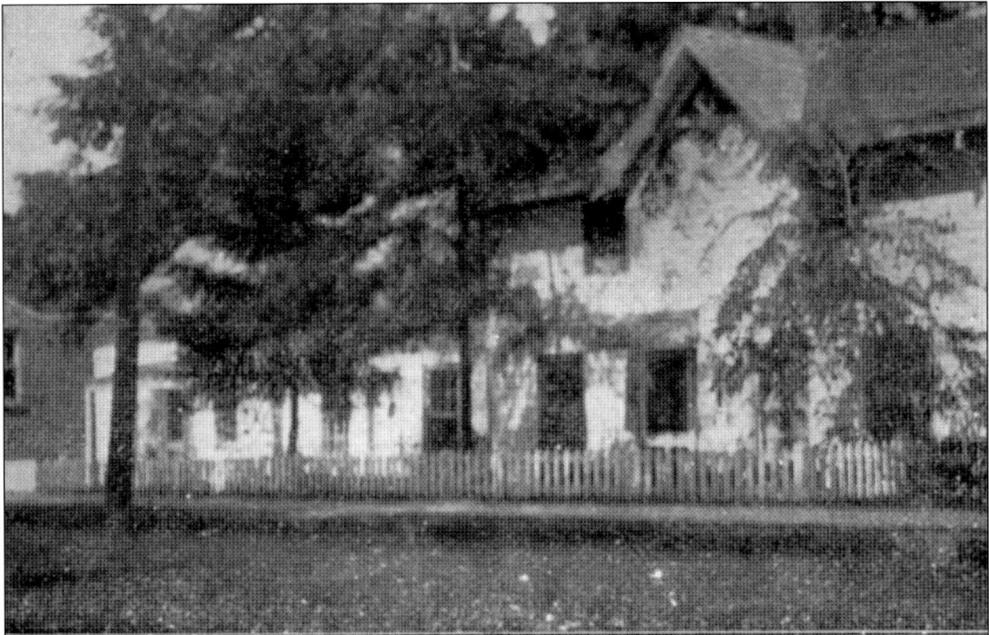

THE QUILTING BEE COTTAGE TEA ROOM, RYE, N. Y.

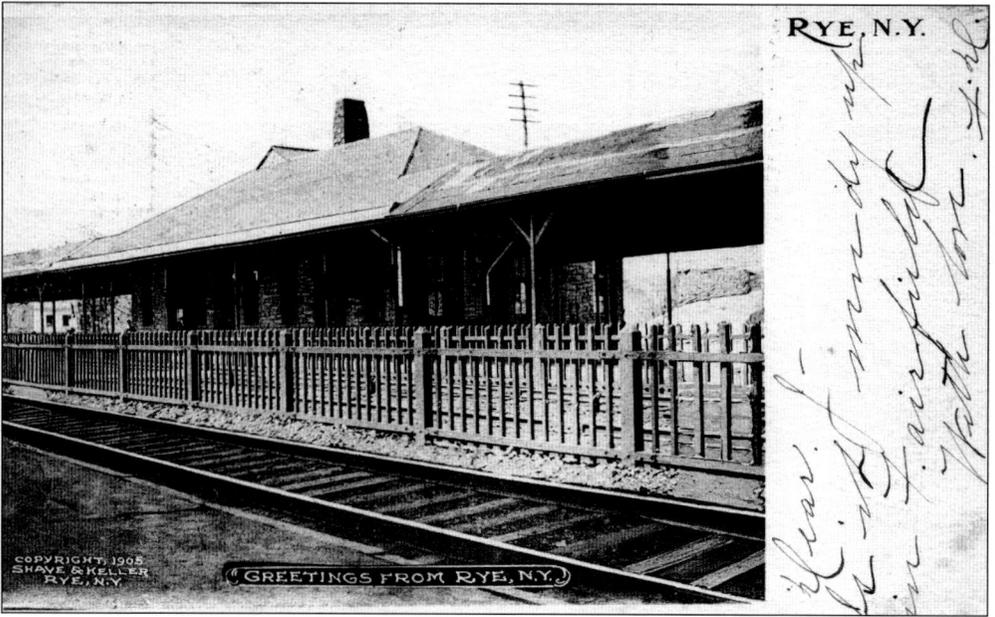

As with many towns, the nature of Rye changed with the advent of the railroad. In this case, it was the New York, New Haven and Hartford Railroad, whose tracks came through Rye in 1849. People could travel between Manhattan and Rye in 45 minutes or so, which is not much different than today. No longer would one have to go by stage. The first track lines were laid at ground level, crossing Purchase Street at the point where they do today, although they have since been elevated for safety. The first station was demolished with the elevation. These two views show the second station, which was built soon after 1900. There were two tracks, soon to be made four. This station in turn was demolished when Interstate 95 came through Rye, closely following the tracks. (Below, Steven Feeney.)

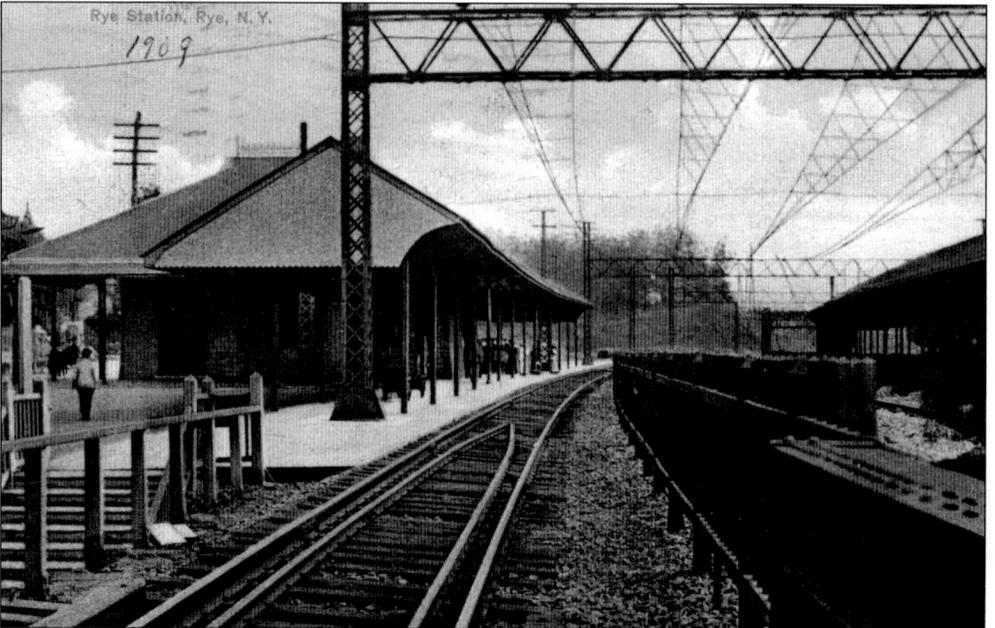

Rye Station, Rye, N.Y.

1909

Two

AROUND TOWN

There has been a great deal of change in Rye over the last 100 years. Most noticeably, the streets are paved. Rye expanded in housing and population with the development of new streets over the past century. Subdivisions were created on the remaining farms and large plots that went with the Gilded Age mansions. The subdivision work was well underway by 1900 with such developments as Ryan Park, Sound View Park, Indian Village, and Loudon Park (now Loudon Woods), and it continued until there were virtually no large plots left to break up. Many of the large landowners did their own subdivisions; others were done by early realtors, such as Merritt and Wilson.

With these subdivisions came new streets. Before a law change, developers could pick their names, which led to such names as Eve and Ann (probably for their wives). After the city council required they be picked from a list consisting of deceased city fathers, names such as George Langeloh Court, Martin Butler Court, and Stanley Keyes Court were used.

The most notable land-use change around town is the construction of the interstate highways—Interstate 95 runs north and south, generally paralleling the train line, and Interstate 287 branches off from it toward White Plains. However, these massive 1960s projects did not destroy any neighborhoods. Interstate 95 mainly runs over land that had been set aside for a country parkway, and the interchange with Interstate 287 is in northern area that had a few estates.

A second major land-use change, reflected in the views in this book, relates to the creation of Playland. This also led to the creation of Playland Parkway, directly connecting the amusement park with the interstate system.

A journey around town also involves a tour of the extensive waterfront. Rye has the Kirby tide mill, the last of its type existing in the county; Pine Island and Reynolds Cove; and most importantly to Rye's history and current usage, the development of the inner Milton Harbor, including the city marina.

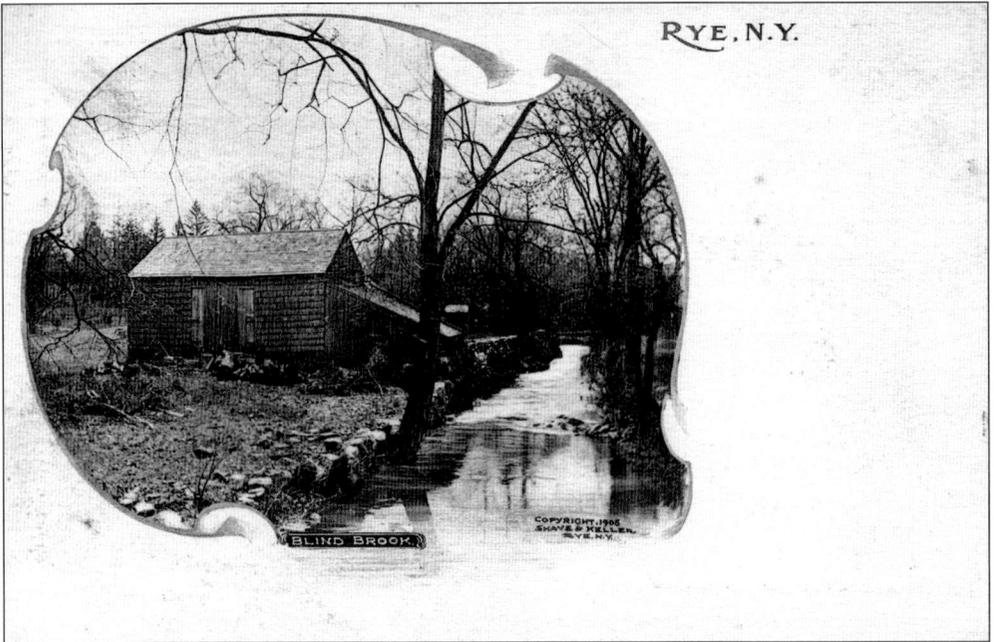

RYE, N.Y.

BLIND BROOK.

COPYRIGHT 1905
SHAVE & KELLER
RYE, N.Y.

The major stream in Rye is Blind Brook, named perhaps because it often runs through town in a deep trench. It arises in Purchase, runs through downtown, and ends in Milton Harbor. It is not always as tranquil as pictured above; it has rampaged the city on numerous occasions. The bucolic view above from 1905 was probably taken at the point where the Boston Post Road runs parallel to the brook. The view below shows Blind Brook living up to its name; it is down in a culvert where the trees are. This walkway leads to Locust Street. The big boulder, which is still present, marks the location of an early gristmill. (Below, Steven Feeney.)

VIEW IN VILLAGE PARK, Rye, N. Y.

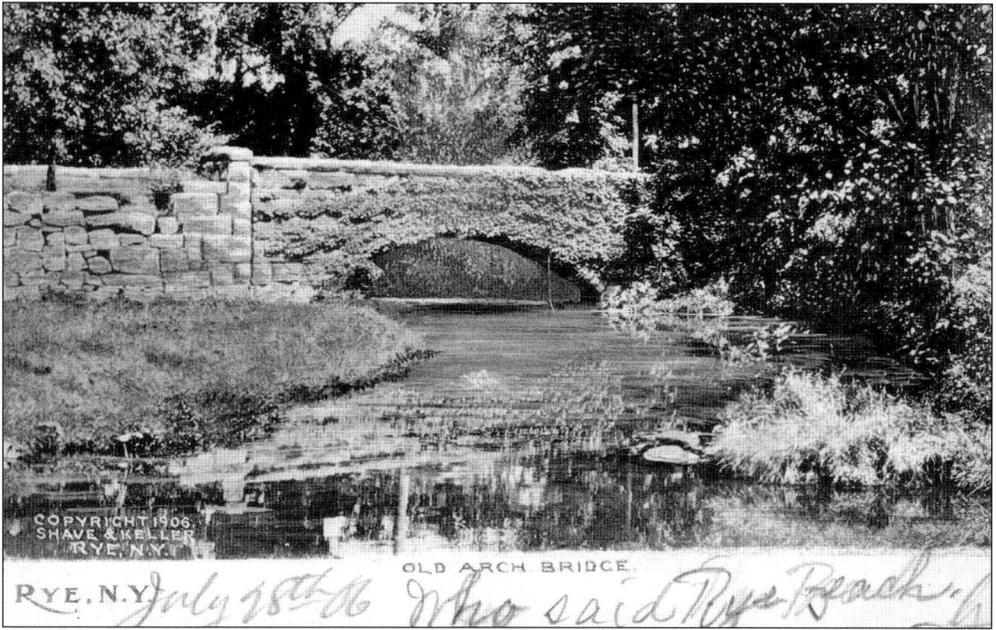

OLD ARCH BRIDGE.

RYE, N.Y. July 18th 06 Who said Rye Beach.

The pictures show old stone bridges in Rye dating from the 19th century, both crossing Blind Brook. The arch bridge was on the Boston Post Road near where Parsons Street is today. When the road was straightened and widened, it was rebuilt, but the present bridge has the same structure. Parson's Bridge, below, crossed the stream near the arch bridge on a private road that ran up to the Parsons house. The 60-foot-long bridge was built in 1870 with open stonework on the top. It now leads to the Rye Nature Center.

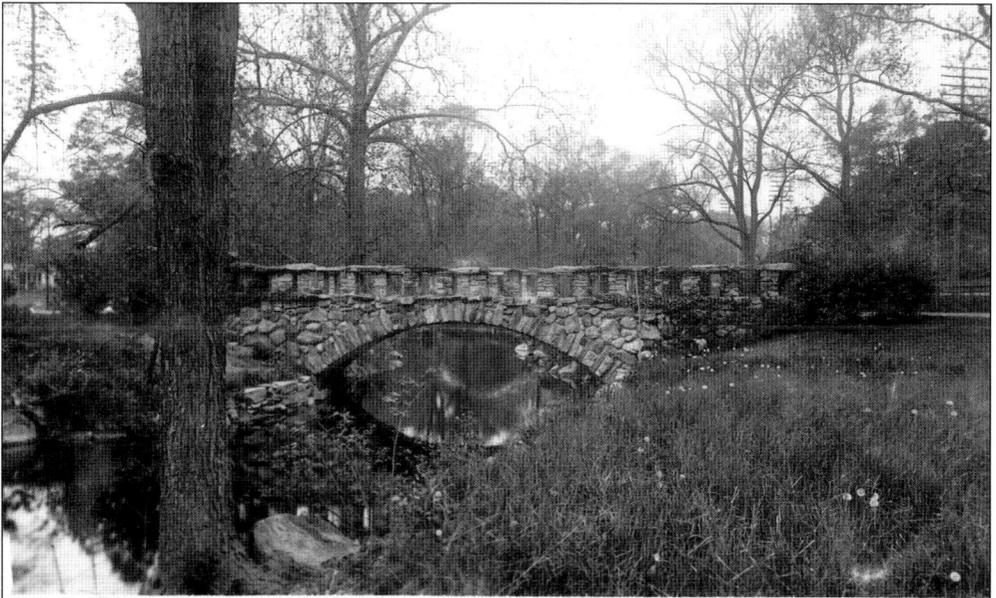

P1997 Parson's Bridge, Rye, N. Y.

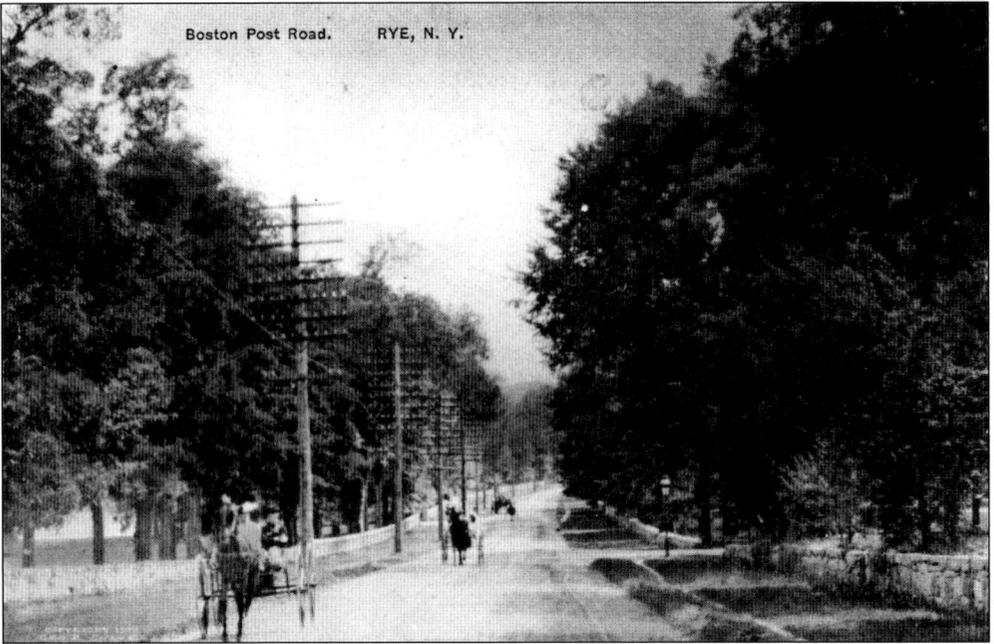

Boston Post Road. RYE, N. Y.

The scene above along the Boston Post Road, known then as the flats, is near today's Rye Golf Club. Like all of Rye's roads in the early 1900s, it is still dirt. What is notable in this view is that sulky racing is going on. This was a popular sport; local residents left their carriages behind and tried a sulky. The Boston Post Road and its predecessor trails have been the main artery north and south through Rye. Below is a scene on Milton Road, another main artery in Rye, running north to the Boston Post Road downtown. On the right is Christ's Church.

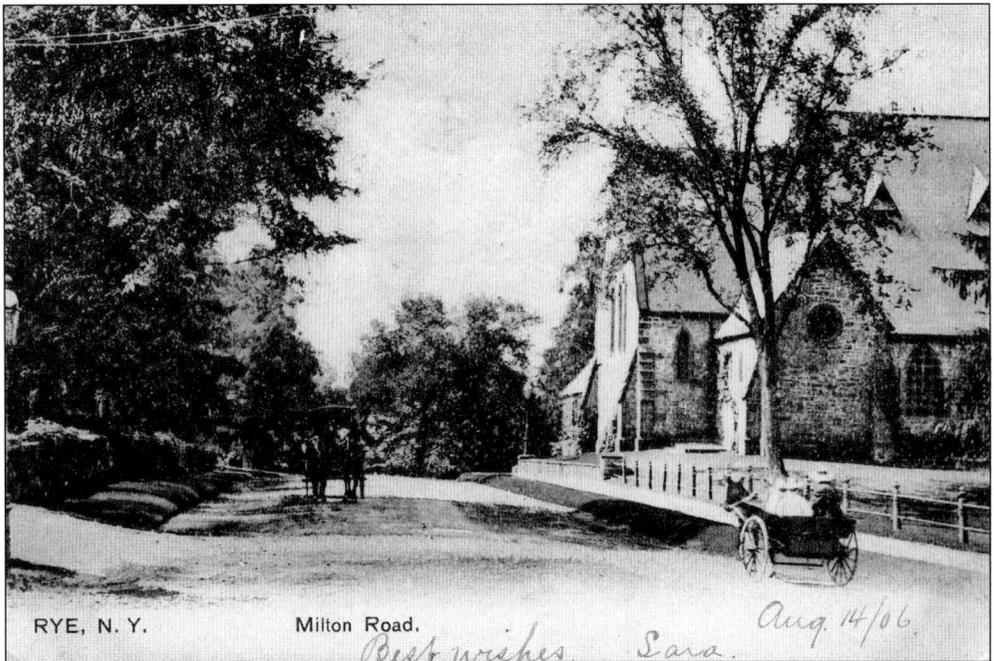

RYE, N. Y. Milton Road. Aug. 14/06.
Best wishes. Sara.

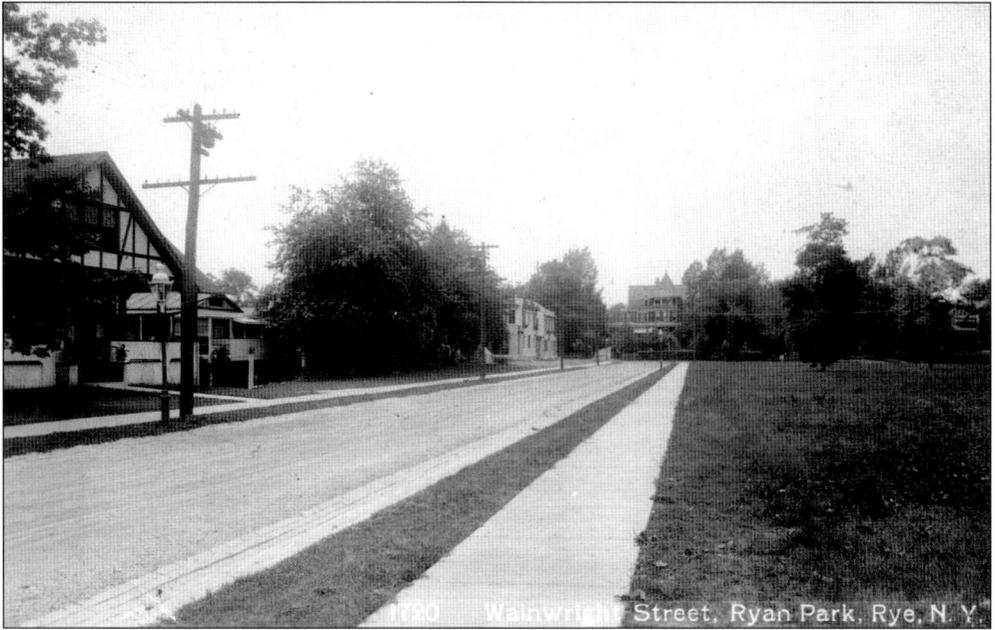

1720 Wainwright Street, Ryan Park, Rye, N. Y.

These views depict streets developed as part of subdivisions. The scene above is a street in Ryan Park, a subdivision off Forest Avenue developed by James S. Merritt. Some five streets were created, including this one named after Col. J. Mayhew Wainwright, who lived on Forest Avenue. The house on the left is 30 Wainright Street today. Redfield Street, below, was created in 1901 or before as part of Lounsbury Park, a section also running from Forest Avenue to the beach (not the harbor as stated). It was also developed by Merritt with 35 lots. The subdivision name was a family name, and Redfield was his sister's married name. The house on the right is 24 Redfield Street today. In each view, note the presence of streetlights, which had to be lit each night.

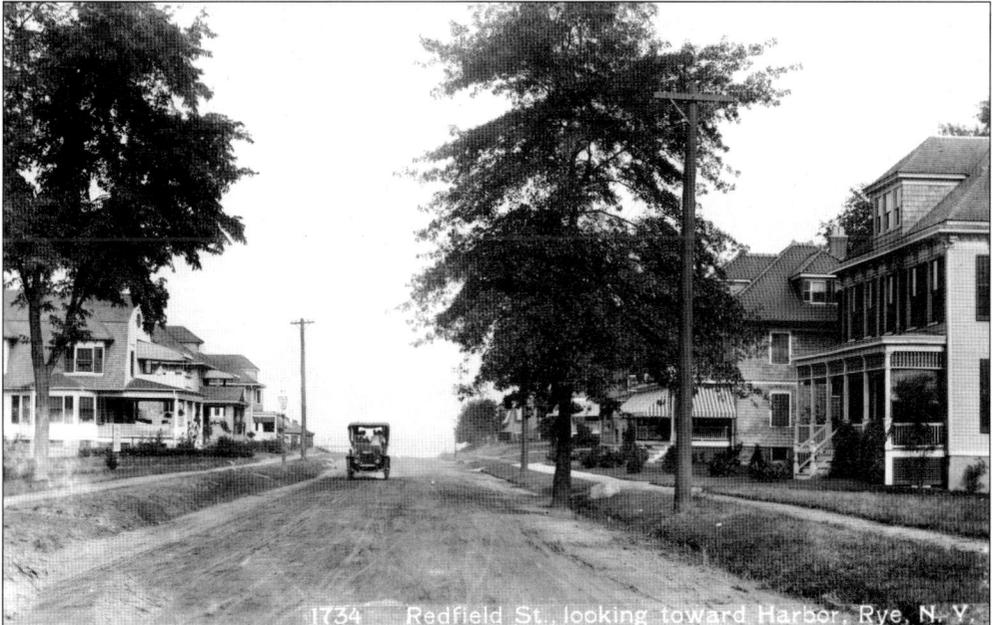

1734 Redfield St. looking toward Harbor, Rye, N. Y.

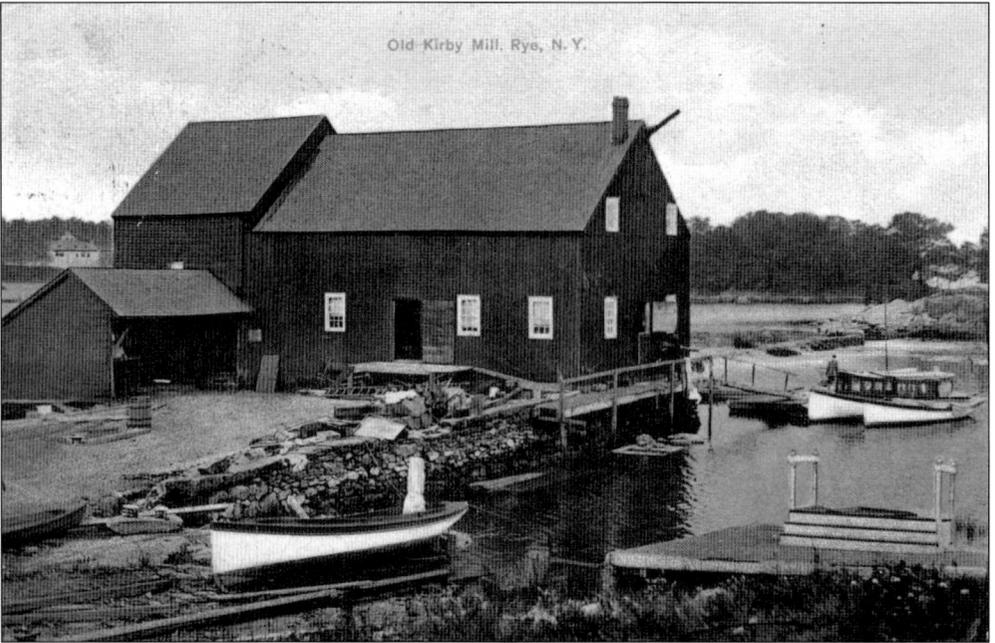

Old Kirby Mill, Rye, N.Y.

Around 1770, Wright Frost built a mill in Rye near the Port Chester Harbor, which operated with the tides in Long Island Sound. It was used for grinding grain, but unlike those operated by streams where the wheels revolved vertically, here the wheel turned horizontally as impounded water from a high tide ran out. This meant that the operations took place twice a day at hours that were not necessarily convenient to the miller. The back pond holding the water was built by a series of dams between small islands. The mill was sold to David Kirby in 1812, and his name has remained attached to it and to the street that reaches it. The mill building still exists, but the property on Kirby Lane is known as the Tide Mill Yacht Basin.

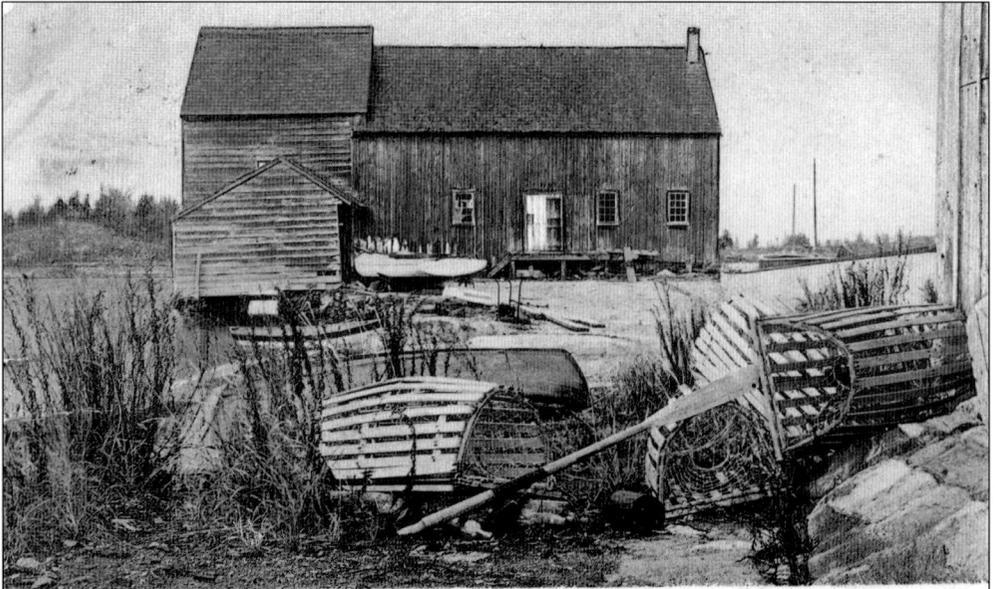

K. 3014 The Old Mill, Rye, N.Y.

Artino post cards New York City & Germany

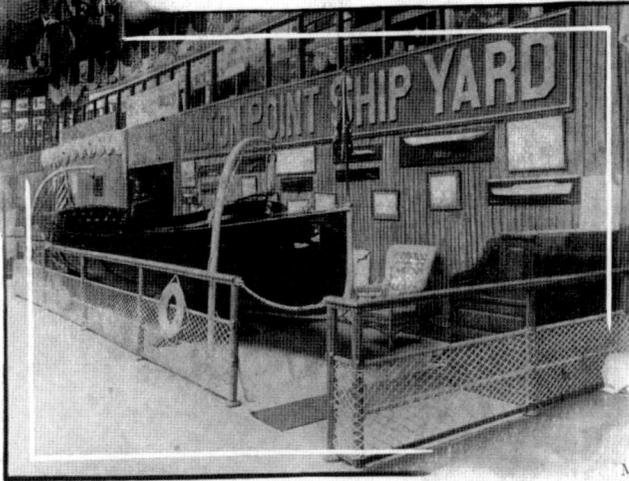

MILTON POINT SHIP YARD

"OUR EXHIBIT"

MILTON POINT
SHIP YARDS
Rye, N. Y.

In the 1850s, David Kirby Jr., the son of the man who ran Kirby Mill, began to build boats in Milton Harbor. In the 1870s, he produced a boat that won the America's Cup. Over time, the yard grew and changed hands. A later product of boatbuilding was displayed in New York City, as shown above. The peak of activity came in World War II when the boatyard, now owned by William Edgar John, made boats for the U.S. Navy. The scene below shows the busy yard. Among the boats it turned out were 50-foot diesel launches. Today a large development, Milton Harbor House, has replaced it entirely. The inner harbor is occupied by the Rye City Marina. (Below, RHS.)

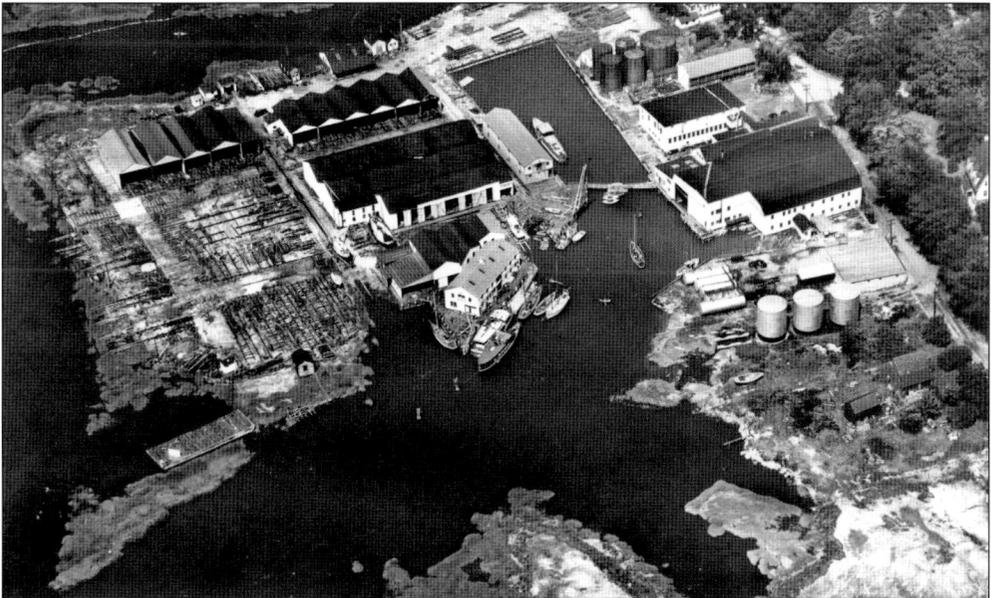

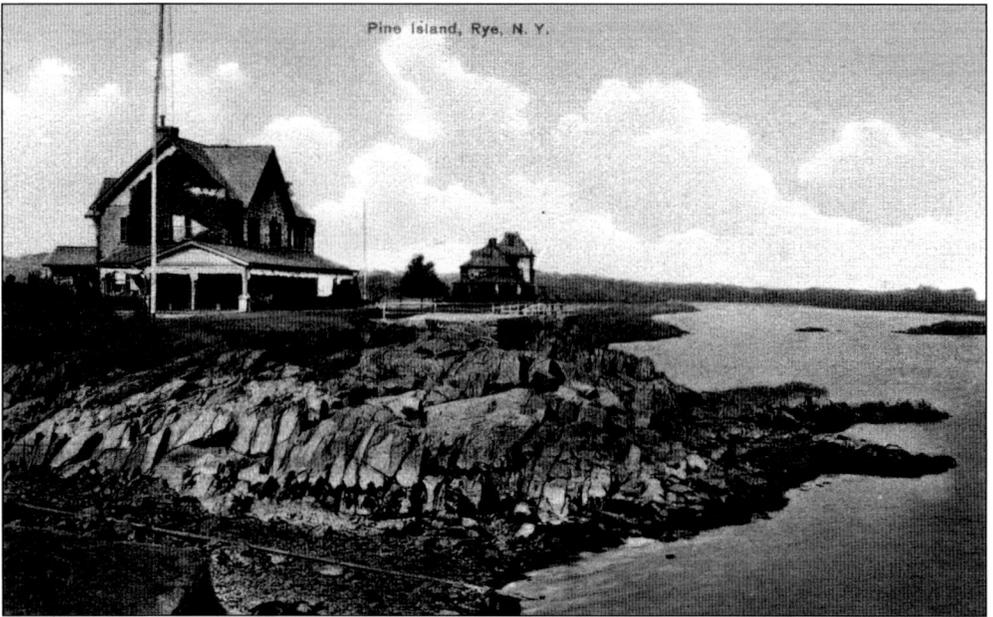

Pine Island, Rye, N. Y.

Lying just off Milton Point in Long Island Sound is Pine Island, which no longer has pine trees but was developed with a number of mansions, some made of stone to withstand the waves and winds. A causeway connected it to the mainland. The first house was put up about 1850. In this scene is the southern tip of the island; the house shown, although modified, is still there. (RHS.)

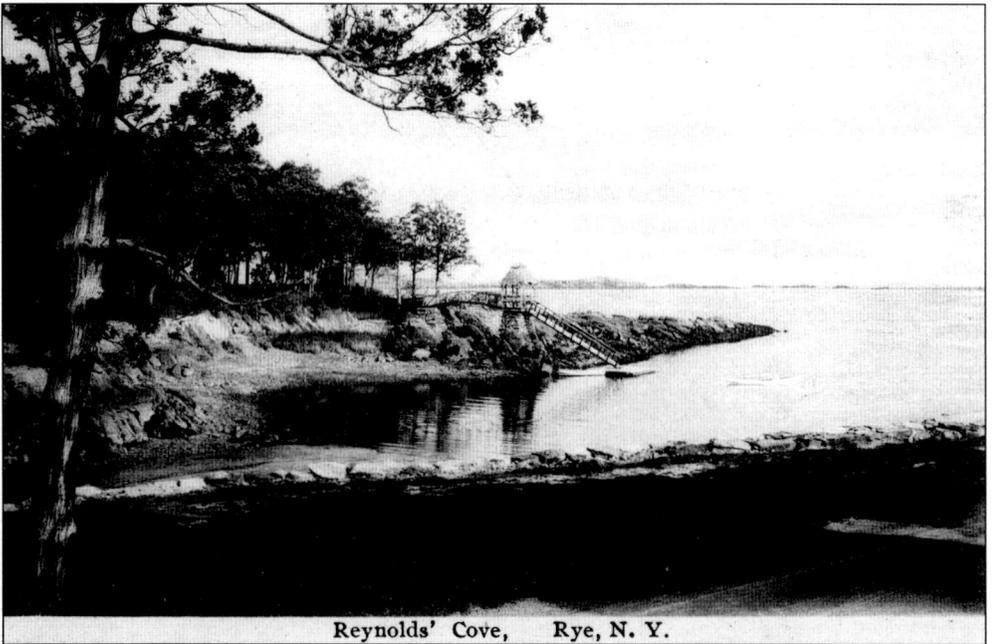

Reynolds' Cove, Rye, N. Y.

Reynolds Cove is a small indentation on the shore of Milton Point, cutting up to Forest Avenue. It was also called Sniffen Cove and Kniffen Cove. Unlike the peaceful scene here, in Rye's early history it had a town dock and warehouses and was used for graving boats. Marble Hall is to the south, and the home of Simeon Ford is to the north.

Three

HOMES

The early, simple homes of Rye built in the Milton Point area are long gone except for one, the Knapp house, which is the oldest in Westchester County (1667) and preserved by the Rye Historical Society. Also of great historical value is the Square House in downtown Rye, the second-oldest structure in town, which traces back to about 1730.

In the 1800s, three homes in a row on the Boston Post Road were erected, all of which are on the National Register of Historic Places, are designated as national historic landmarks, and are still standing virtually unchanged. Two are illustrated in this book, the Jay mansion and Whitby Castle. The third, which sits between them, is Lounsberry, a brother to the Jay mansion in the Greek Revival style. It was built for the merchant Edward Lamb Parsons and remains in his family.

Whitby Castle lies on a large tract of land that was built up by Roger Park, who owned Bloomer's Mill on Blind Brook and was himself descended from Roger Parque, an original settler. The castle is illustrated on page 65. After Roger Park came Joseph Park, who lived in Whitby and established the Park Institute, a private school. Park Avenue is named after him and supposedly was laid out so he could go directly from his castle to the newly created Harrison train station.

The Jay mansion was built on another large tract of land, going back to original deeds from Native Americans. It was threatened by destruction in the 1980s when it came into the ownership of a builder. It was saved, however, by a community effort, purchased by the County of Westchester, and made into the Jay Heritage Center.

Many old, famous houses are long gone, including the Old Stone Fort on the Boston Post Road (built as a protection against Native Americans and later known as Van Sicklin's Inn) and Strangs Tavern, which was on the Boston Post Road at Rectory Street.

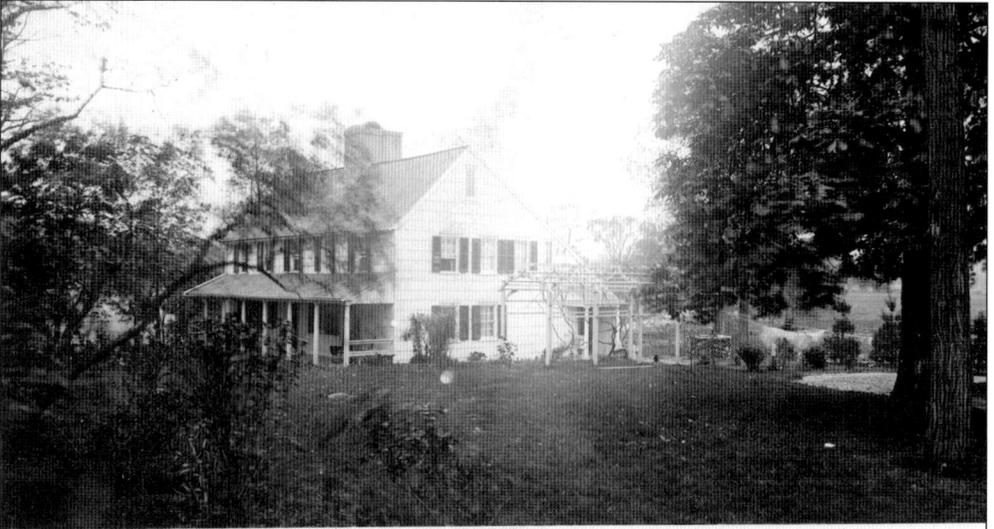

P1998 An Old Homestead, Rye Beach Avenue, Rye, N. Y.

Pictured is the Knapp house, the oldest house not only in Rye but also in Westchester County and owned by the Rye Historical Society, which has preserved it. Records indicate that the earliest portion of this house was built about 1667 as part of the early Mill Town development. Timothy Knapp, the owner, added rooms over time. The style is known as saltbox. It is located at 265 Rye Beach Avenue and is open to the public.

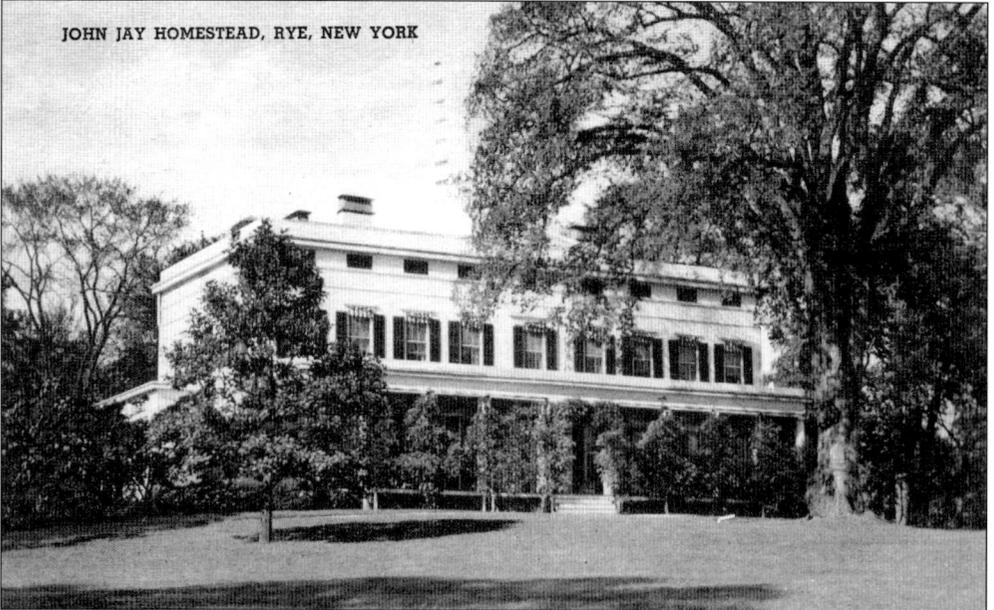

JOHN JAY HOMESTEAD, RYE, NEW YORK

The home of Peter Jay was built in 1837 on the Boston Post Road, with land running down to Milton Harbor. He was the son of John Jay, the first chief justice of the U.S. Supreme Court, who had lived here in a smaller farmhouse. This mansion, known as Alansten, is in the Greek Revival style, with the side that faces toward the street having large columns. The back side shown here is more family oriented. The Jay Heritage Center owns the premises at 210 Boston Post Road.

MILTON POINT INN, RYE, N.Y. 3398

This home was built in the 1860s as the home of John Howard Wainwright, whose sons played a very large role in the development of Rye and were major benefactors. The house, located at 530 Milton Road today, was near Blind Brook where it empties into Milton Harbor. Over the years, this structure has housed a number of restaurants, including the White Elephant and now La Panetiere. (Steven Feeney.)

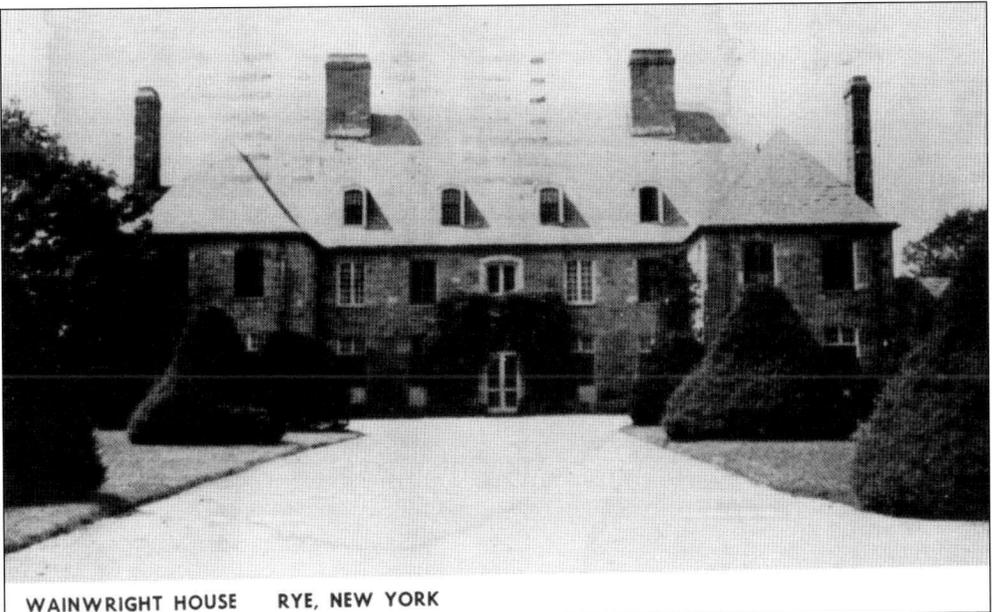

WAINWRIGHT HOUSE RYE, NEW YORK

This mansion was built in 1931 for Col. J. Mayhew Wainwright, one of the Wainwright sons. It was modeled on a 17th-century French chateau, Raincheval, where the colonel had been posted during World War I. On a large lot running down to Milton Harbor, the home devolved upon his daughter Fonrose Condit, who left it to the Layman's Movement in 1951. Today it is a spiritual center located at 260 Stuyvesant Avenue.

35

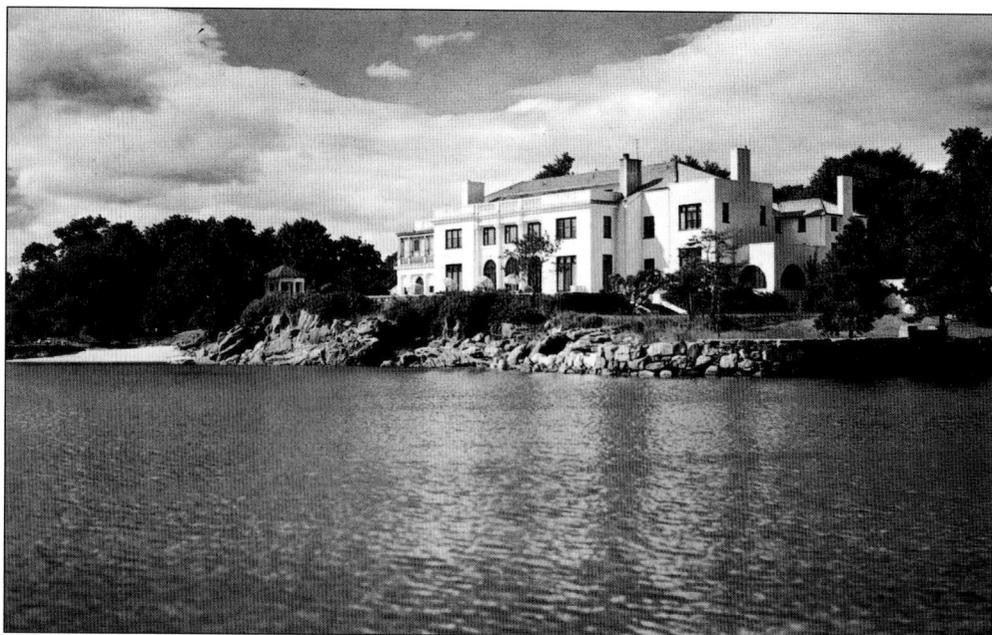

Rye had its own Gilded Age mansion built on Long Island Sound by Pliny Fisk. As pictured here, it was sold and operated as a luxury women's health club and sanitarium. The house had magnificent interior rooms, with fountains and generous use of marble, hence its name in later years. Fisk was an extremely wealthy Manhattan banker who built the house in what was called Rye-on-the-Sound for $500,000. His fortunes took a downturn, and he died impoverished in 1939, although he was still famous enough to have an obituary in *Time* magazine. Thereafter, the Fisk house was used briefly as the clubhouse for a golf course. It was torn down in the 1990s and replaced by five homes on the newly created Martin Butler Court.

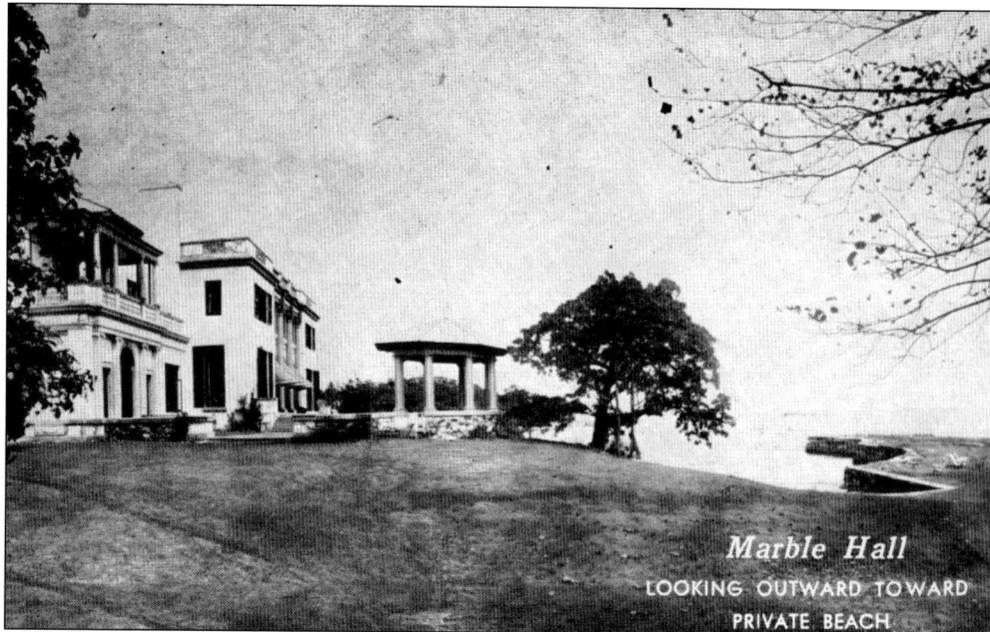

Marble Hall
LOOKING OUTWARD TOWARD
PRIVATE BEACH

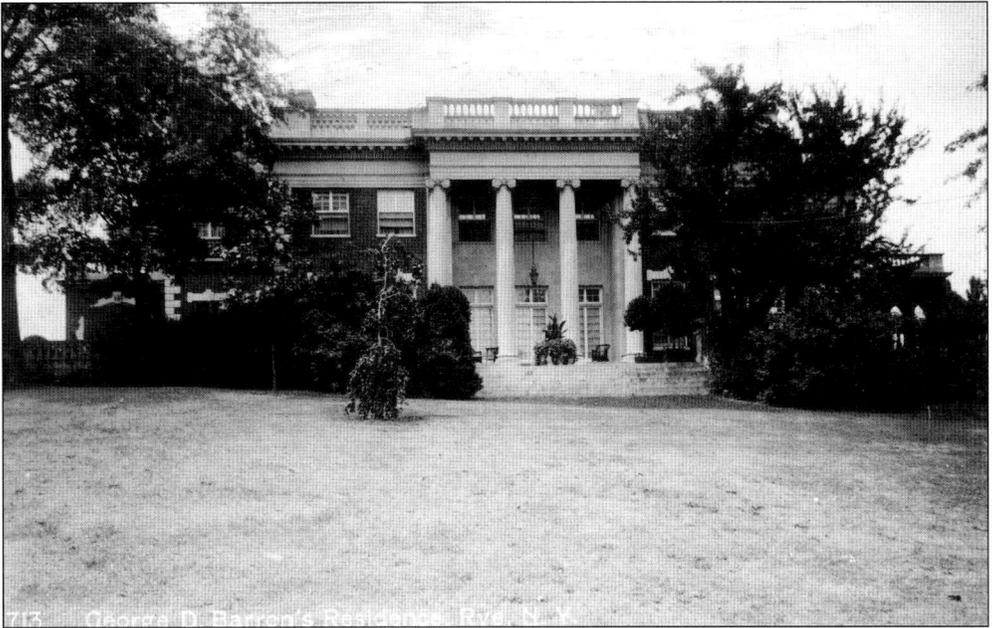

One of the great mansions built around 1900, Villa Aurora was built for George D. Barron, an owner of tin mines in Mexico and other ventures. The architect was George Albee Freedman. The property ran from Forest Avenue to Midland Avenue and had many outbuildings, some of which are used today as part of the Rye school system. It had gardens and ponds, as shown in the view below. Barron was a trustee of the village and benefactor as well. The property at 200 Forest Avenue was purchased in 1950 by the Rye Community Synagogue and converted in parts over the years. It was totally replaced in 2007. (Above, Steven Feeney.)

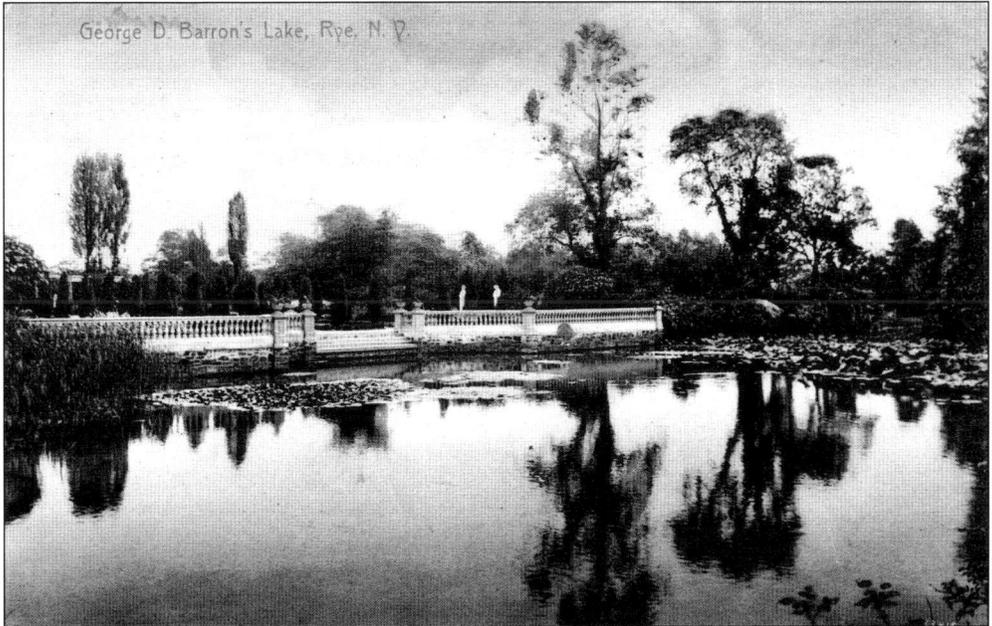

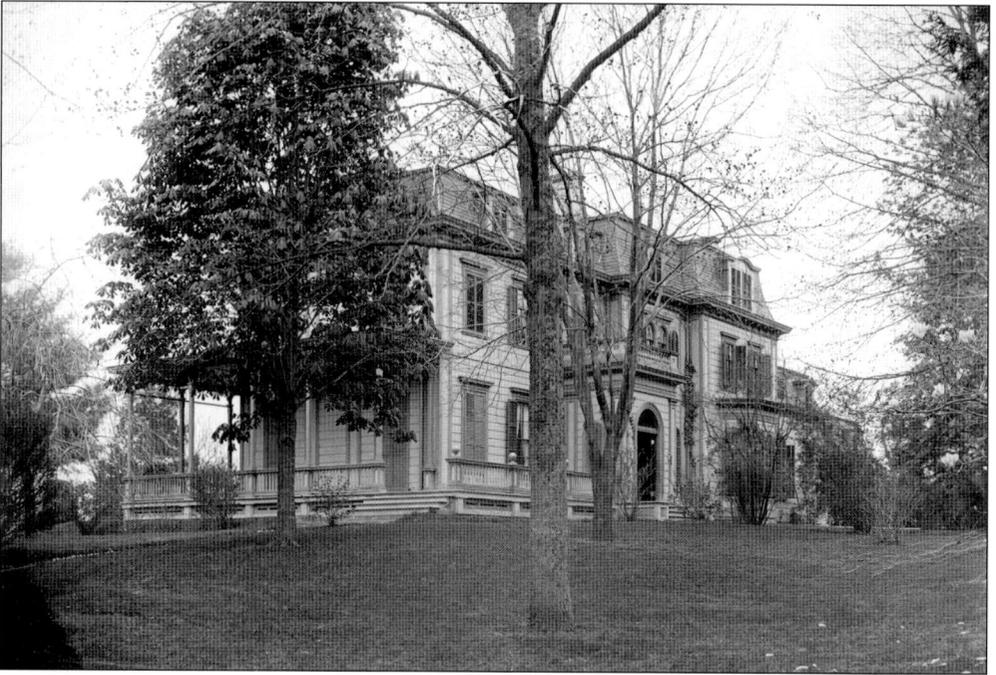

This photograph from around 1890 shows a house that went with a nearly 100-acre property around the Mill Pond off Grace Church Street. It was the Sackett family estate, called the Hummocks, located at 350 Grace Church Street. The various relatives had many houses around the pond and were active in Rye affairs and philanthropy.

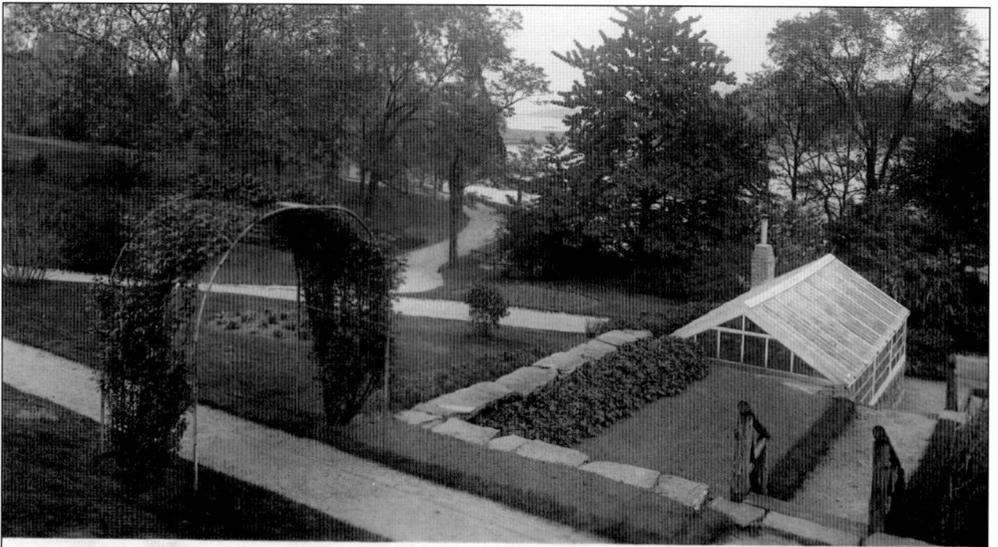

P2001 The Homocks, Rye, N. Y.

This is a view from Grace Church Street looking toward the Mill Pond and Long Island Sound south of the Nichols estate. The name Hummock described isolated mounds of land that were above the water level. The hummocks also formed the basis for the Kirby tidal millpond. Note the greenhouse in the foreground and the paths, part of one of the old estates on Grace Church Street, perhaps that of the Sacketts.

38

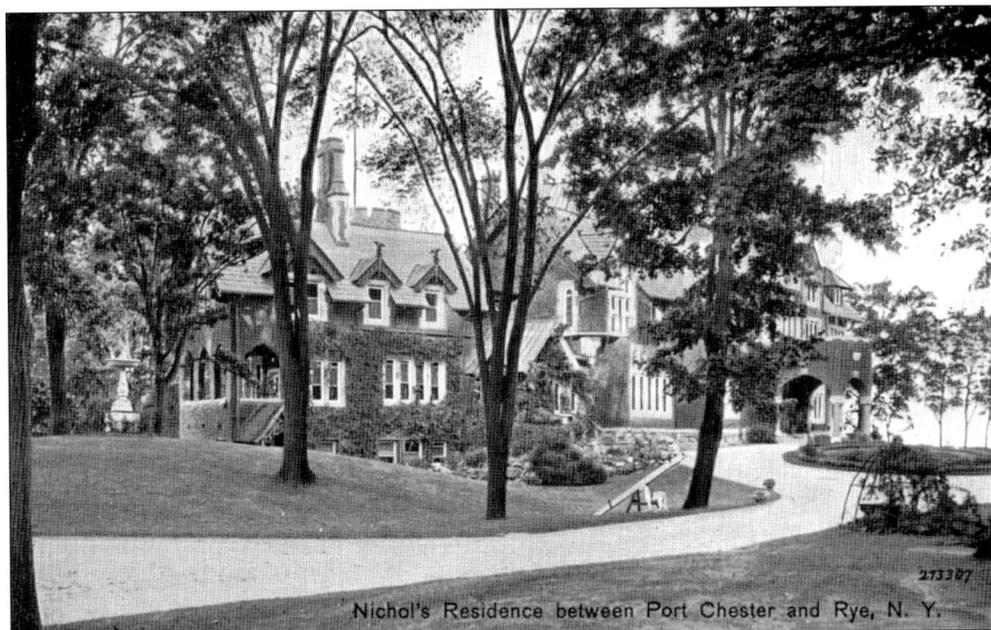

Nichol's Residence between Port Chester and Rye, N. Y.

This mansion, known as Petronia, stood off Grace Church Street on a large lot running down to Long Island Sound. The owner was William Gilman Nichols, an executive in the well-known New York interior-decorating firm Herter Brothers. The estate at 460 Grace Church Street is long gone, replaced by a number of smaller homes, but several outbuildings have survived.

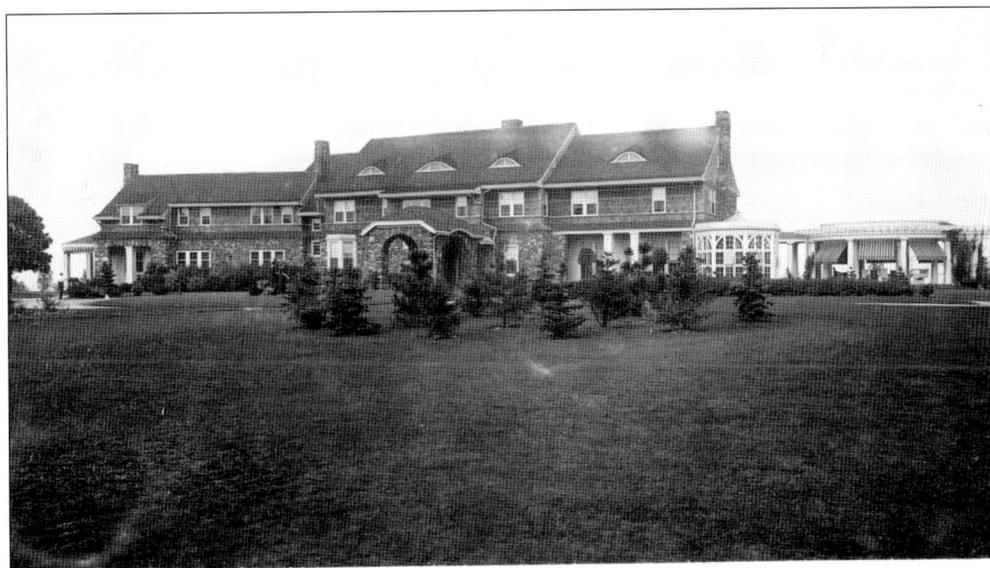

P1991 Residence north end of Manursing Island, Rye, N. Y.

A number of large homes were built on Manursing Island facing Long Island Sound. This one was the home of William H. Browning. In 1907, he wrote an article for the *New York Zoological Bulletin* describing his extensive aviary there. In 1900, Mrs. Browning was mentioned in the *New York Times* as among Rye's social elite. The house has since been cut down a floor and is on North Island Drive.

39

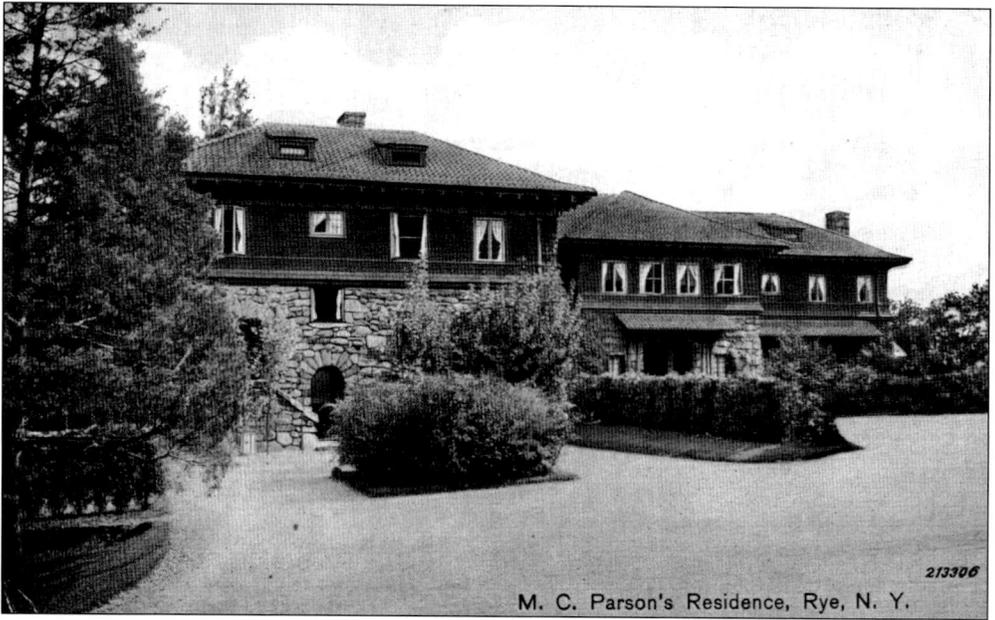

M. C. Parson's Residence, Rye, N. Y.

213306

This was the estate of Marcelis C. Parsons at 873 Boston Post Road. It involved a large plot running from the Boston Post Road to what is now Theodore Fremd Avenue. The house burned down in a spectacular fire in December 1942, and the land was given to the city. It is now the Rye Nature Center. The stone base of the building is noticeable today as one drives into the center.

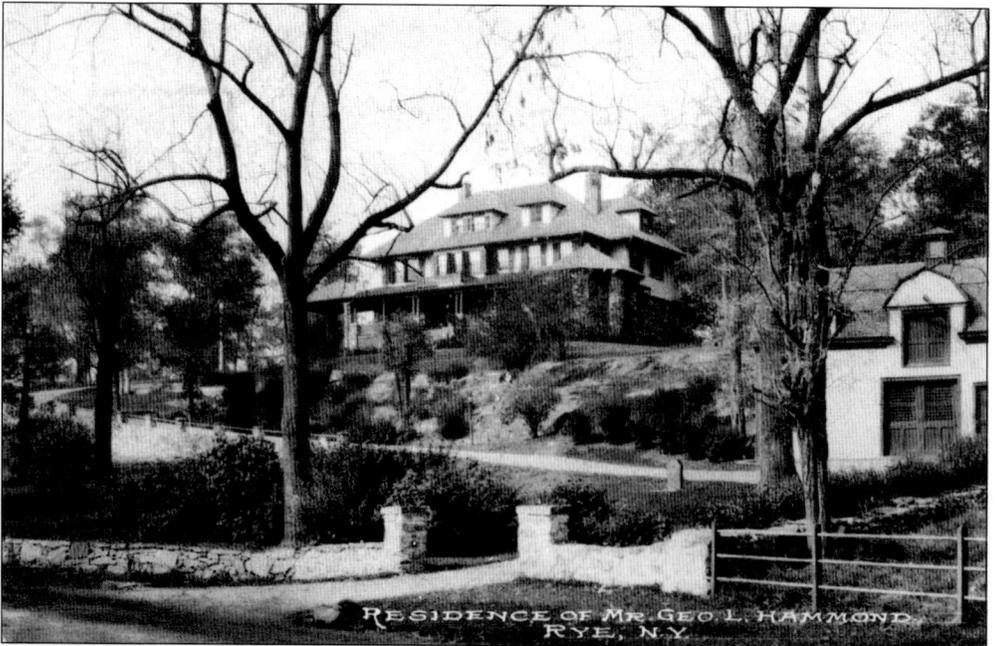

RESIDENCE OF MR GEO L HAMMOND
RYE, N Y

Many large homes were chosen for early Rye postcard illustrations. This is the residence of George L. Hammond at 815 Boston Post Road. This house and many others were depicted in the 1917 book *Views of Rye*. It was rephotographed in 2007 by the author of this book for the book listed in the bibliography. (Steven Feeney.)

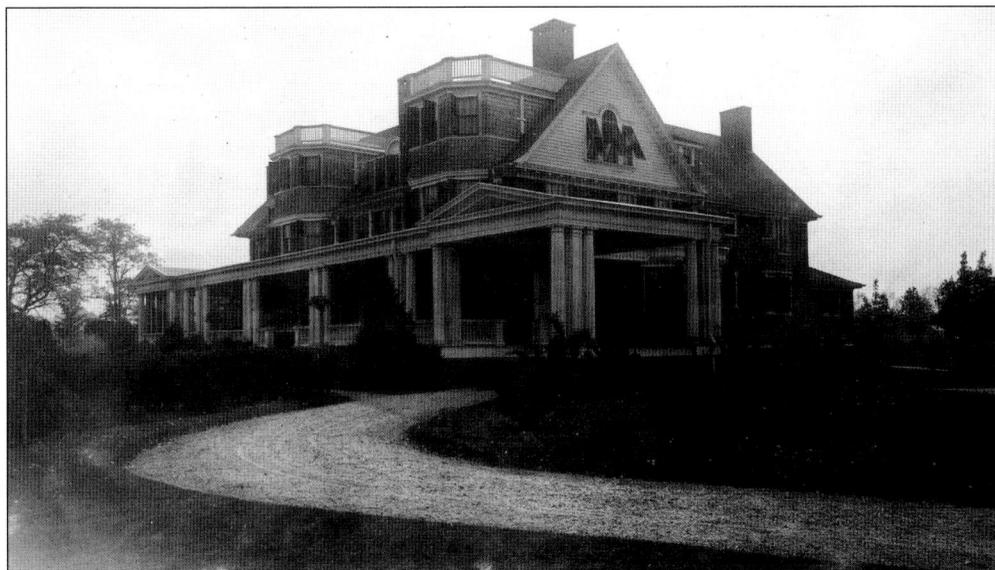

The owner of this house was John Huyler, a major candy manufacturer. His factory was in New York City. A sign for his candy is in the window of the drugstore on Purchase Street shown on page 13. The house, on Gramercy Street, was later used as a group home and was torn down around 2004 to allow for a subdivision.

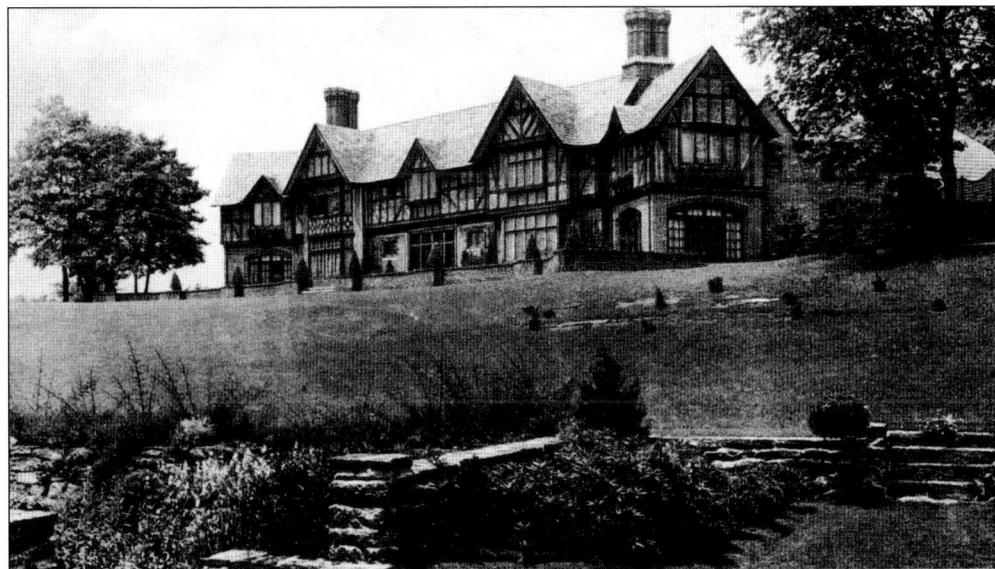

RESIDENCE AT RYE, N. Y. HOBART B. UPJOHN, ARCHITEC

EDWIN OUTWATER, INC., BUILDERS.

The pictured house is at 16 Clark Lane. It was on a large plot stretching to Forest Avenue but is now somewhat hemmed in by a subdivision. Numerous advertisements appeared for major houses as wealthy families moved out to Rye. The New York architect for this French Renaissance–style house was the well-known Hobart B. Upjohn. Edwin Outwater was a well-known New York City builder.

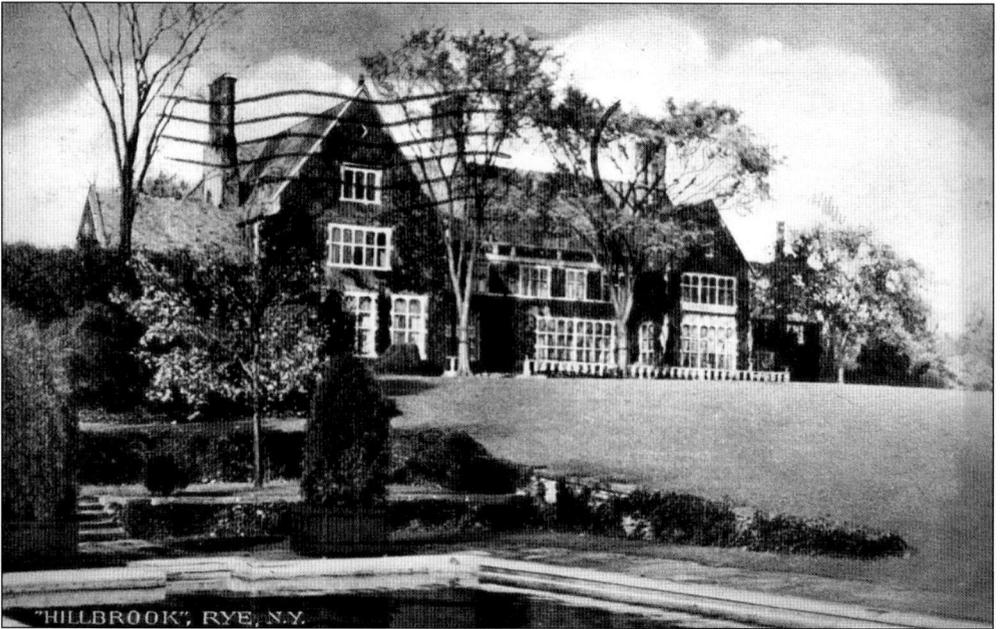

"HILLBROOK", RYE, N.Y.

Many of the largest mansions for which postcards were made set them in Rye, perhaps because the name was felt to carry prestige, but the homes were actually in adjoining towns, in this case Harrison. The mansion above sat on an 80-acre plot on Lincoln Lane and was the summer home of George Arents Jr. The man was described as having a tobacco fortune. The architect was Lewis Cort Albro, and the house was finished in 1918. Less is known about the Matthews mansion below, which was an imposing Gothic structure on North Street, as shown here in 1905. This probably was the home of William Matthews, who had previously been a Rye resident on Milton Road. The mansion, long gone, was probably at 206 North Street. Matthews also erected a hotel for travelers at the Harrison train station.

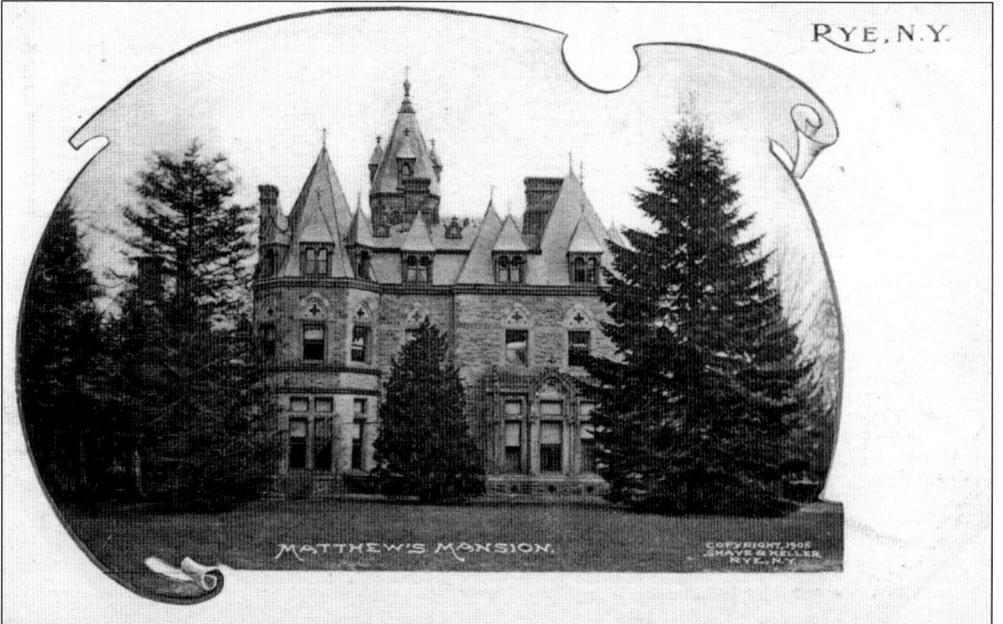

RYE, N.Y.

MATTHEW'S MANSION.

COPYRIGHT, 1905
SHAVE & KELLER
RYE, N.Y.

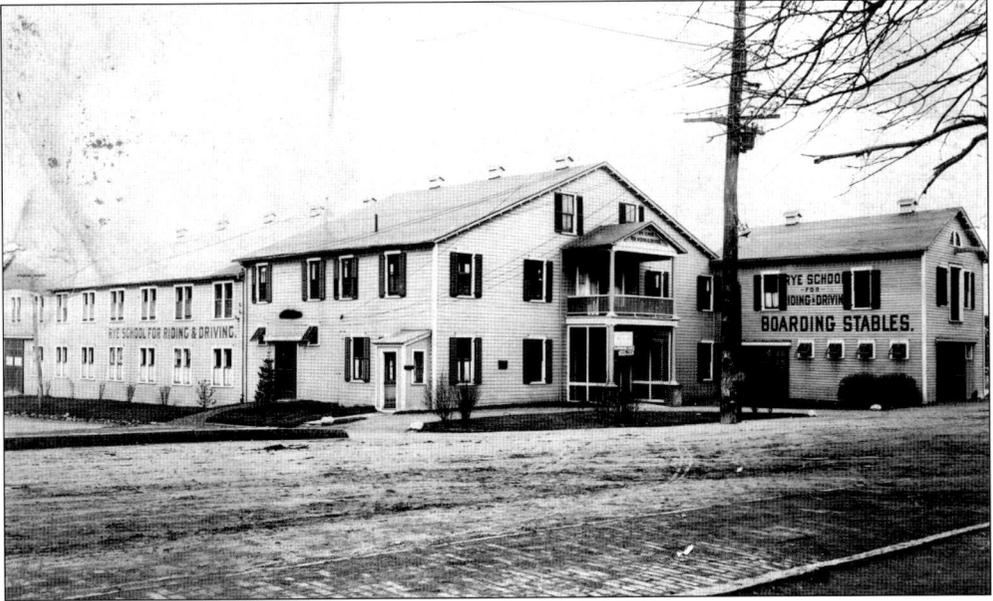

Until a decade or two into the 20th century, the horse was the primary means of getting around town. Just off Purchase Street were a series of stables pictured here. These were known as the Highland Stables, or, as shown here, Rye Boarding Stables. However, notice the signs, which state, "Rye School for Riding and Driving." The stables were replaced by the Highland Hall apartments. (RHS.)

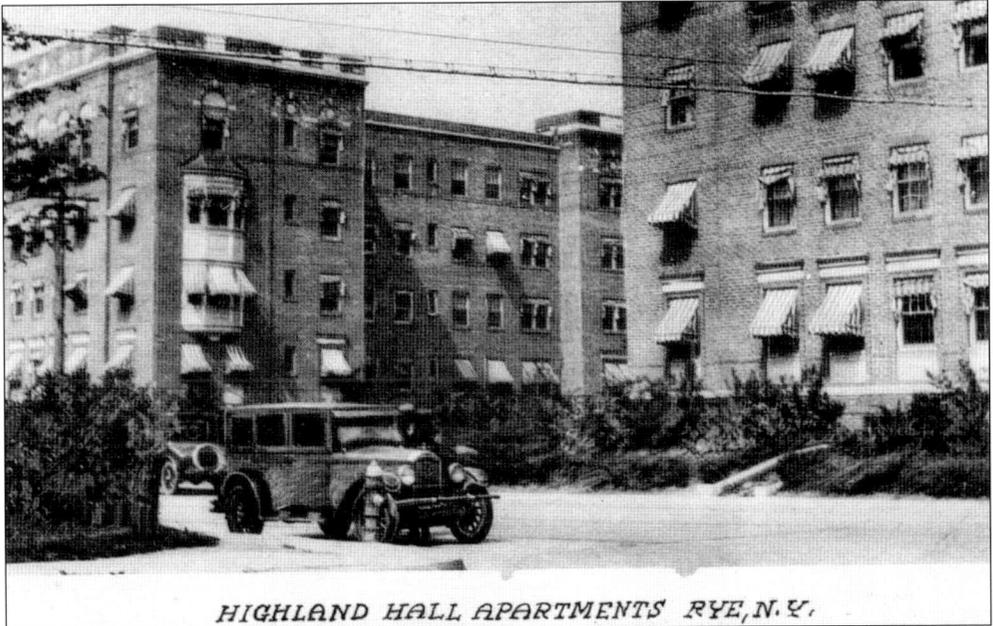

HIGHLAND HALL APARTMENTS RYE, N.Y.

In the 1920s, Rye witnessed the advent of large apartment houses. Only three were built before World War II though, helping preserve the overall impression of Rye as a town of single-family residences. The first built, in 1925, was Highland Hall, on the site of the stables pictured above, located at 147 Purchase Street today. The apartments were close to the railroad station, accommodating people who commuted to New York City.

Blind Brook Lodge Apartments, Rye, N. Y.

The second apartment building erected was Blind Brook Lodge in 1925, seen above. The architects were Van Wert and Wein, adapting a medieval style. It was located on the Boston Post Road, stretching to Milton Road. Today apartment use has given way to condominium ownership. Initially the structure had a restaurant, pictured below. That space was later converted to professional offices. The third pre–World War II apartment building was Manursing Lodge on Manursing Avenue. These buildings are joined by other postwar developments, such as Rye Gardens on the grounds of the former town field on Purdy Avenue.

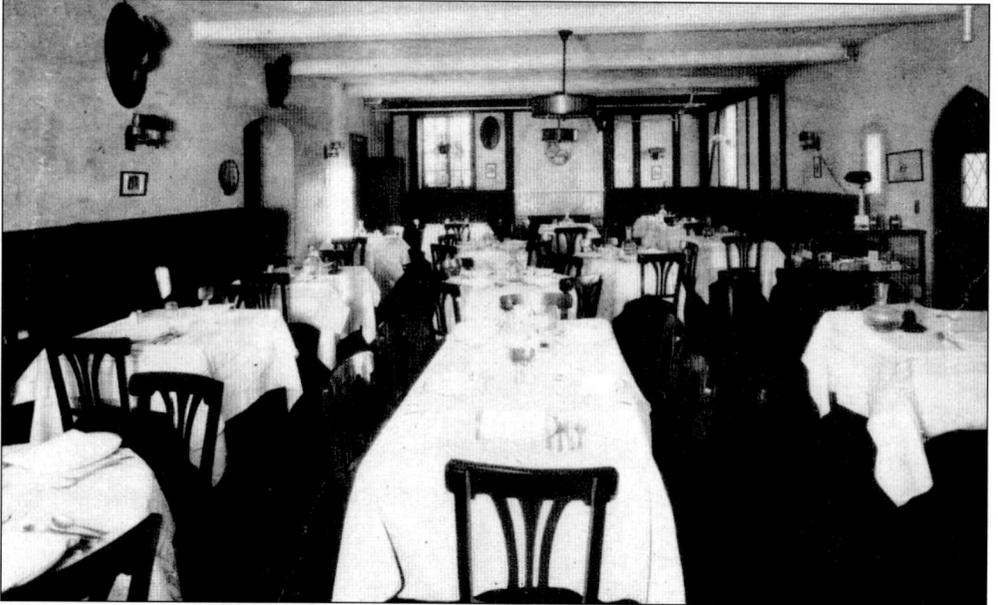

Four

CHURCHES

Worship began as soon as the settlers arrived in Rye. The history of Christ's Church as an Anglican congregation in Rye dates to around 1695. In 1788, on the site of the current Christ's Church, a wooden structure was built. The building was known as Grace Episcopal Church, which gave its name to the street. In 1854, the building was moved to 51 Milton Road in order to allow the current Christ's Church to be constructed. The house is pictured in the preface. Two buildings associated with Christ's Church are of architectural note: the rectory was designed by McKim, Mead and Bigelow in 1878, and the parish house was designed in 1911 by Hobart B. Upjohn.

The history of Presbyterians in Rye traces back to 1665, when there was a congregation but no church. The congregation had its own meetinghouse by 1729, which was described as being on Pulpit Rock, a lot near where Rye Country Day School is today. The next location was a small building on the Boston Post Road, constructed in 1841. The current church was built there in 1872. The old church was moved across the street, renamed Union Chapel, and served as a meeting hall until it was torn down in 1894. Rev. Charles W. Baird (1828–1887), a beloved minister for 26 years, wrote a superlative history of Rye.

The Catholic history of worship in Rye traces back to 1880. The structures associated with the church are well illustrated in this chapter.

The Methodists first worshiped in the Rye Old Fort, which has since been torn down and replaced by two churches.

Jewish religious history in Rye starts with the formation of the Rye Community Synagogue in 1948 and the purchase of the Barron estate, the mansion depicted in chapter 3. At first, the main building was used as a school with a temple added; more recently, the house was torn down and replaced with a new school building.

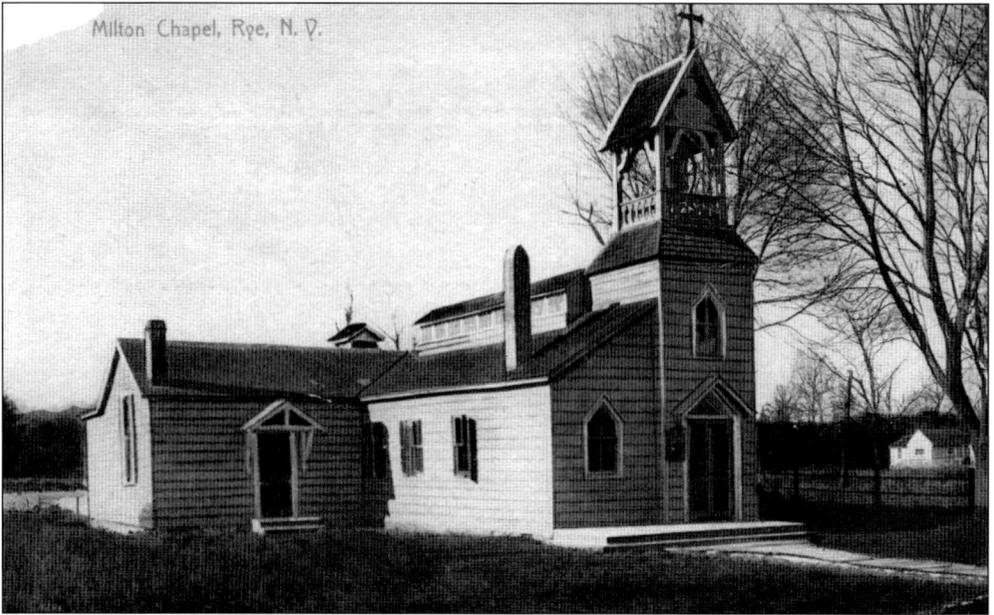

Milton Chapel, Rye, N. Y.

Rye's earliest church is Grace Chapel, still standing, also at times called the Milton Chapel of Christ's Church. It was the outpost for Episcopalian worshipers who lived in the Milton Point section. The origin of the structure is unconfirmed, but it is possible that it was converted from a school moved from elsewhere. In 1959, it became the Quaker or Friends Chapel and is located on Milton Road. It is on the National Register of Historic Places. (RHS.)

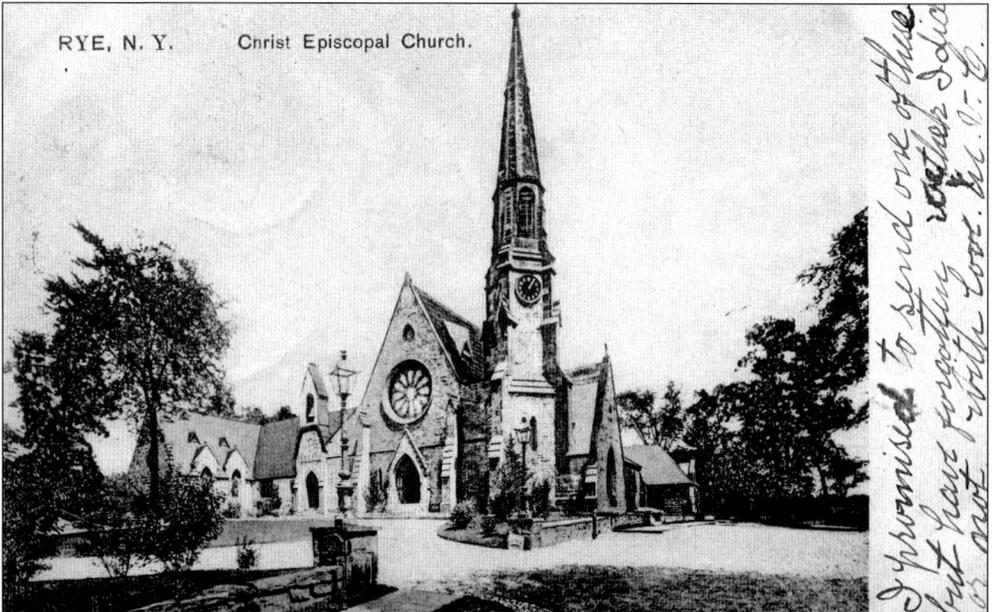

RYE, N. Y. Cnrist Episcopal Church.

Christ's Church is the Episcopalian church in Rye, one of two massive Gothic Revival edifices. It is at the start of Milton Road at Cross Street. Florentine Pelletier was the architect of the church, which was consecrated in 1869. Some of the dark granite for the church came from the site itself. Two smaller Episcopalian churches had existed on the same site, one of which was moved and is now the Rye Arts Center.

46

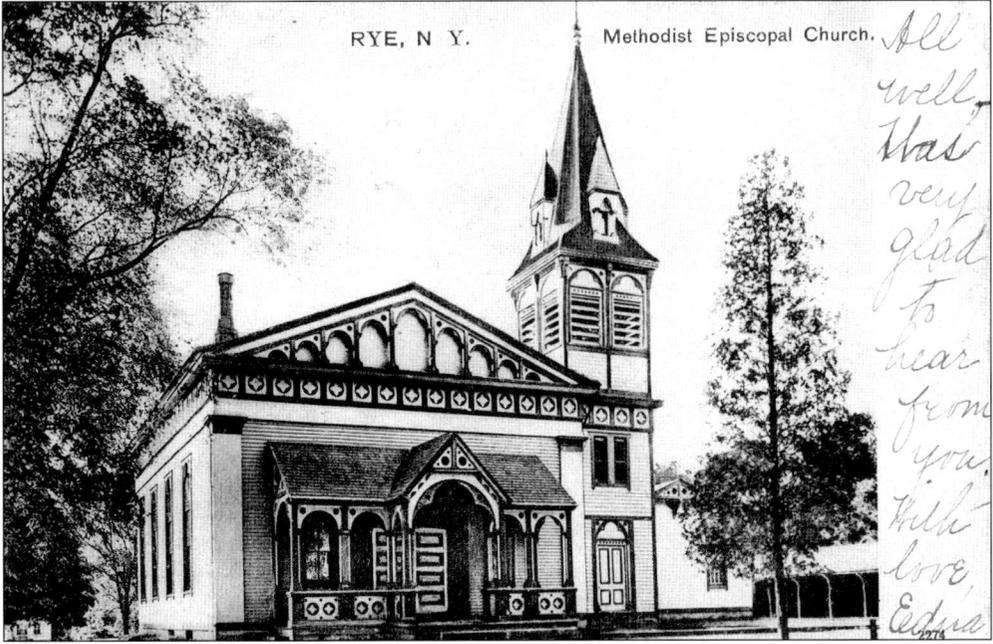

RYE, N. Y. Methodist Episcopal Church.

All well, was very glad to hear from you, with love, Edna

The view above is the first Methodist church in Rye; the view below is the second and current one. The first was built in 1833 in a style described as Grecian. It was substantially remodeled in 1872 so as to appear newer, as shown above. The architecture of the current building, below, is Romanesque in style, and it was erected in 1910 at 964 Boston Post Road. Note the two semicircular arched windows. The design of the church is pursuant to the Akron plan, which involves two intersecting cubes, one stressing worship and the other education.

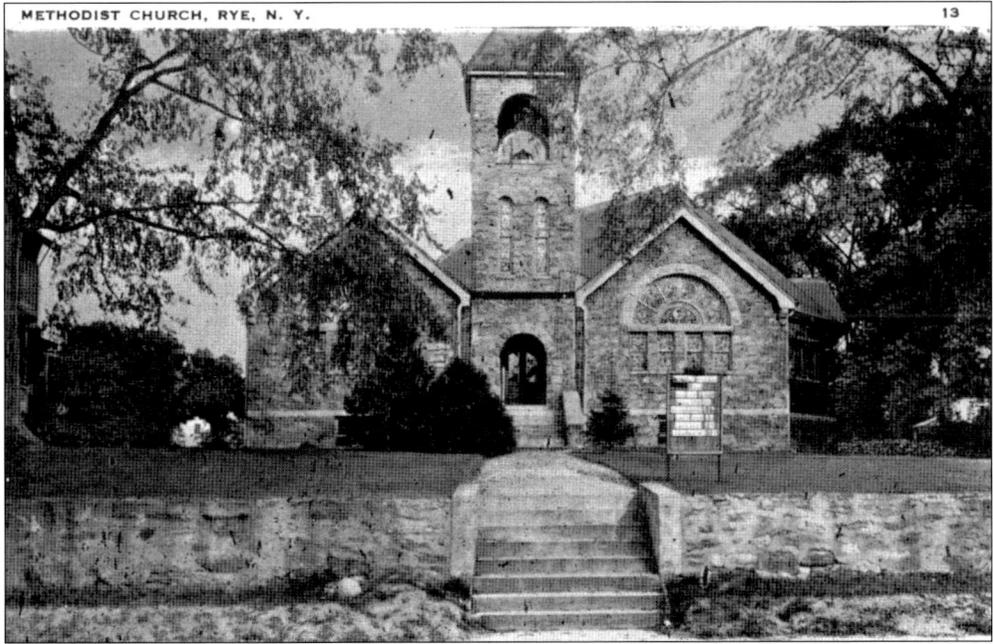

METHODIST CHURCH, RYE, N. Y. 13

Municipal Square,
Post Road & Purchase St., Rye, N. Y.

The Catholic parish in Rye, the Church of the Resurrection, has had three locations. The first, shown above, was in the former home of William Smith. The church bought the house in the 1880s for $5,500. The location is where the Boston Post Road heads north to the right and Purchase Street starts on the left. When the building shown below was put up, the Smith house became the rectory. The large, wooden building below is the second church. Construction was begun in 1886, and the church was dedicated 1889. The architect was Lawrence J. O'Connor of New York City. The big rose window was a major feature. Today there is a building with stores and offices at 22 Purchase Street.

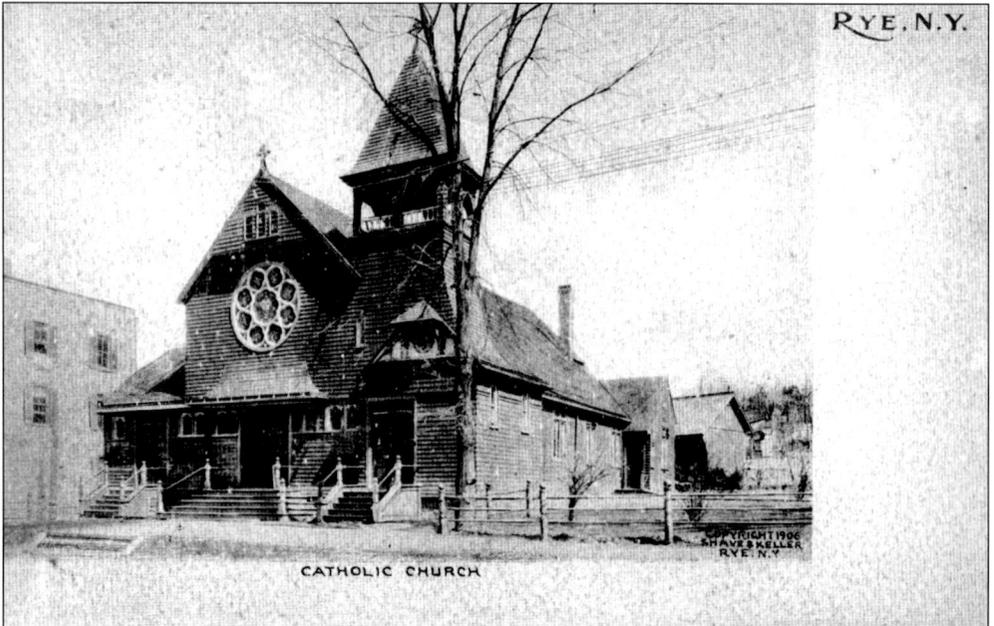

RYE. N.Y.

CATHOLIC CHURCH

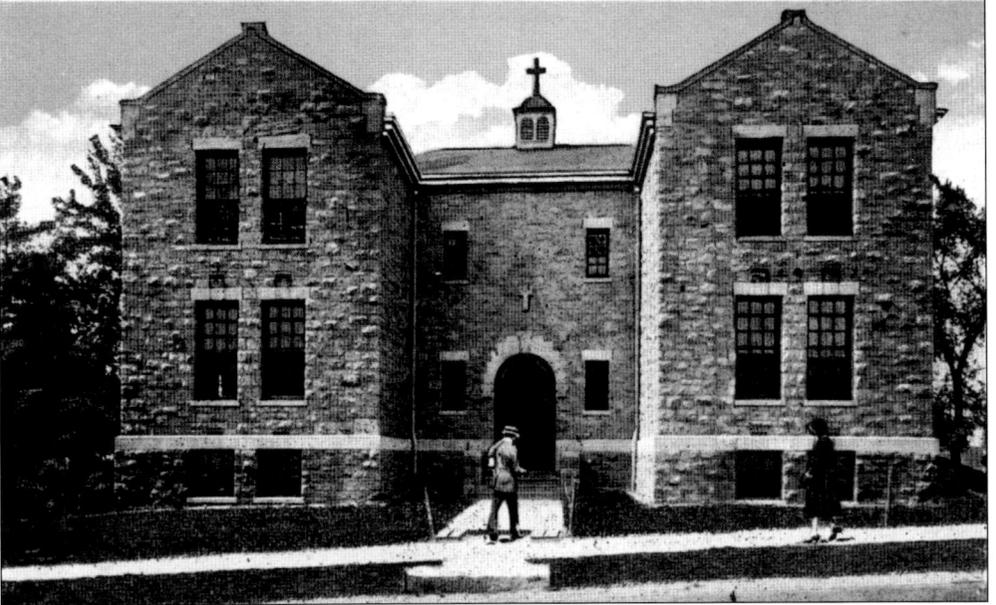

The parochial school for the Church of the Resurrection on Purchase Street was built in 1907 on the Boston Post Road behind the church. The current address is 1085 Boston Post Road. The building pictured above then became a residence for nuns and was later converted into private apartments. Below is the current Church of the Resurrection at 910 Boston Post Road. The architects were Henry D. Murphy and Edward Lehmann, and the building opened in 1931. Its massive design led to its nickname as the Cathedral of Westchester. It replaced a small structure known as Kirklawn. Meanwhile, the parochial schooling continued in buildings next to the new church, including the former Academy of the Resurrection for girls, constructed in 1950.

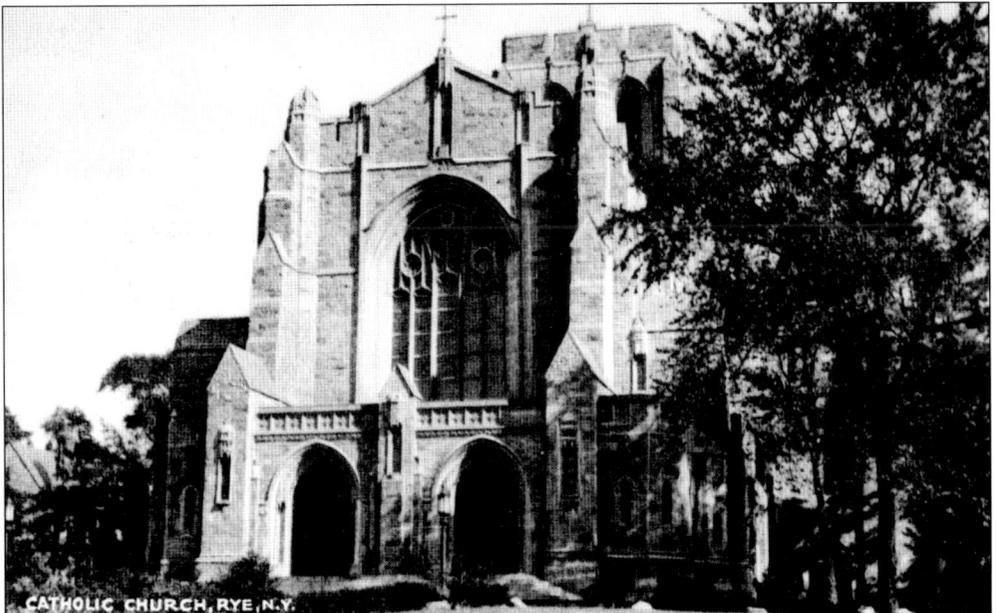

CATHOLIC CHURCH, RYE, N.Y.

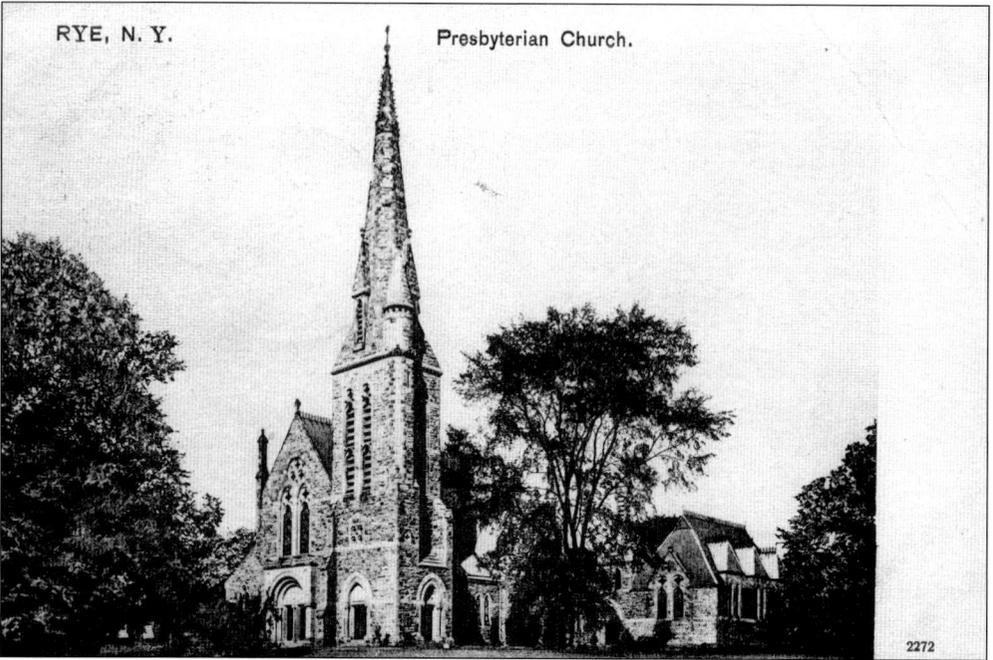

Presbyterian Church.

2272

Presbyterian Church, Rye, N. Y.

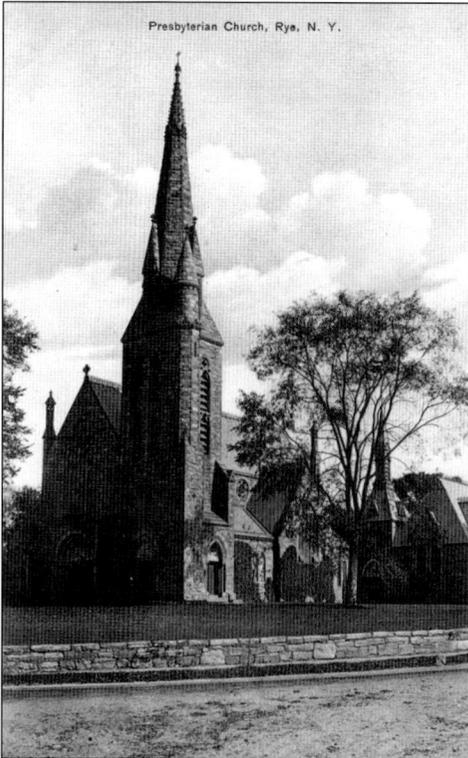

The present Presbyterian church, pictured above and at left, was built 1872. Like the Episcopalian church, it is in the Gothic Revival style and has a massive tower 150 feet high. The two churches can be told apart because the tower of Christ's Church is set at a 45-degree angle. Richard M. Upjohn, son of the nationally famous architect Richard Upjohn, was the architect. This church was built next to an earlier Presbyterian church, which was later moved across the street and became Union Chapel.

Five

SCHOOLS AND INSTITUTIONS

Rye was divided into school districts in Milton Point, Rye center, Rye Neck, and Port Chester. The first sizeable structure for central Rye was Union District No 3, a wooden building. This was replaced by a large school on the Boston Post Road at the corner of Gedney Street and is illustrated here along with those built thereafter.

For the Milton Point development, there was a small, wooden school at 630 Milton Road known as the yellow schoolhouse, which is still standing and used as a home. This was followed by Milton School, still in its current location. The original building was soon outgrown and became the gymnasium. The handsome Rye High School was originally built in 1930 and has been added to substantially over the years, maintaining the Gothic style of architecture. More recently, a middle school was added as a wing. It has extensive playing fields. In place of the old grammar school, Rye has two schools, Midland and Osborn.

Rye also has a long history of private schools, in part owing to the absence of a good public school system. One of the earliest was the Chrestomathic Institute (the name implies teaching from literary anthologies). The first notable one was a girls' school, the famous Rye Seminary (also called Life Seminary). For boys, there was the Park Institute (named after Joseph Park), located near the Life Seminary. Then there was Heathcote Hall for boys, which was on the Boston Post Road at Park Avenue. This school moved over the border to Harrison and later merged into Rye Country Day School. Most of these buildings are illustrated here, along with the Marvell School, which was on the Boston Post Road.

Rye has had other institutions. First and foremost is the Osborn Home, referred to on the cards as the "Old Ladies Home." It is seen here in 1907. And for many years, St. Benedict's Home for Destitute Colored Children stood on the Boston Post Road in Rye. Currently there is the Wainwright house (chapter 3) and the Rye Psychiatric Hospital.

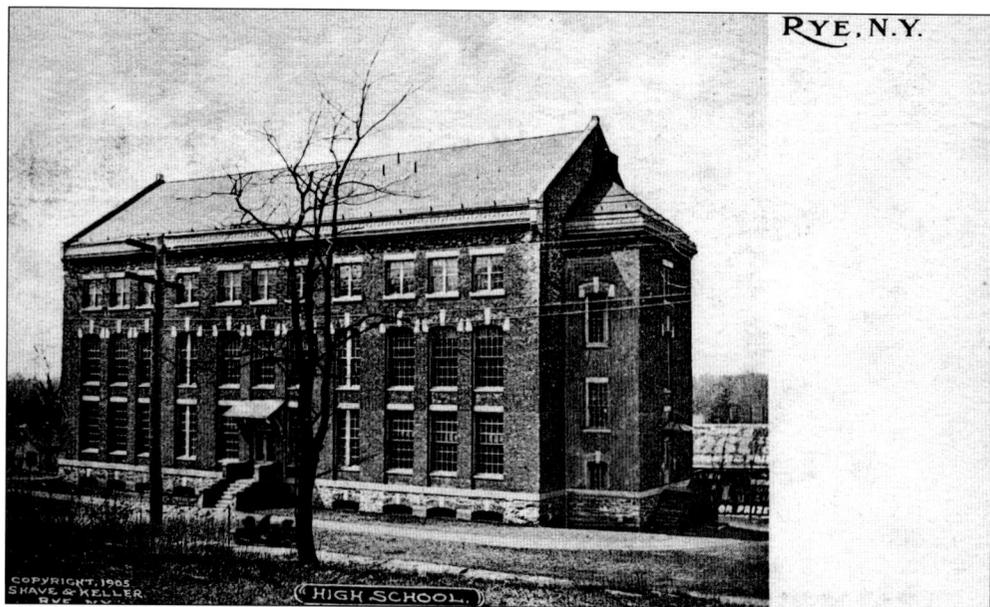

Union Free School District No. 3, pictured above and below, was constructed in 1902 on the site of Rye's first school, a wooden building. The structure was originally built to accommodate grades 1 through 12. Some of the students are shown below (perhaps in a class photograph). Attendance was not large. In 1904, only four graduated from high school. After new grade schools were erected around the city, this structure was torn down in the 1950s and replaced by a one-story building at 1037 Boston Post Road.

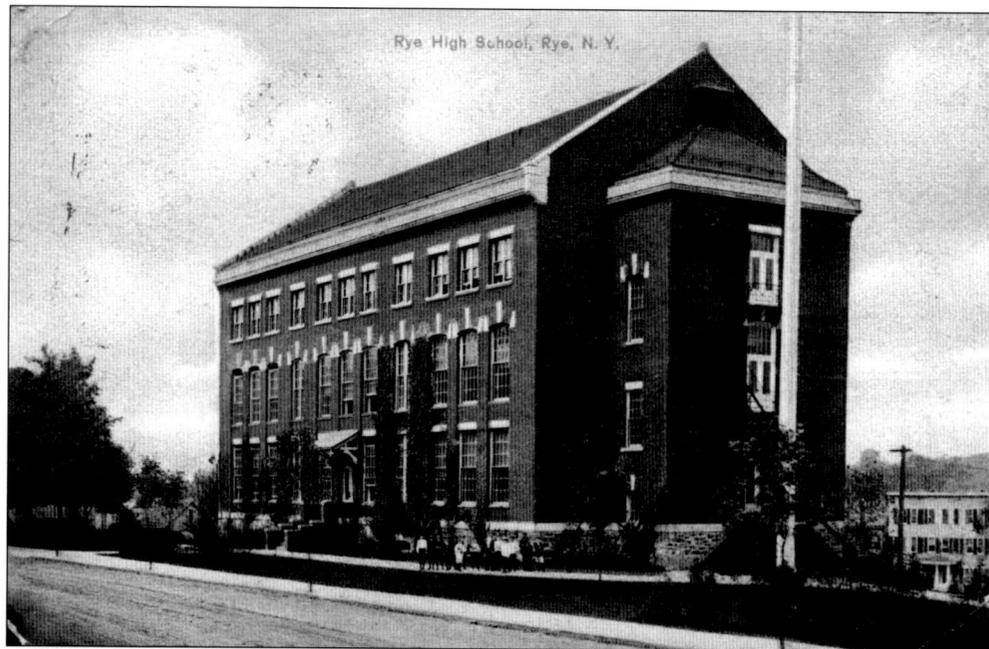

52

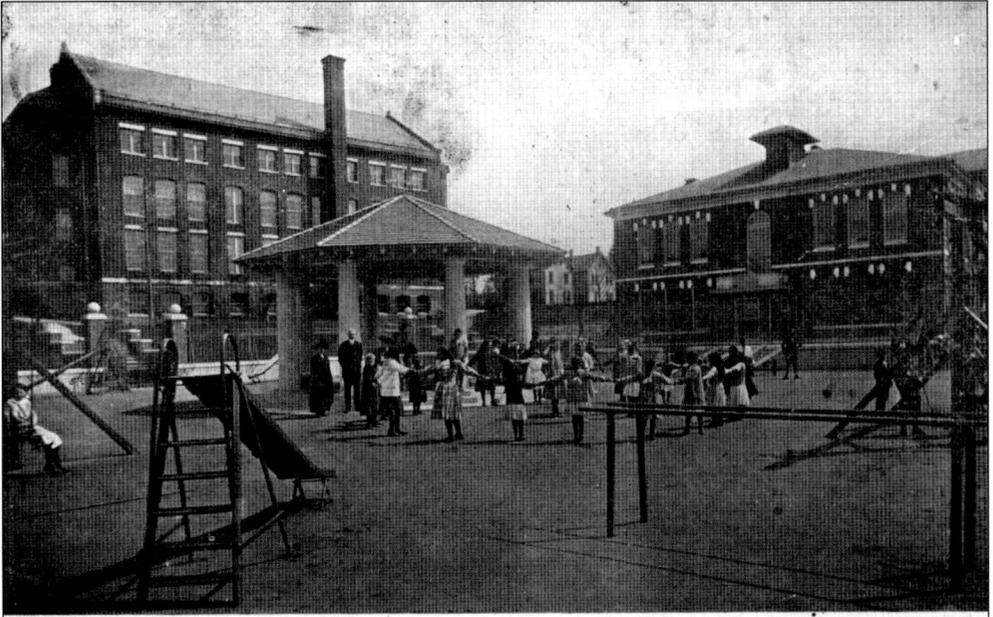

PUBLIC SCHOOL PLAYGROUND, Rye, N. Y.

The early schools did not have true playing fields, but at least the one on the Boston Post Road had a playground, as seen above. Today it is a parking lot. Located just below the school on the previous page, the high school, below, was built in 1910 and connected to it by a corridor to accommodate a rapidly growing student population. The older structure was then restricted to grades one through eight. The building still stands at 16 School Street but is an office building, and the corridor is a dead end. Further population growth and commitment to a full education has led currently to three grammar schools.

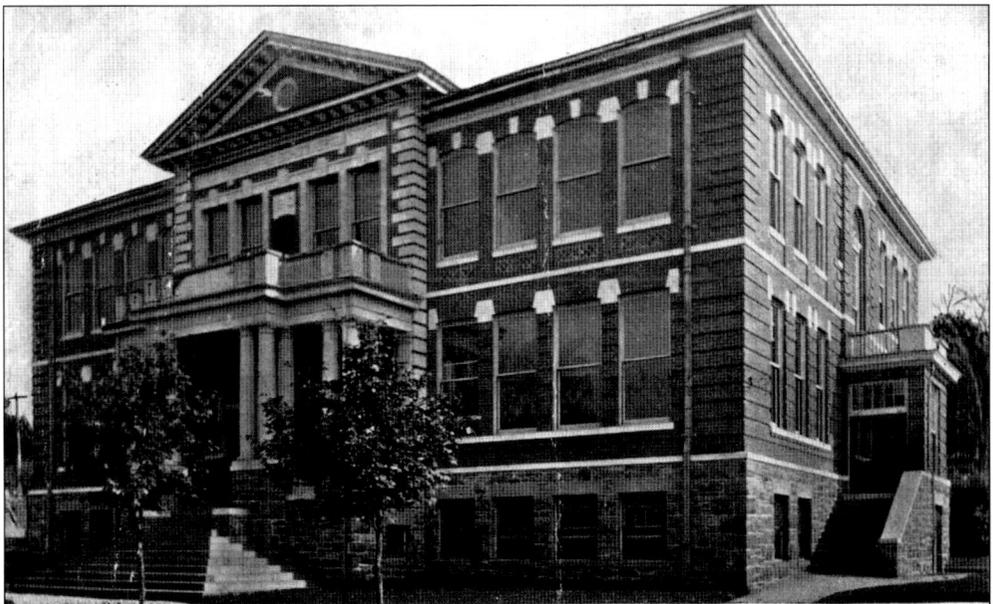

HIGH SCHOOL, Rye, N. Y.

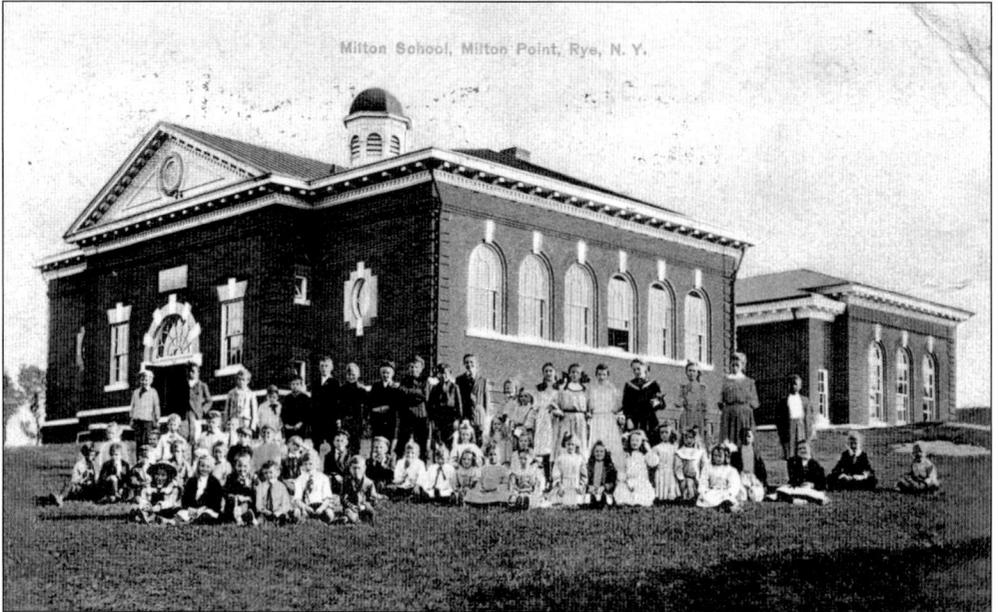

Milton School was the public school for the Milton Point area of Rye. From the varied ages of the students in the picture, it appears this is a school portrait, not a class portrait. Located on Hewlett Avenue, the school was begun in the late 1890s and has been added on to. The original building shown still stands and is the gymnasium.

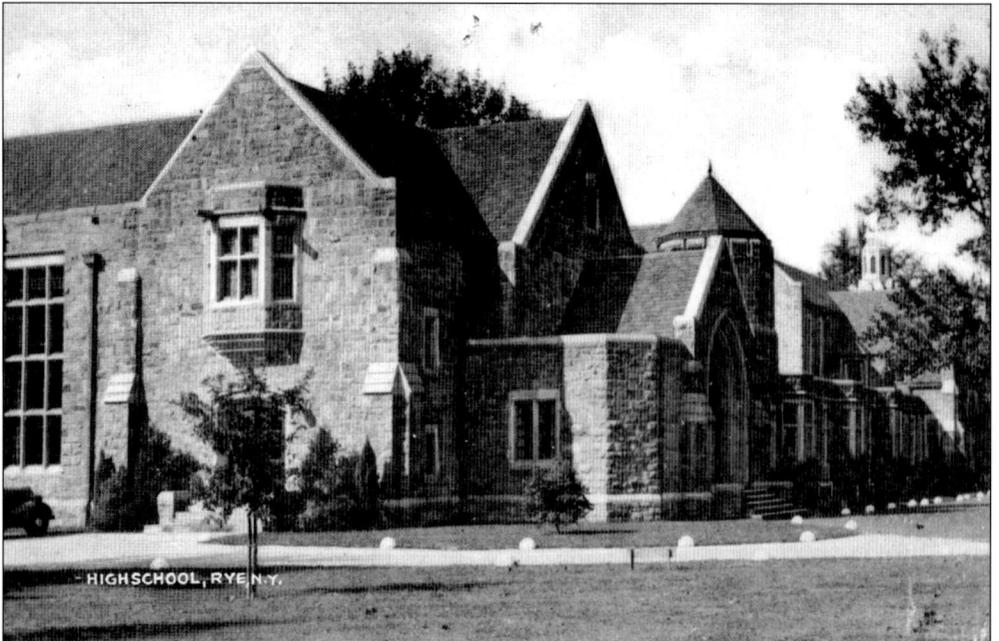

In 1930, Brookside, the estate of William Parsons on the Blind Brook, was acquired by the City of Rye. The large high school shown here was built of rough granite in medieval Gothic style. Chapman and Woolsey were the architects; the cost was approximately $1.5 million. Large fields were laid out for football and track. Over the years, the building on Parsons Street has been greatly extended.

54

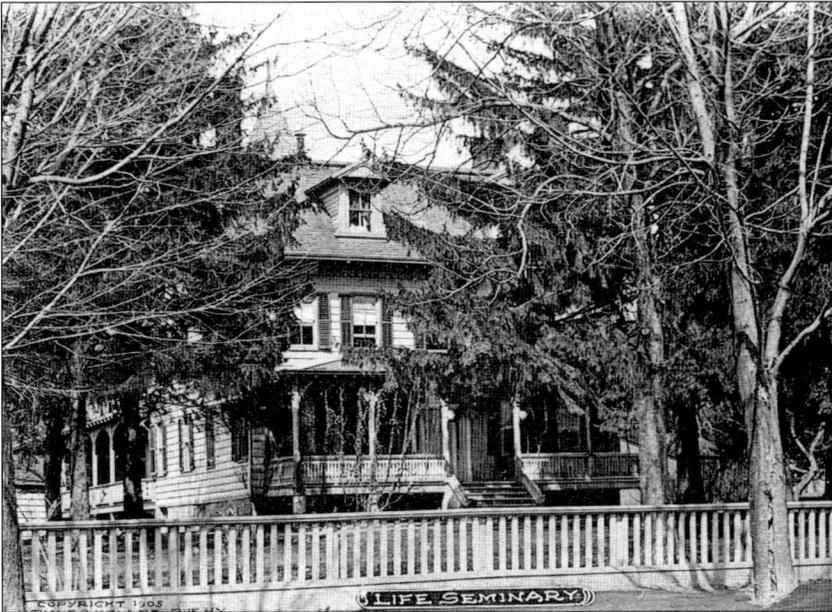

RYE, N.Y.

LIFE SEMINARY

Very important to the life and culture of Rye in the 19th and early 20th centuries was the Rye Seminary, also known as the Life Seminary. It was a private boarding school for girls begun in the mid-1860s. A very strict classical course was taught, including Greek, Latin, and mathematics. The proprietors and teachers of the school were William J. Life and Susan J. Life, hence the name often given to the institution. It was advertised as the best boarding school between New York City and New Haven. Operation of the school later passed into the hands of the Stowe sisters. It was merged into Rye Country Day School in the 1920s. For a period of time, the building pictured was used as part of the new school, but it was moved and has been torn down.

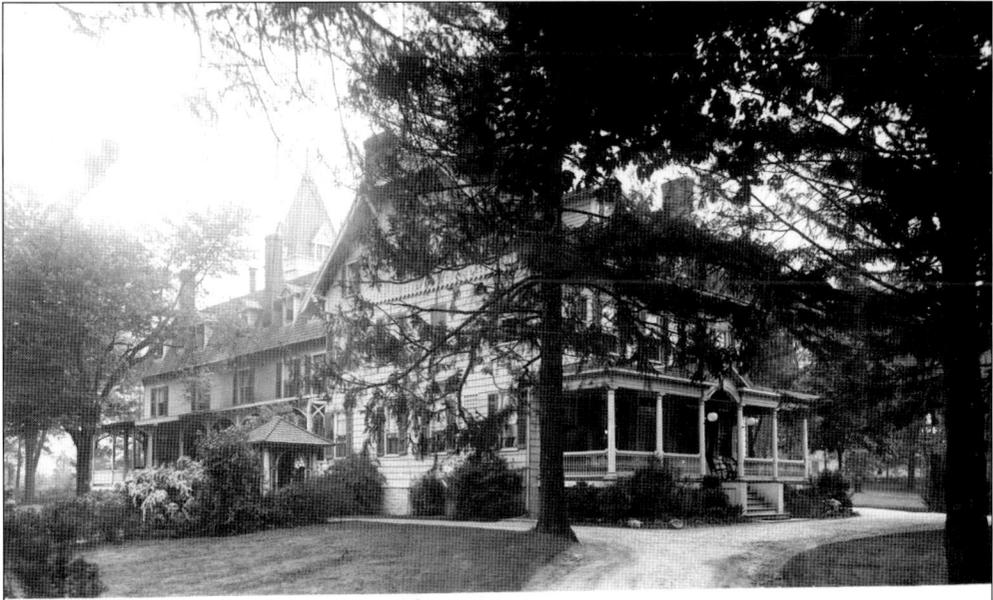

P1994 Rye Seminary, Rye, N. Y.

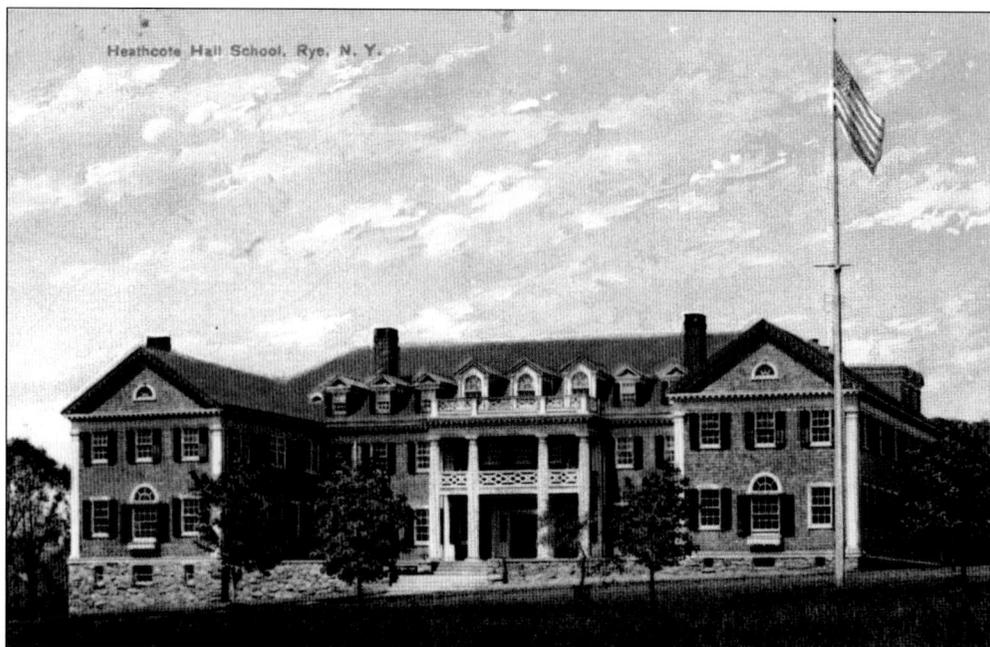

The building pictured was the variously called Rye Country Day School for Boys or Heathcote Hall. It was actually located just over the border of Rye in the town of Harrison on South Street. It is no longer standing. The school formerly was in Rye on the Boston Post Road at Park Avenue. It was merged with the Life Seminary to form Rye Country Day School in the early 1920s.

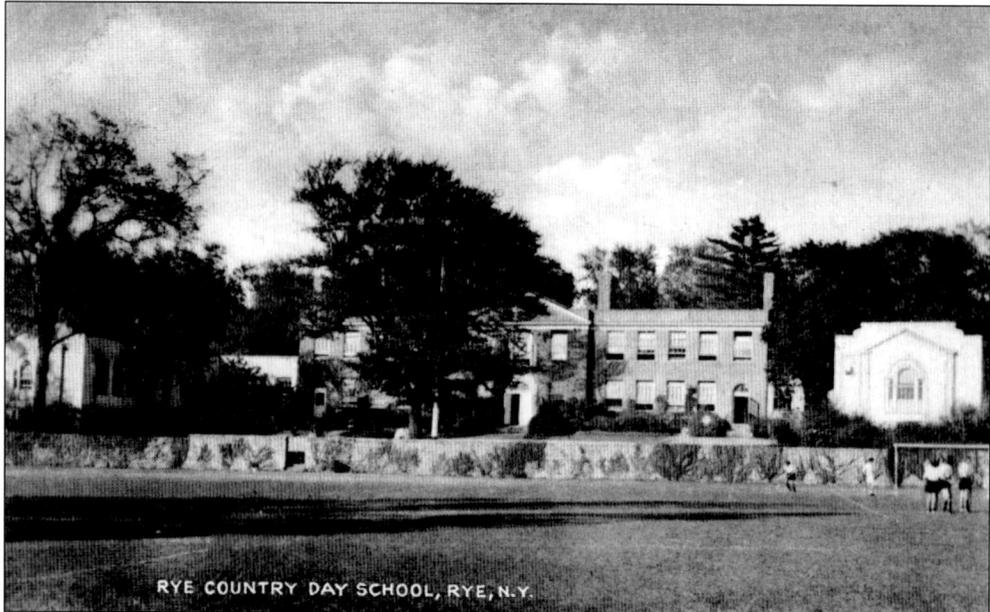

Located on a large campus along the Boston Post Road, the private Rye Country Day School is pictured, the result of the mergers previously described. The school runs grades 1 through 12. A great variety of buildings have been added, including a hockey rink. The playing field is where St. Benedict's Home for Destitute Colored Children once stood.

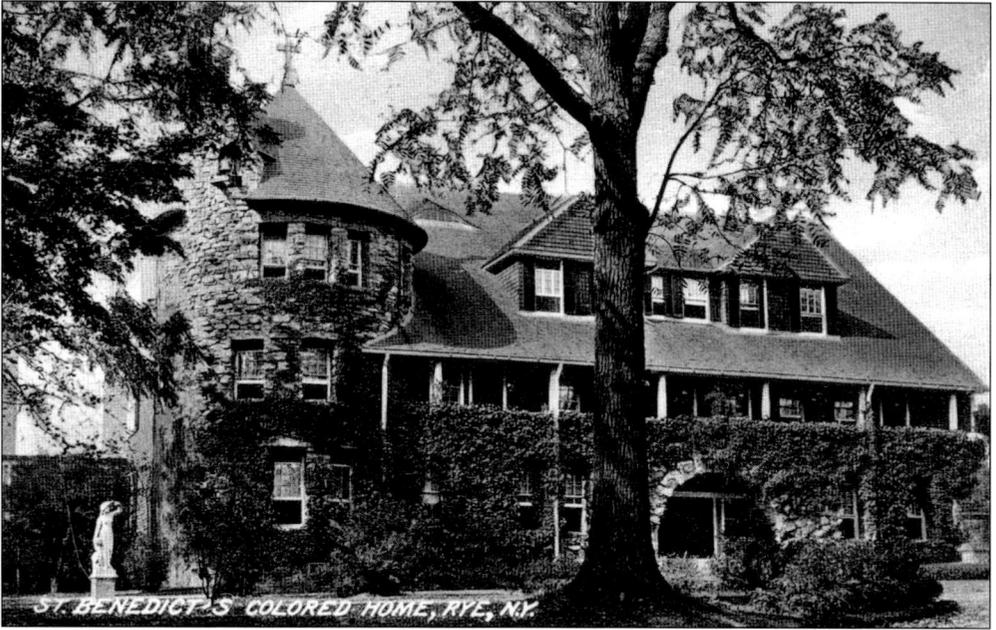

St. Benedict's Home for Destitute Colored Children, or "Colored Home," as it was called here, sat on the Boston Post Road in Rye for some 60 years. Rev. John E. Burke of New York City appreciated a need for a school for black orphans, and in 1890, he paid $20,000 for an eight-acre tract in Rye on the Boston Post Road. He hired the firm of Little and O'Connor to design the building shown in these cards, which was constructed for $45,000 and opened in 1891. Children ages 3 to 16 attended classes through the eighth grade. In bad physical shape, the school closed in 1940. After World War II, the buildings were used for returning war veterans. The main building and outbuildings were torn down in the 1960s, and the land became the playing field of Rye Country Day School.

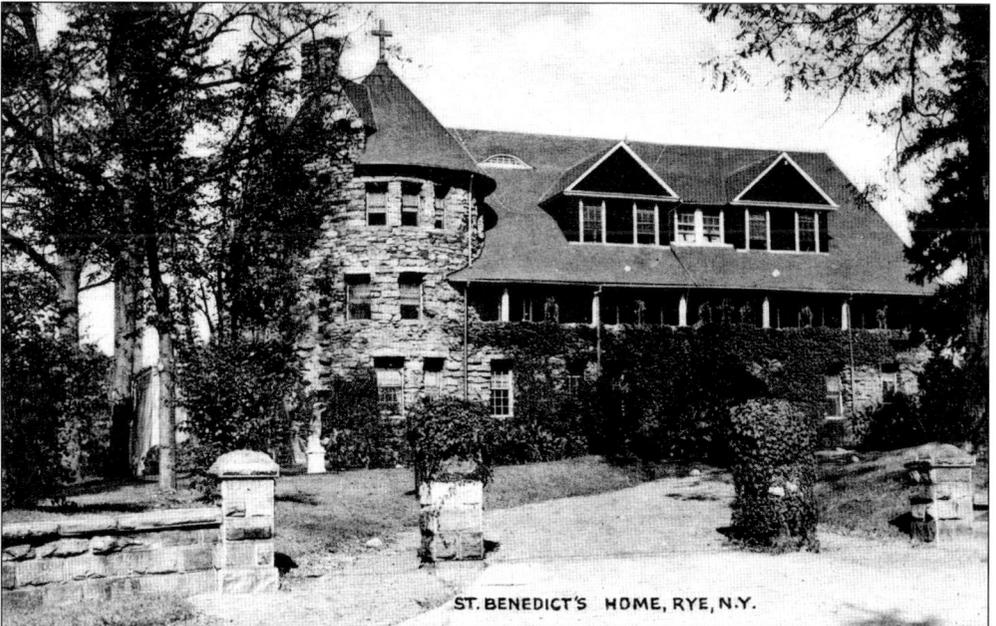

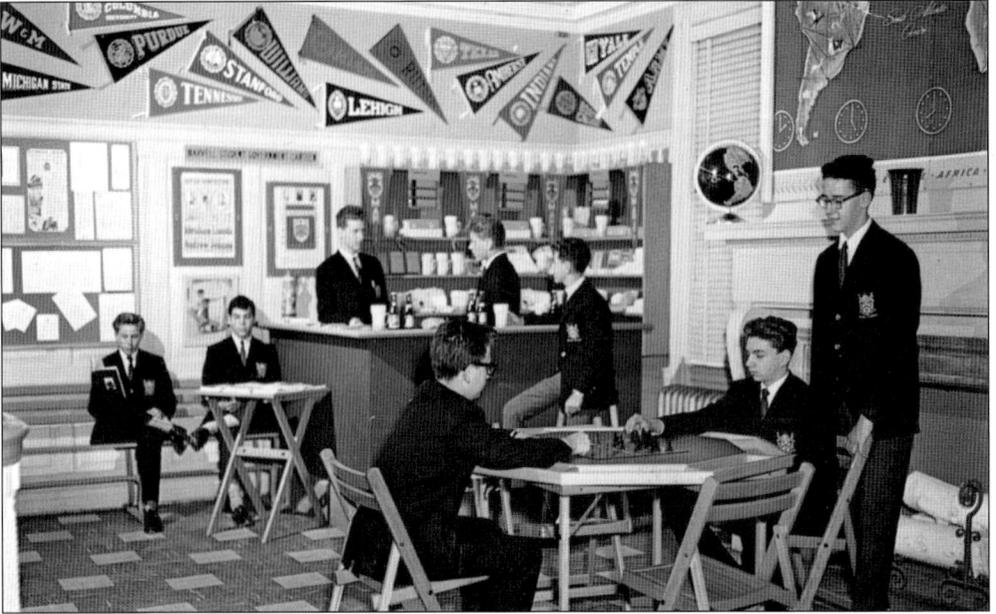

Marvell Academy was a boys' preparatory school at 446 Boston Post Road. The photograph is a carefully staged advertisement, showing the young boys in the recreation lounge, playing chess, and, if one looks closely, it appears learning how to sit at a bar. The college pennants make the not-too-subtle hint that this is where one's son could go. The school was replaced by several homes.

Much of Rye was made up of farms at the dawn of the 20th century. One of the largest was the Mead farm west of the Boston Post Road. Over 50 acres of it were purchased for the development of the Osborn Home. This was done by New York lawyer John W. Sterling without revealing the purpose. The Mead Pond area has since become a separate development with homes around the lake; it is the only natural lake in town.

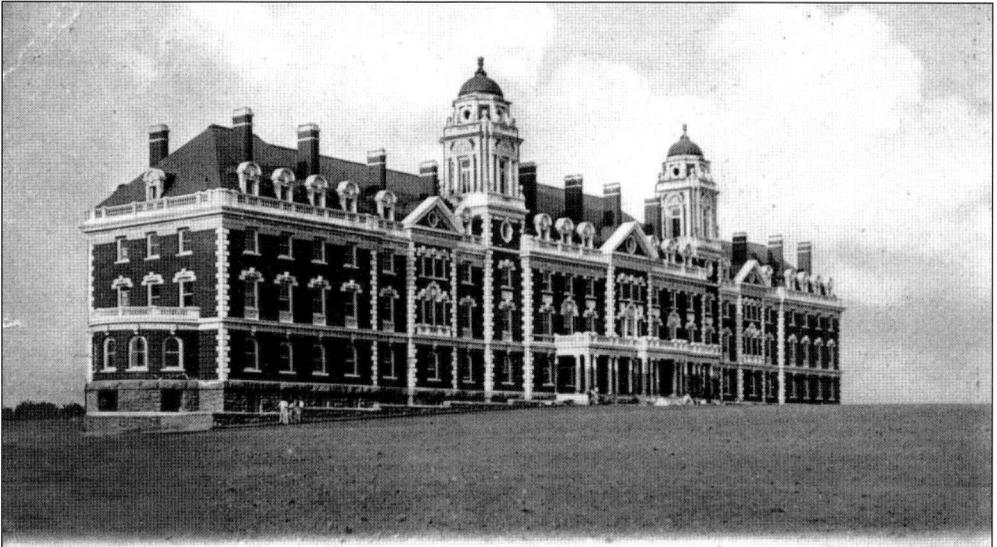

Old Ladies' Home. Harrison, N. Y.

Here is where I am going to put you as soon as school is out, Aunt Becky. Mettie.

The Osborn Home, familiarly known as the old ladies home and now simply the Osborn, is one of Rye's major establishments and is famous for its early concept of providing residence for "respectable, aged women in needy circumstances." It was the genius idea of Miriam Osborn. The main building, shown above, was designed in a Georgian Renaissance style by Bruce Price. The grounds followed a design of B. S. Olmstead. The home opened in 1908. Wings were added over the years in different architectural styles, as shown in the view below. More recently, the facility has greatly expanded, adding individual residences for those transitioning from retirement to the need for medical services. The address is 101 Theall Road.

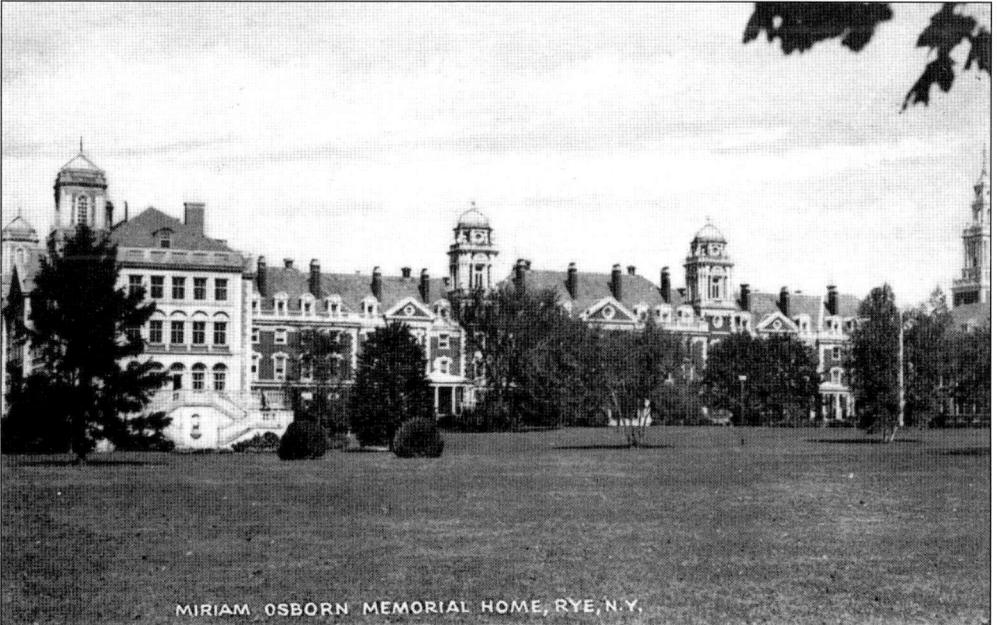

MIRIAM OSBORN MEMORIAL HOME, RYE, N.Y.

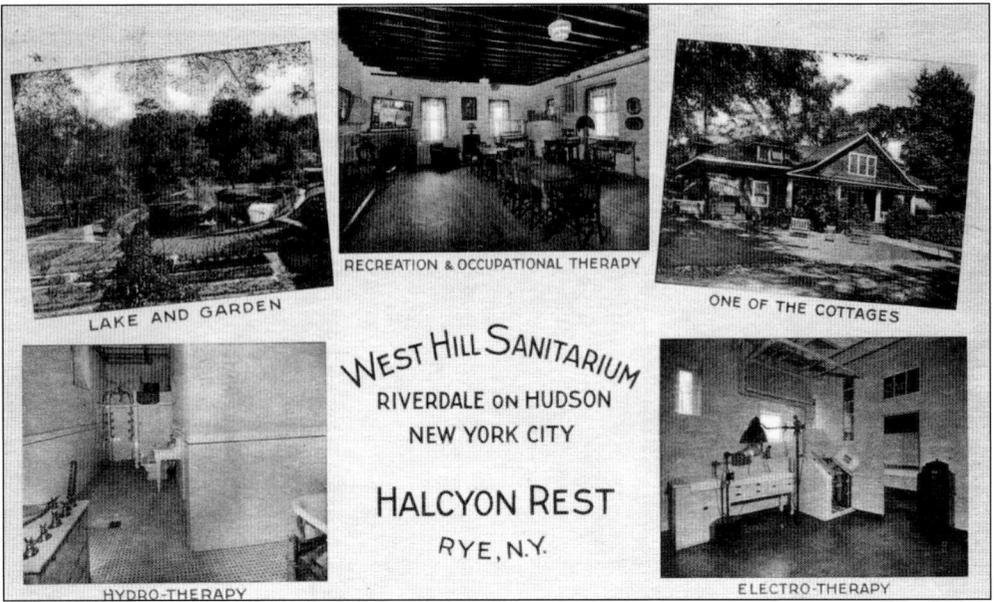

RECREATION & OCCUPATIONAL THERAPY

LAKE AND GARDEN

ONE OF THE COTTAGES

WEST HILL SANITARIUM
RIVERDALE ON HUDSON
NEW YORK CITY

HALCYON REST
RYE, N.Y.

HYDRO-THERAPY

ELECTRO-THERAPY

Halcyon Rest was a private institution treating mental and nervous disorders in Rye. It was founded in 1928 in an old home dating back to the 1700s on the Boston Post Road. Evidently the cottage and grounds shown on the card are at its sister location. It later became an accredited psychiatric hospital in the 1950s, changing its name to Halcyon Hospital. Today is it known as Rye Psychiatric Hospital at 754 Boston Post Road. (Steven Feeney.)

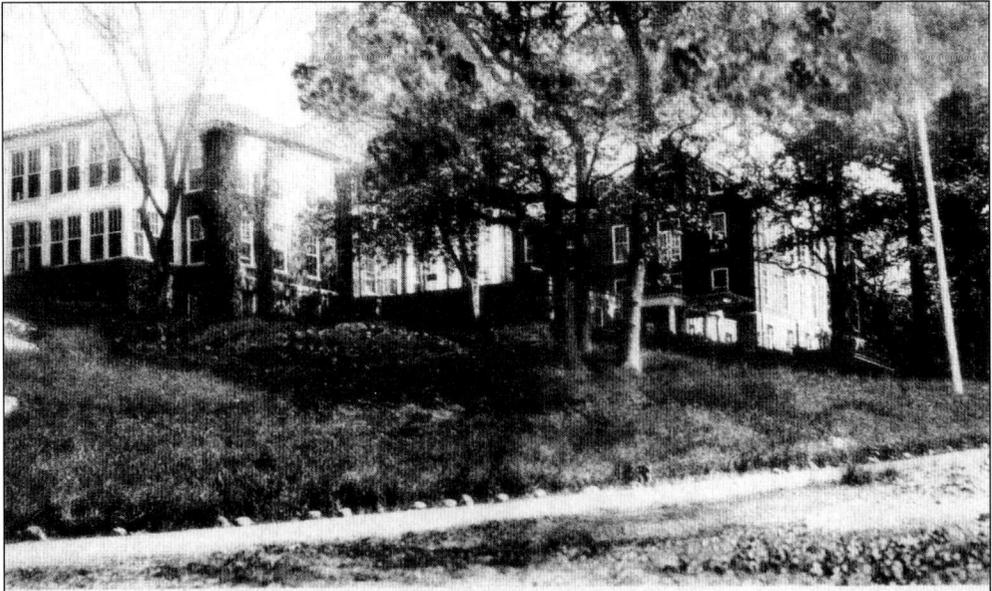

United Hospital, Rye and Port Chester, N. Y.

Like some other buildings just outside Rye, United Hospital in Port Chester liked to state it was in Rye. For many years, it was the general hospital serving residents of Rye and Port Chester. Its history traced back to a small downtown building in Port Chester in 1889. However, due to various problems, it went bankrupt in 2005, the hospital was closed, and the property was sold.

Six

CLUBS

Rye has an unusual amount of clubs for a town its size. There are presently two golf clubs, a yacht club, and five shore clubs. Perhaps this is due to the social and wealthy nature of the community but also to the abundance of waterfront that facilitates them. Scenes from all of these are in this chapter. The sports engaged in are also well represented by the views here.

Other clubs and sports had their role in earlier times. There was the Rye Lawn Tennis Club at Drake Smith Woods in 1884 in the earliest days of club tennis. Today most of the clubs have courts and platform tennis as well. And in the 1880s when the horse was king, there was the Westchester Military Riding Club at Highland Stables, shown on page 43. The members styled themselves as the Rye Rough Riders, a name associated with Theodore Roosevelt.

Golf too had an early history in Rye. The Apawamis Club, pictured in this chapter in its present location, had two previous courses, one on the then north side of what is now Apawamis Avenue and the next at Jib's Farm near the train tracks. There was also a short-lived golf course on Milton Point, which used the Marble Hall mansion (see page 36) as is its clubhouse. The streets in this neighborhood still have the golf names Fairway, Green, and Turf.

The waterfront of Manursing Island became the venue for two clubs, the Manursing Island Club developed in 1912 and the Westchester Beach Club developed in 1919 as an offshoot of the Westchester-Biltmore Country Club. While cutting the public off from the shorefront on Manursing Island, these clubs spared Rye the development of yet another amusement park for which the acreage had been offered.

The Milton Point vicinity became the situs of four private clubs, the American Yacht Club, Rye Golf Club (at Whitby), Shenorock, and Coveleigh.

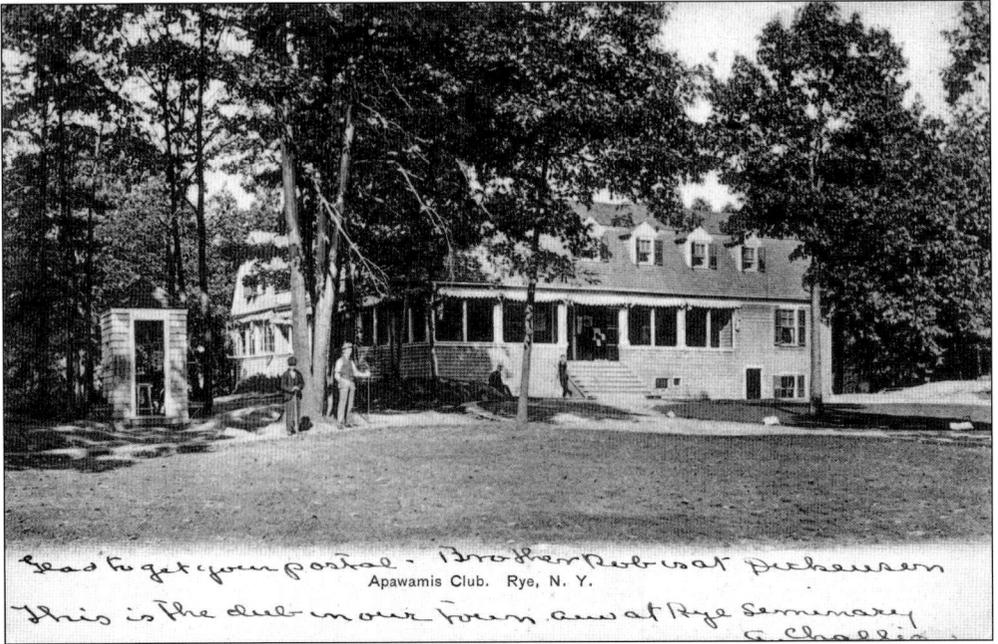

Glad to get your postal - Brother Rob is at Dickerson. This is the club in our town and at Rye Seminary. G. Challis

Apawamis Club. Rye, N. Y.

Apawamis Club was the first golf club in Rye, but its present location, shown here, was actually its third. The club, which was founded in 1890, had a nine-hole course first on the Anderson farm adjacent to what is now Apawamis Avenue and then at Jib's farm near the railroad station. In its present location on Club Road, it has an 18-hole course. The original clubhouse, shown above, was built in 1899 and burned down in February 1907. It was soon replaced by the one shown below. The name is taken from a Native American name for an area of Rye.

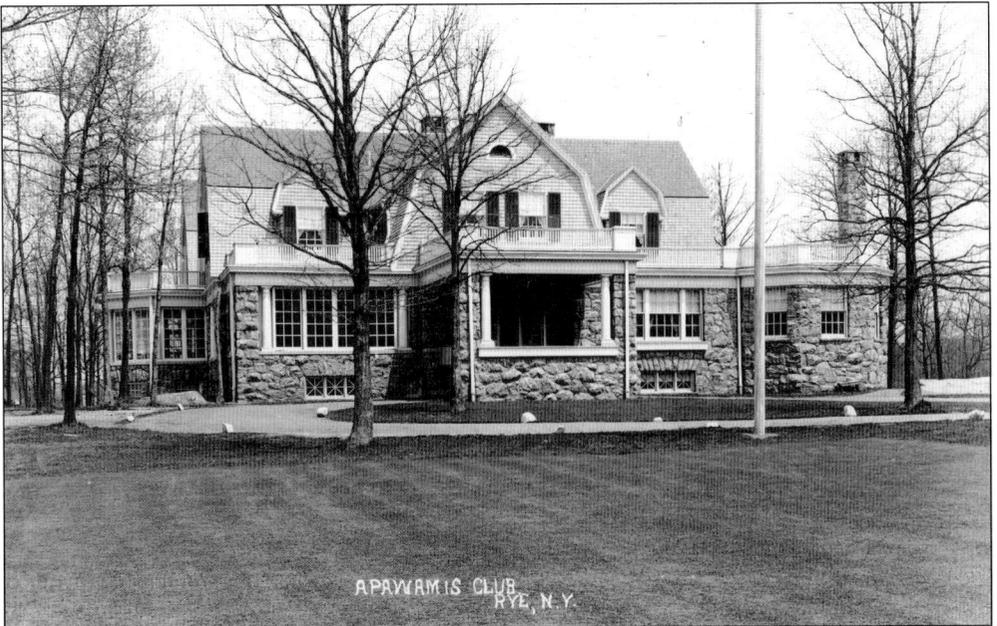

APAWAMIS CLUB
RYE, N. Y.

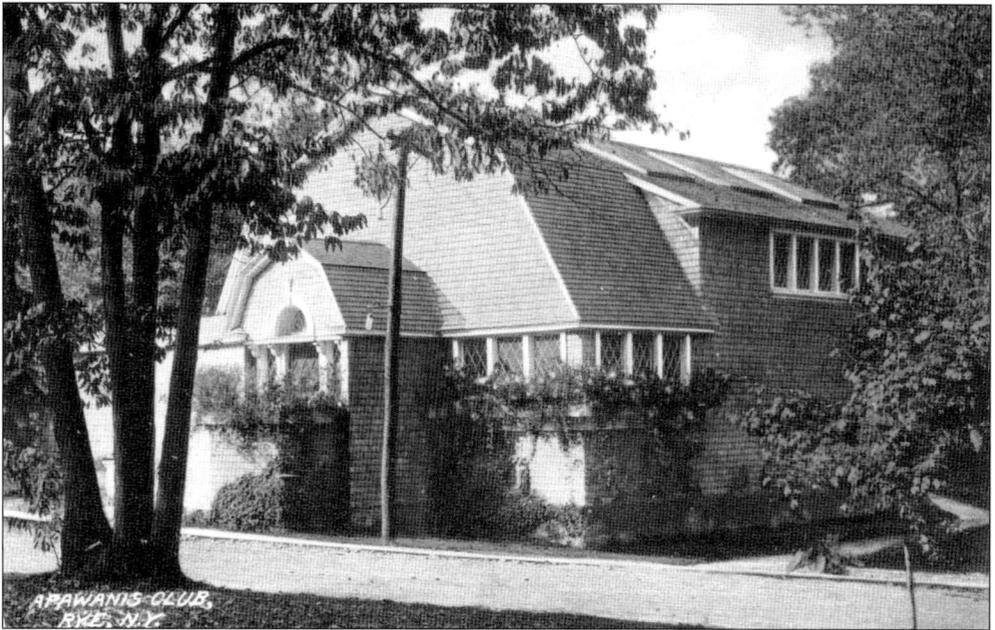

As time went by, Apawamis Club added more and more buildings, some of which are shown here. These include the squash house. And over the years, the club, which is one of the earliest in the country, has hosted many national and regional golf tournaments, including the U.S. Amateur championship in 1911. Gene Sarazen was among the well-known players to use the links. Apawamis was also an early promoter of tennis. (Below, Steven Feeney.)

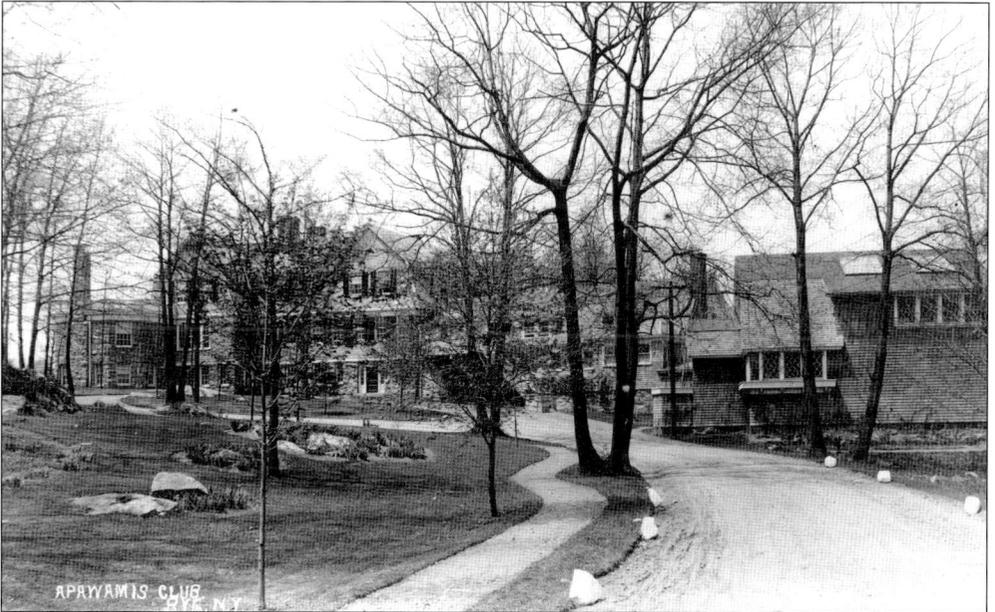

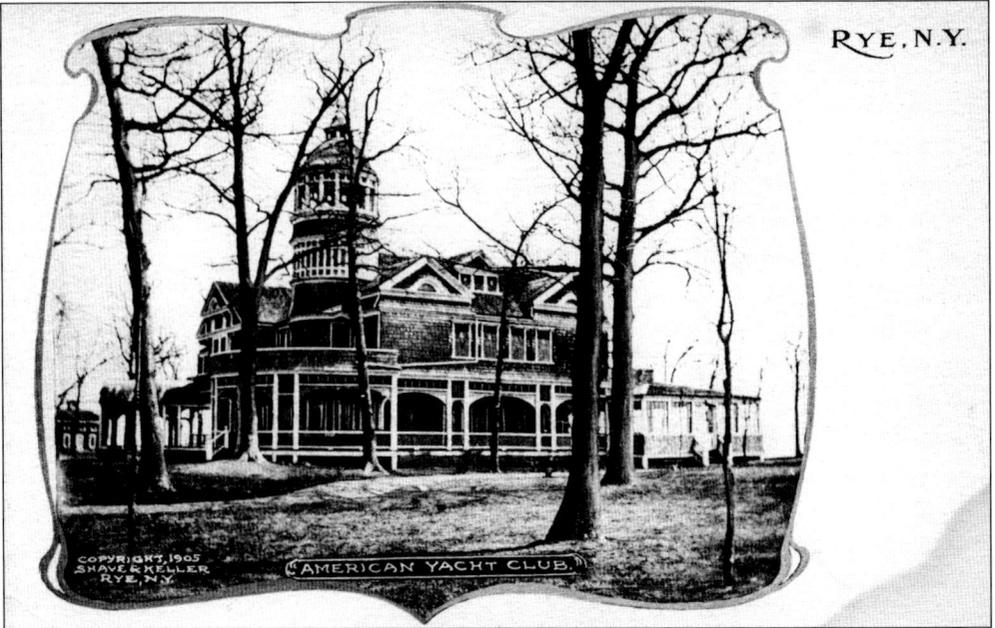

COPYRIGHT, 1905
SHAVE & KELLER
RYE, N.Y.

AMERICAN YACHT CLUB.

Rye's first yacht club, one known worldwide, was the American Yacht Club. It was begun by New York financier Jay Gould in 1883 at a time when boating meant steam yachts. Twelve acres at the southern tip of Milton Point were purchased for $6,000 from the Wainwright family. The clubhouse pictured above was built in 1888 and burned in a disastrous winter fire in 1951. The grand, old building was replaced by a one-story utilitarian one. The club grounds occupy the tip of Milton Point with water views on three sides and moorings for the many yachts that members own today. The view below of the rocks was taken at low tide. There is a story that early members were shocked when Ethyl Barrymore smoked a cigarette in public.

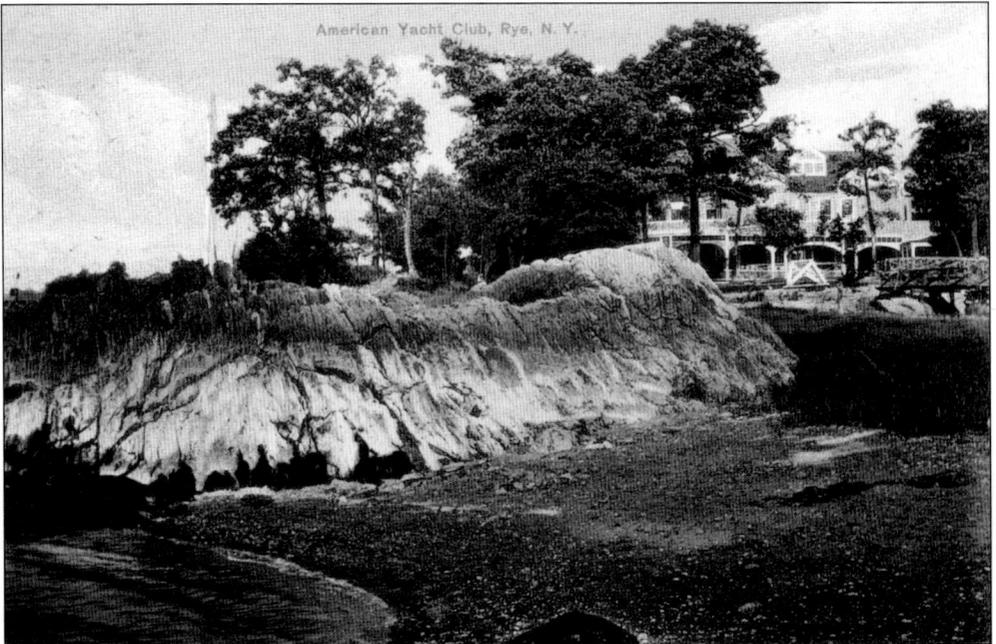

American Yacht Club, Rye, N. Y.

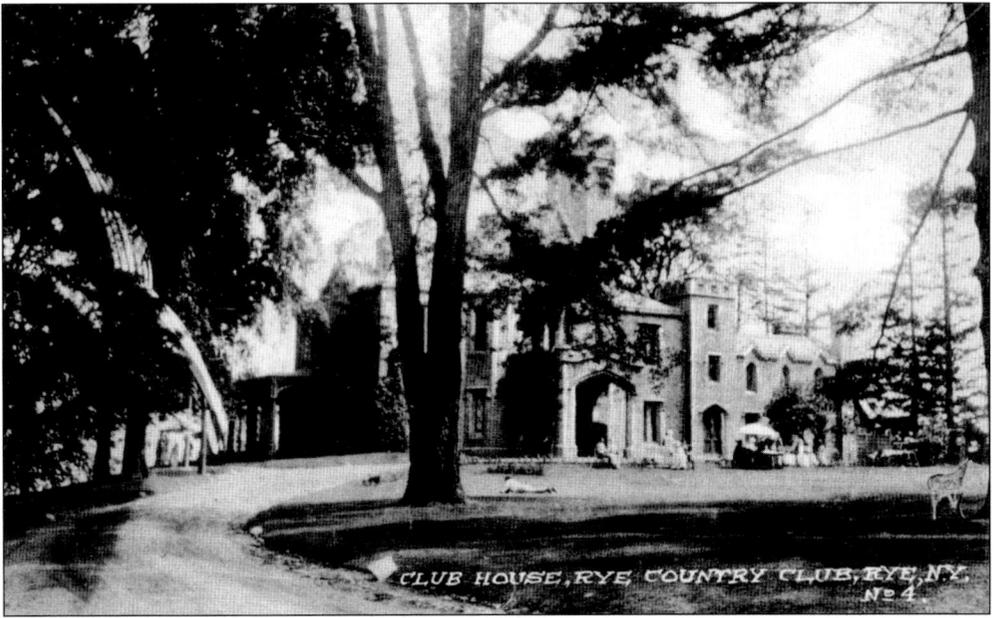

CLUB HOUSE, RYE COUNTRY CLUB, RYE, N.Y.
No 4.

The building pictured above is one of Rye's best-known landmarks, Whitby. It began life in 1854 as a mansion for New York City stockbroker William P. Chapman, who purchased some 40 acres on the Boston Post Road. The architect was the noted Anthony Jackson Davis, who had previously designed Lyndhurst, also in the Gothic Revival style. The name Whitby came from a ruined Britsh abbey. It was later purchased by Joseph Park, owner of Park and Tilford, the New York grocers. In 1920, the property was purchased for the construction of the second golf course in Rye, a private club named Rye Country Club. The main building is essentially unchanged. Golfers are shown at play, below, in the proper attire of the day. (Below, Steven Feeney.)

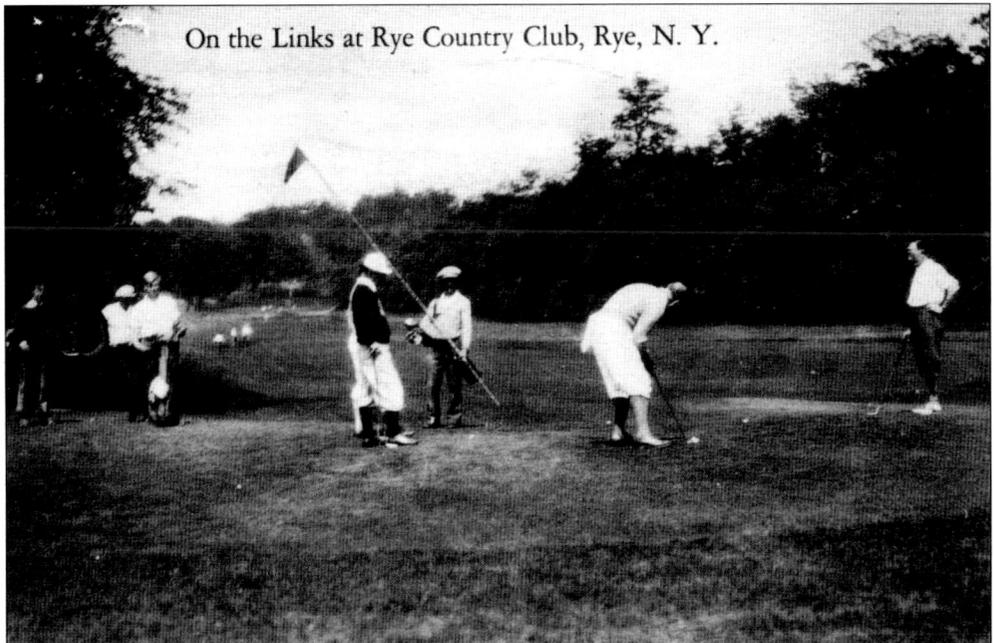

On the Links at Rye Country Club, Rye, N. Y.

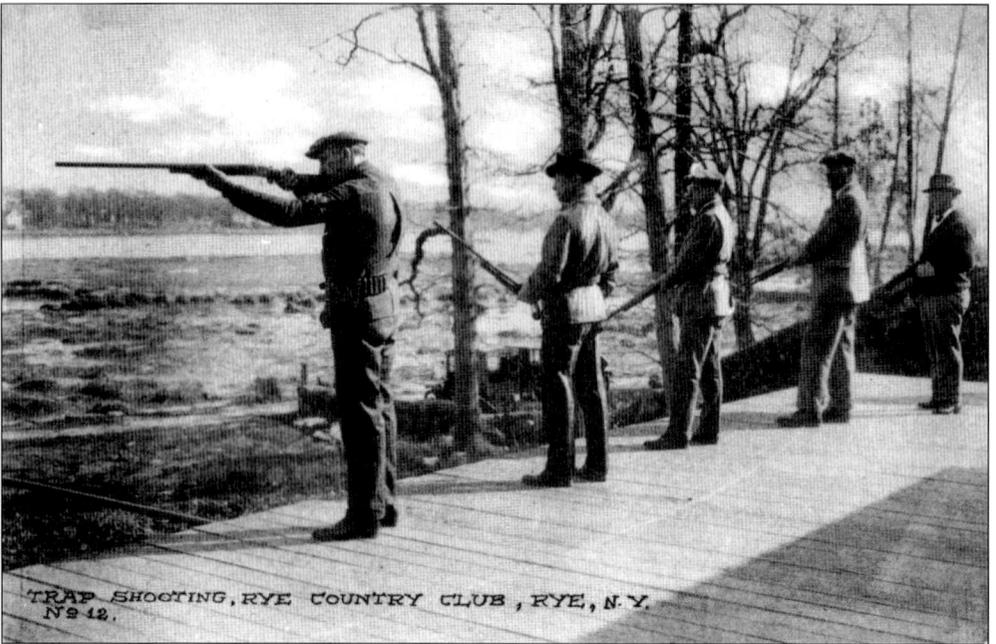

TRAP SHOOTING, RYE COUNTRY CLUB, RYE, N.Y.
No 12.

The Rye Country Club hosted activities beyond golf. Shown above is an off-season club sport, trap shooting. The men are on a platform at the lower end of the property overlooking Milton Harbor. Below, people are seen skiing, which must have been unchallenging as there are no real hills on the property. The old single-pole method is in use. In 1965, the City of Rye purchased the club and it became the municipal Rye Golf Club at 330 Boston Post Road. Over the years, a kitchen and other back rooms were added to Whitby and a new clubhouse was built along with a large swimming pool. There is a public restaurant in Whitby, allowing one to see the interior of the castle much as it was when built in the mid-1800s. (Below, Steven Feeney.)

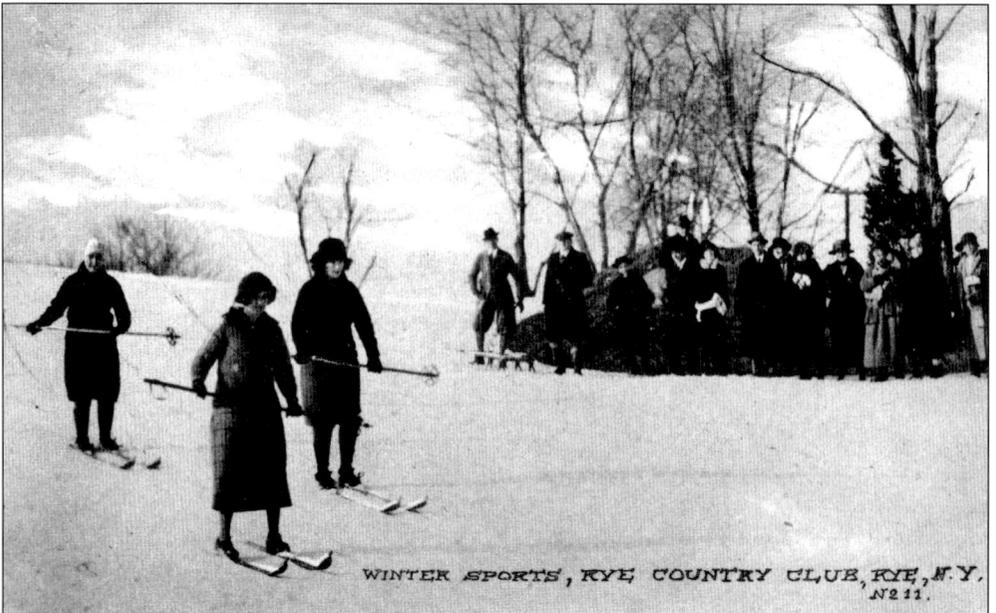

WINTER SPORTS, RYE COUNTRY CLUB, RYE, N.Y.
No 11.

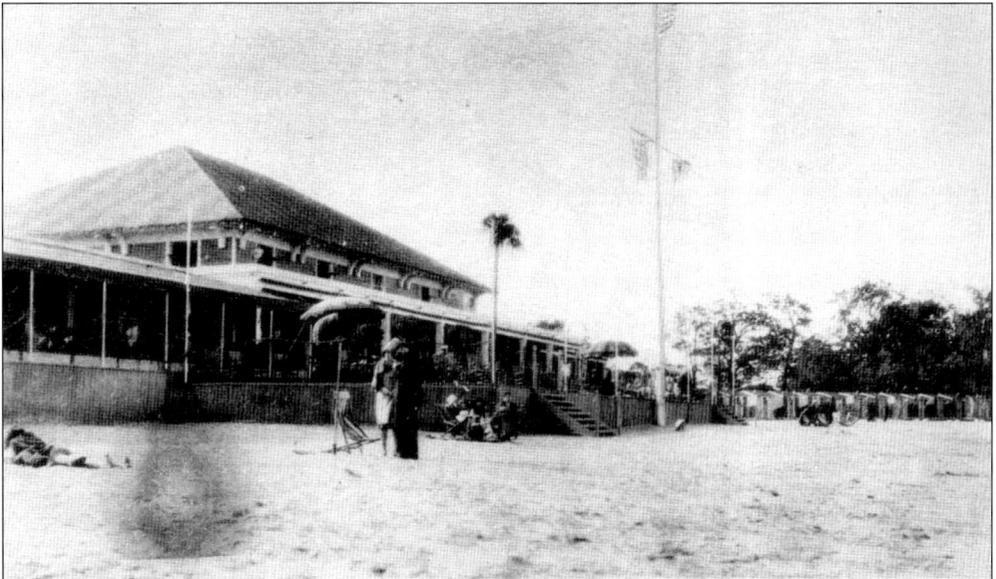

CASINO CLUB AND BEACH MILTON POINT ROAD RYE, N.Y.

In addition to the American Yacht Club, a number of other sailing and beach clubs have been built on Milton Point. Pictured here is a club built in 1924 and known then as the Milton Point Casino (the word *casino* does not imply gambling, as it might today). Initially big bands and singers, including Rudy Vallee, performed in the space as shown below, but the club closed during World War II. It reopened in 1946 under the name of Shenorock Shore Club, by which it is known today. (Below, Steven Feeney.)

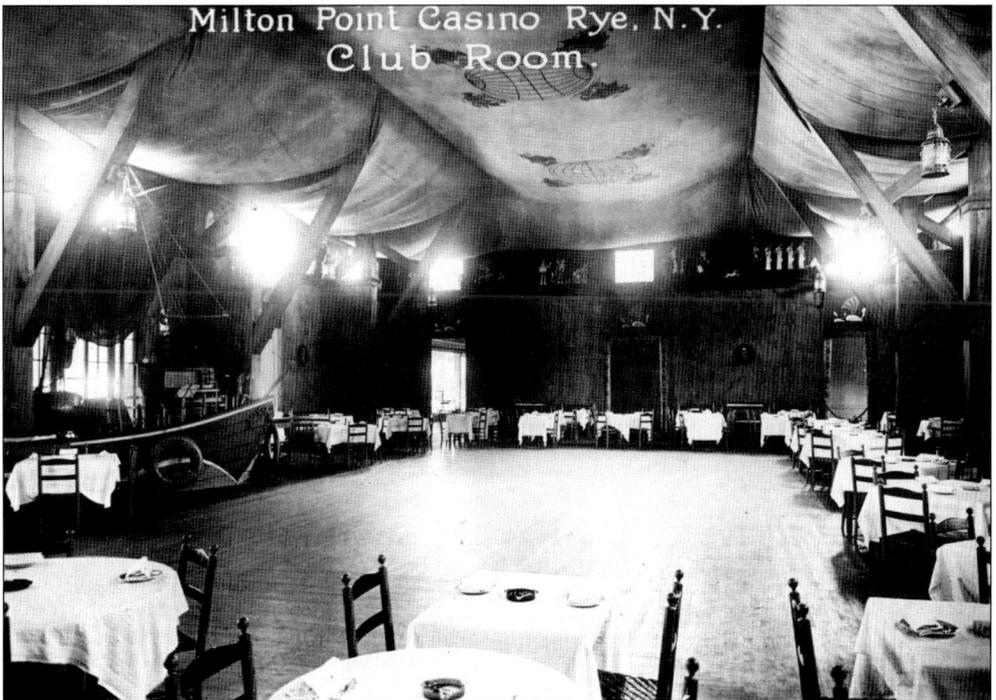

Milton Point Casino Rye, N.Y.
Club Room.

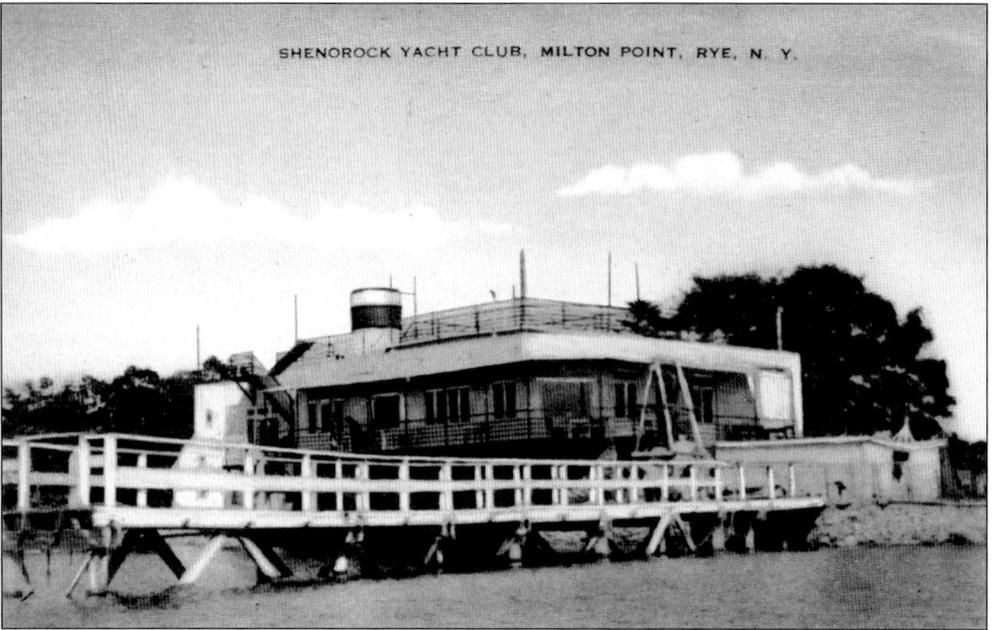

SHENOROCK YACHT CLUB, MILTON POINT, RYE, N. Y.

These are more pictures of what today is Shenorock Shore Club at 475 Stuyvesant Avenue. The name was taken by a tribal chief of the Peningo Indians at the time of the founding of Rye. The building above began as the Sea Horse Yacht Club and is now the winter headquarters of Shenorock. Near the shore area shown below is a picnic and pool area that had been the site of the family home of Stuyvesant Wainwright called the Bouwerie.

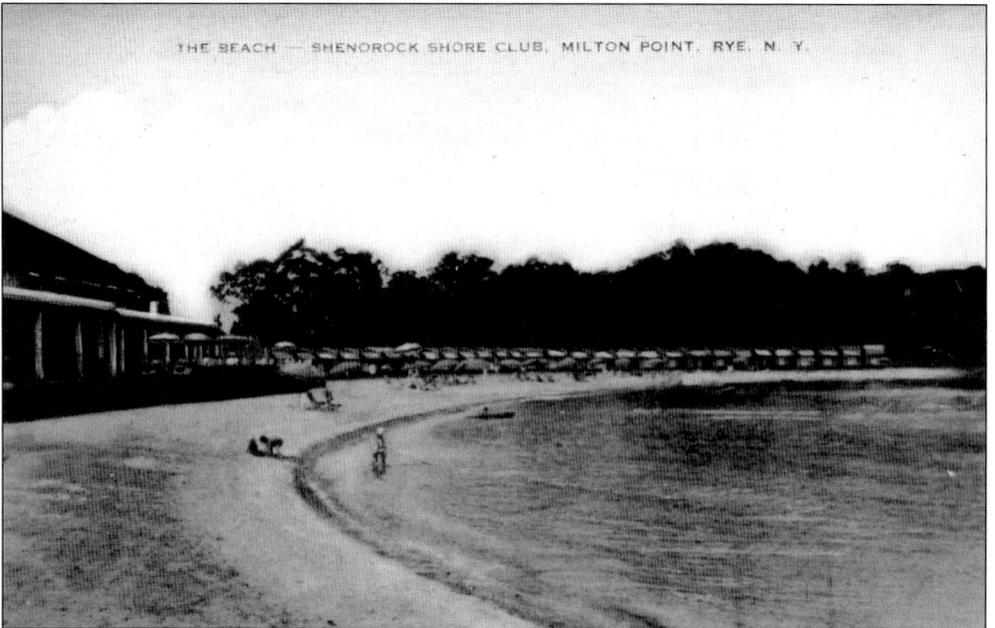

THE BEACH — SHENOROCK SHORE CLUB, MILTON POINT, RYE, N. Y.

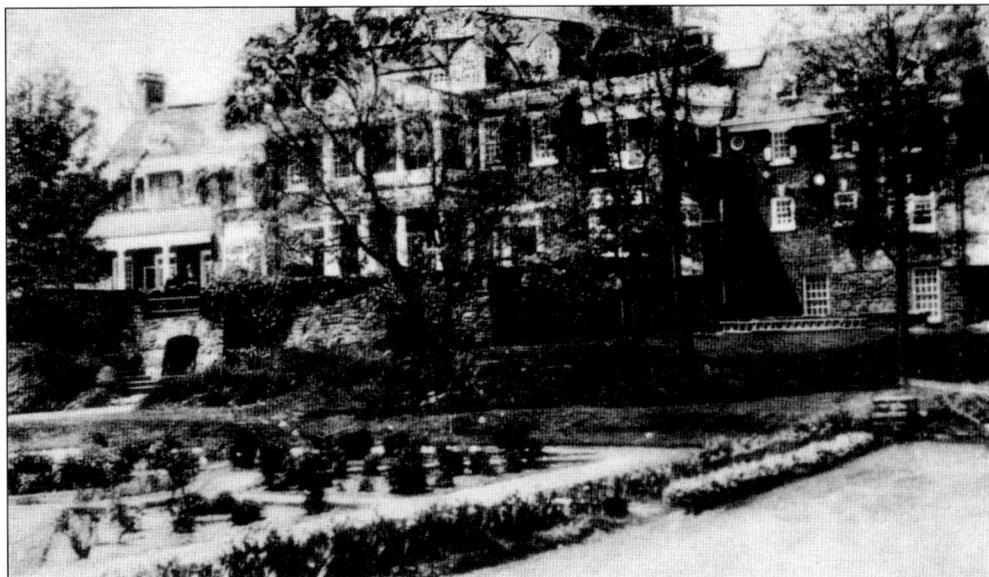

PENINGO CLUB - MILTON POINT ROAD RYE, N.Y.

The structure pictured above was the home of another of the Wainwrights, Richard Tilge Wainwright, who was an architect and designed it himself in the Georgian style. Known as Coveleigh, it was finished in 1904. It later became the Breakfast Club Casino with a speakeasy during Prohibition. It was then named the Peningo Club but failed during the Great Depression, and today it is called the Coveleigh Club on Stuyvesant Avenue on Milton Point. The aerial view at right shows the mansion with its formal grounds in front before the big pool was built. Long piers have been built to reach deeper water and shelter a swimming area.

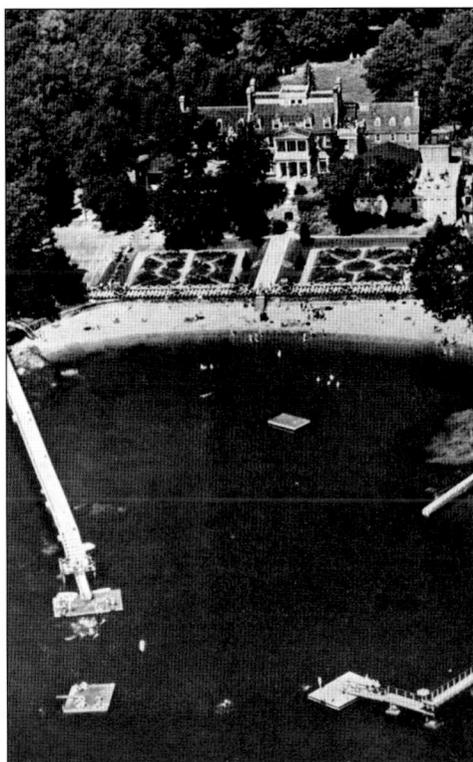

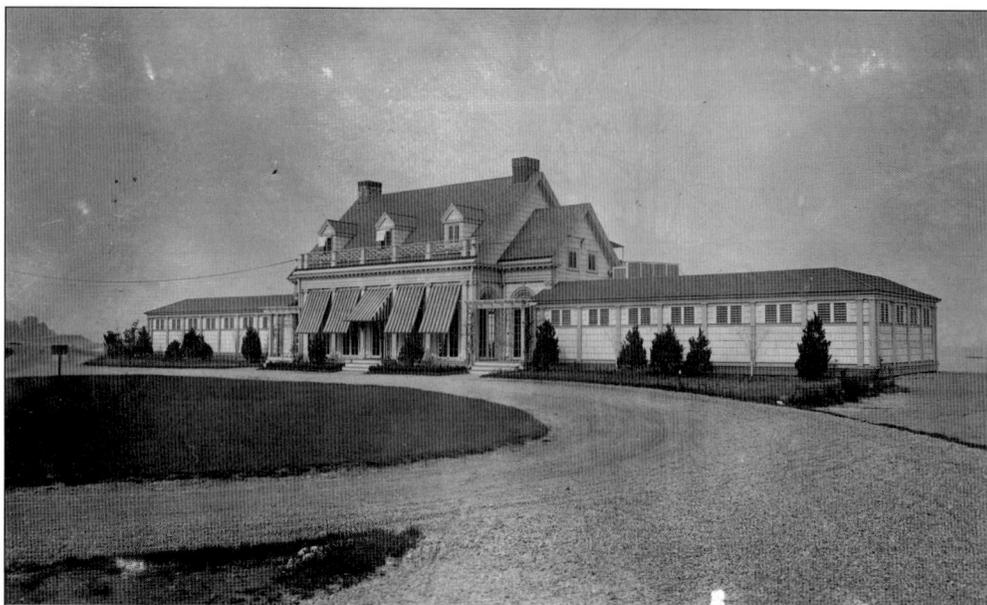

P2005 Manursing Island Casino, Rye, N. Y.

The Manursing Island Club was founded in 1912 on the beach area of Manursing Island. The shorefront area of this and its neighbor, the Westchester Beach Country Club, was at one time advertised as ideal for an amusement park. However, the clubs bought the land. The Manursing Island Club was founded by Rye resident H. F. G. Wey and others. In those days, club membership cost $50, and annual dues were $30. As pictured from the road and beach side, the two-story building was called the casino, with bathhouses flanking it. Below, note the two uniformed lifeguards; this was serious business then. Over time, many tennis courts were added. Tennis greats played here, including Bill Tilden and Alice Marble. The club is on Van Rensselear Avenue. (Below, Steven Feeney.)

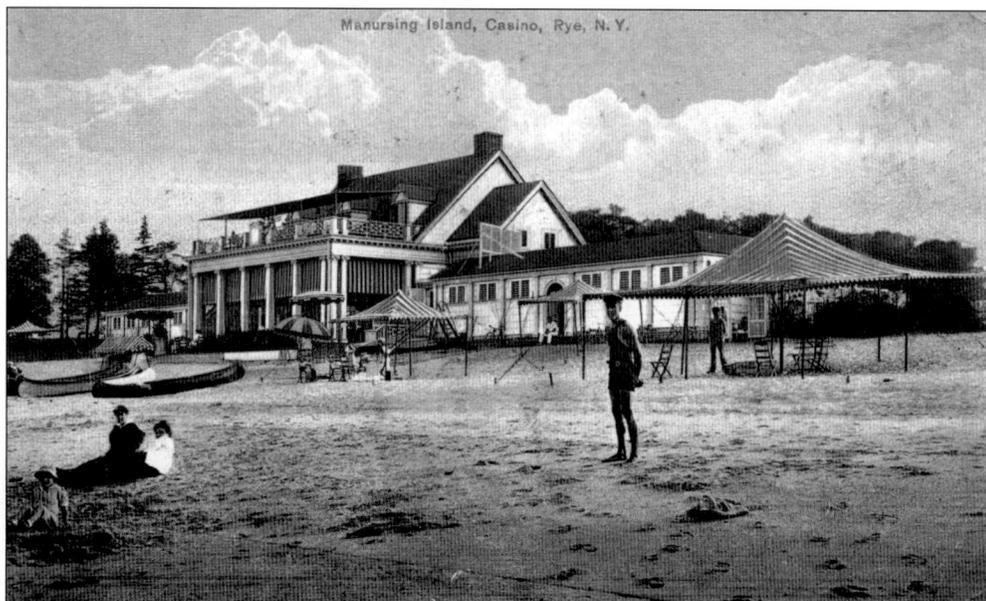

Manursing Island, Casino, Rye, N. Y.

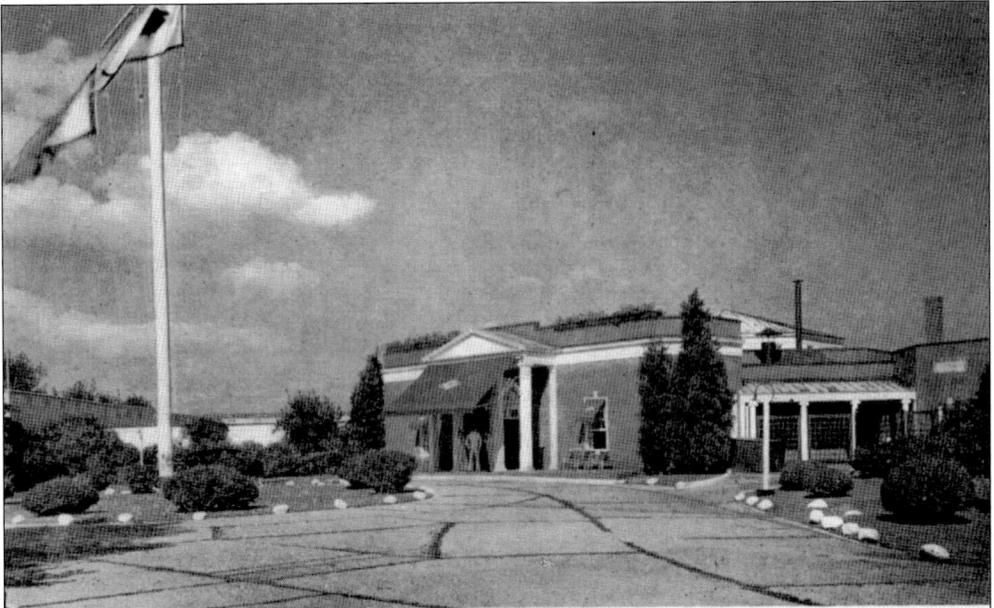

ENTRANCE TO THE BEACH CLUB, WESTCHESTER COUNTRY CLUB, RYE, N. Y.

The Westchester Beach Club on Manursing Island is the shore part of the prestigious Westchester Country Club. North of the Manursing Island Club, 62 acres were bought in 1919 for $375,000. Sand was pumped in to create a beach, and buildings and a large swimming pool were added. Initial plans to add yachting, horseback riding, and golf did not materialize, however. In 1929, with times being bad, the members purchased the club from the owners of the parent club. Pictured below is when times got better, and women wore hats and men wore suits when they danced.

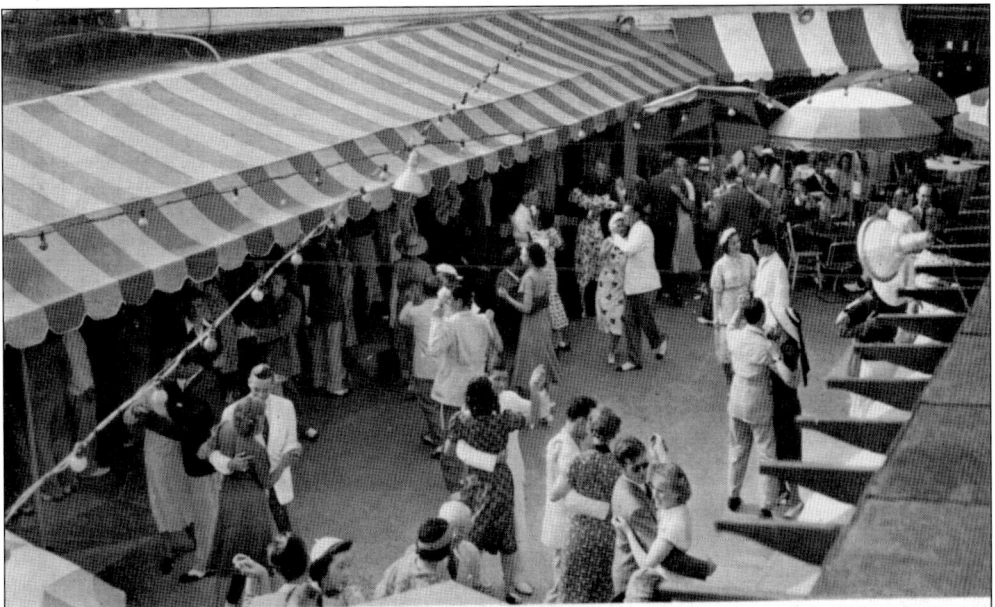

THE SIDEWALK CAFE AT THE BEACH CLUB, WESTCHESTER COUNTRY CLUB, RYE, N. Y.

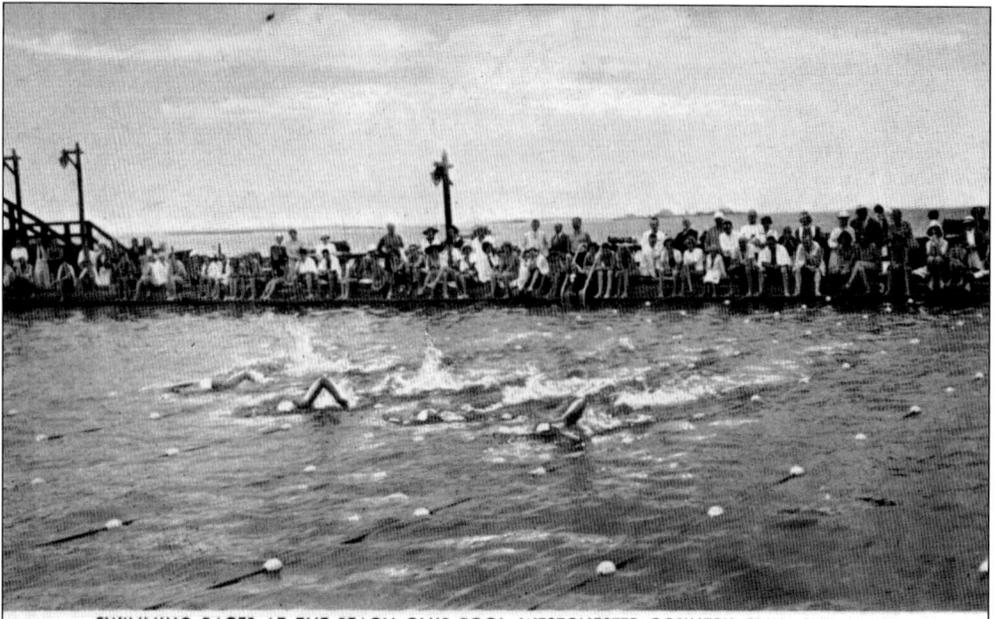

SWIMMING RACES AT THE BEACH CLUB POOL, WESTCHESTER COUNTRY CLUB, RYE, N. Y.

Pictured above is the king-sized swimming pool at the Westchester Beach Club. It was said to hold one million gallons and when built was the largest private pool in the county. It has always been used both for recreational and competitive swimming. The club is on Van Rensselear Avenue. Below is the parent club, first known as the Westchester-Biltmore, which to this day gives its address in Rye even though it is next door in Purchase. New York City hotelier John McEntee Bowman purchased a large farm in Harrison in 1922 and put up the club, pictured, which developed several 18-hole golf courses. Amelia Earhart, a Rye resident, took off from the club grounds on the first cross-country solo flight by a woman.

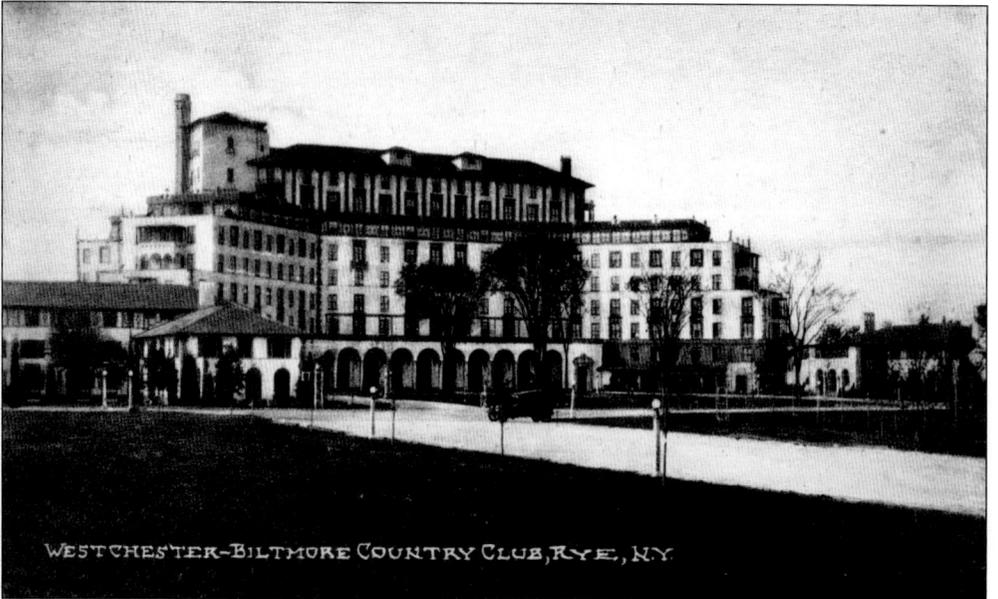

WESTCHESTER-BILTMORE COUNTRY CLUB, RYE, N.Y.

Seven

OAKLAND BEACH AND RYE TOWN PARK

Rye residents and visitors do not always distinguish between the two adjacent beach areas on Long Island Sound, Oakland Beach and Rye Beach. They are actually contiguous, with Rye Beach lying to the north. However, the two areas, including the beach and land behind it, have such different histories that they form separate chapters in this book. What the photographs in this chapter and the next show is the tremendous amount of change that has occurred in the last century in a shorefront only a little over a half mile long. The Oakland Beach part was itself only about 1,500 feet.

As an aid to readers, four maps have been included at the end of the book, pages 122–125, drawn by Susan Morison. These show the major development and changes between 1895 and 1930. However, no matter the changes, the beaches illustrated in these chapters have been a main focus of attraction and activity in Rye from the time when bathing became fashionable to the present.

Before 1909 and the development of the Oakland Pavilion and Rye Town Park, a large tract of land above Oakland Beach was occupied by numerous bungalows. This was property owned by Rye resident Augustus Halsted, who around 1890 began to allow the construction of these buildings and collected rent for their use in the summer.

The bungalow colony on Halstead's property became history in 1909 when the State of New York authorized the purchase of the land and created Rye Town Park. Behind this change was considerable politicking on the part of Rye, the county, and, indirectly, a modern park reform effort that stressed creating public places for the people. Indeed, the park became the first in Westchester County for public use on the sound. The park was designed along concepts of Olmsted and Vaux, with landscaping and areas designated for specific uses.

The major part of development in the new park was the Oakland Pavilion. This assemblage of structures was built in 1909, designed by Upjohn and Conable in what has been called a combination of Spanish mission and craftsman style. A later development was Manger's Bath and Pool.

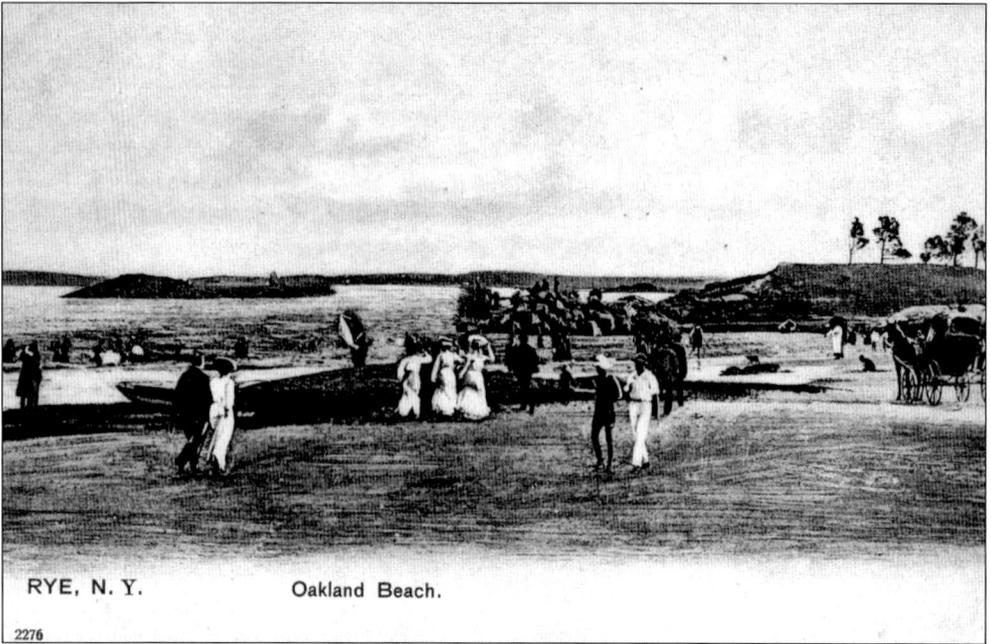

RYE, N. Y. Oakland Beach.

2276

Oakland Beach, pictured above and below just after the dawn of the 20th century, occupied the southern end of the beach area of Rye on Long Island Sound. Its name came from an inn on the beach called Oakland Grove House built by Augustus Halsted (or Halstead). On Sundays, people in their finest walked along paths above the beach. Others swam, wearing the usual bathing costume of the day, including for women tops and bloomers, not to mention black stockings. As pictured below at the foot of Dearborn Street, there was a small pier for boats and a large wooden slide. See the map on page 122.

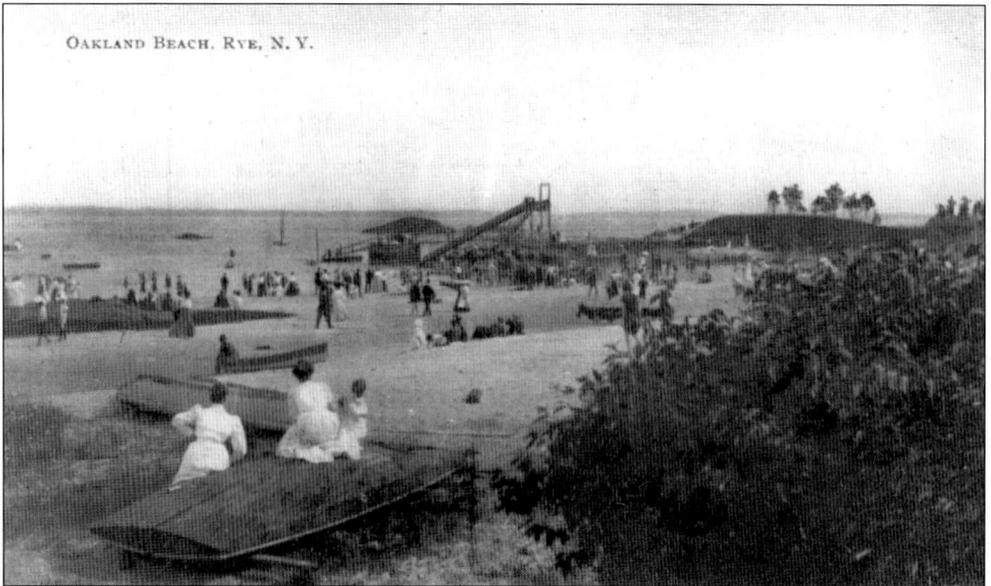

OAKLAND BEACH. RYE, N. Y.

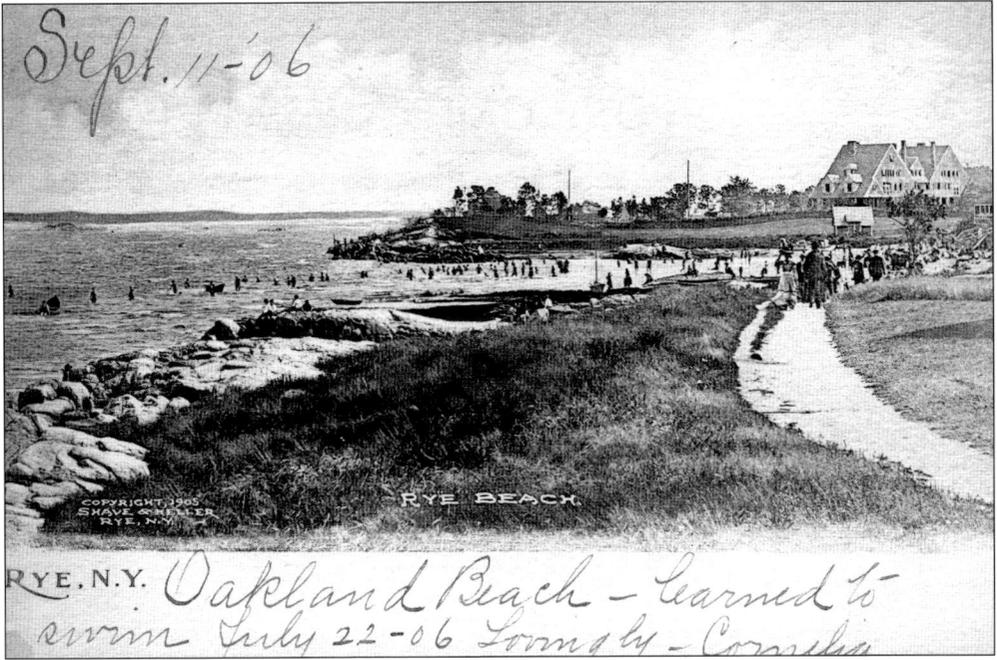

Sept. 11-'06

RYE, N.Y. Oakland Beach — learned to swim July 22-06 Fondly — Cornelia

Here are more scenes of Oakland Beach from about 1906. Beyond the southern end of the beach was the home of Simeon and Julia Ford, above, a summer cottage of some 48 rooms (see page 122). Simeon Ford was co-owner of the Grand Union Hotel in New York. After her husband's death, Julia summered there until 1952; the house burned down in 1956. The Ford family owned the Knapp house. Below, one sees clearer views of the Sunday costumes worn by the visitors from Rye and surrounding towns. The chain of rocks in the center at the rear was named the Bar Rocks. They show up on the maps and are there today.

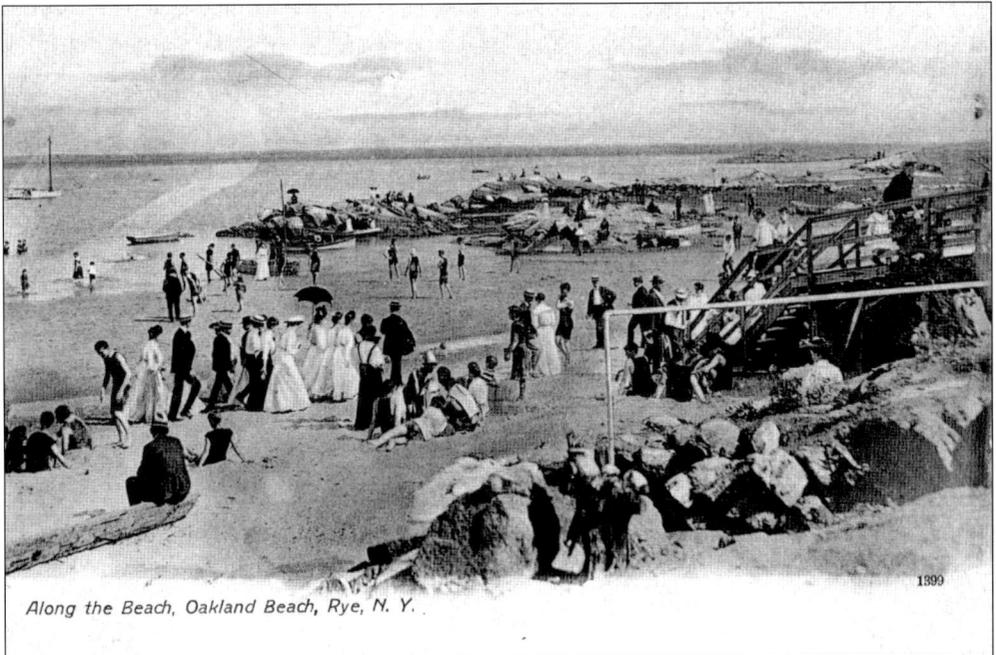

Along the Beach, Oakland Beach, Rye, N. Y.

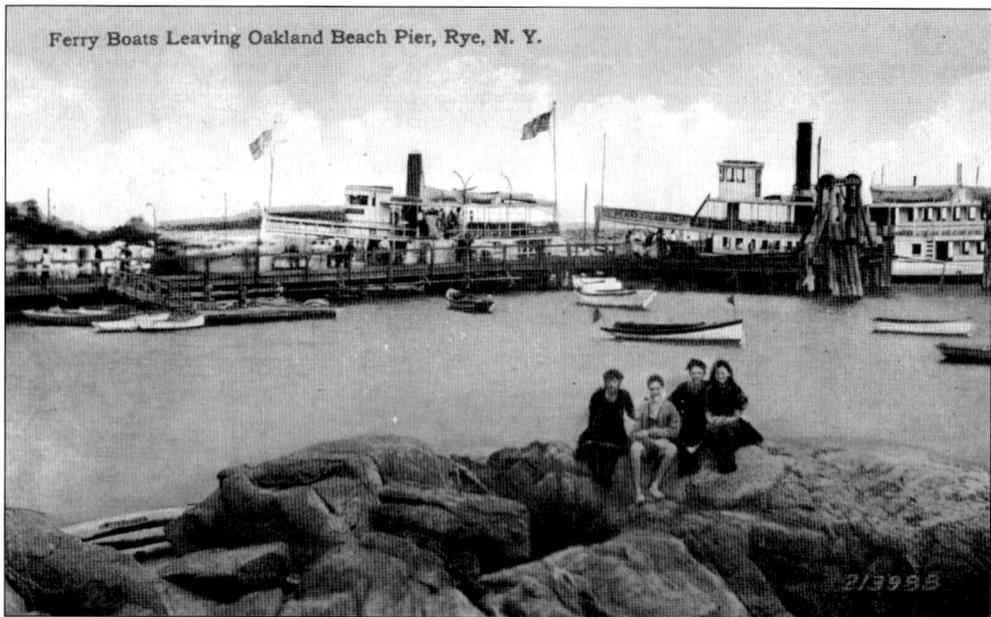

Ferry Boats Leaving Oakland Beach Pier, Rye, N. Y.

The area at the foot of Dearborn Avenue was developed incrementally from the late 1800s to accommodate a growing number of ferries that brought people for the day to the Oakland and Rye Beach areas and its amusement park and inns. Boat times are listed for such ports on Long Island sound as New Rochelle, Mount Vernon, Stamford, and across the sound at Sea Cliff. One such steamer is shown arriving, below, disgorging its passengers for a day of fun.

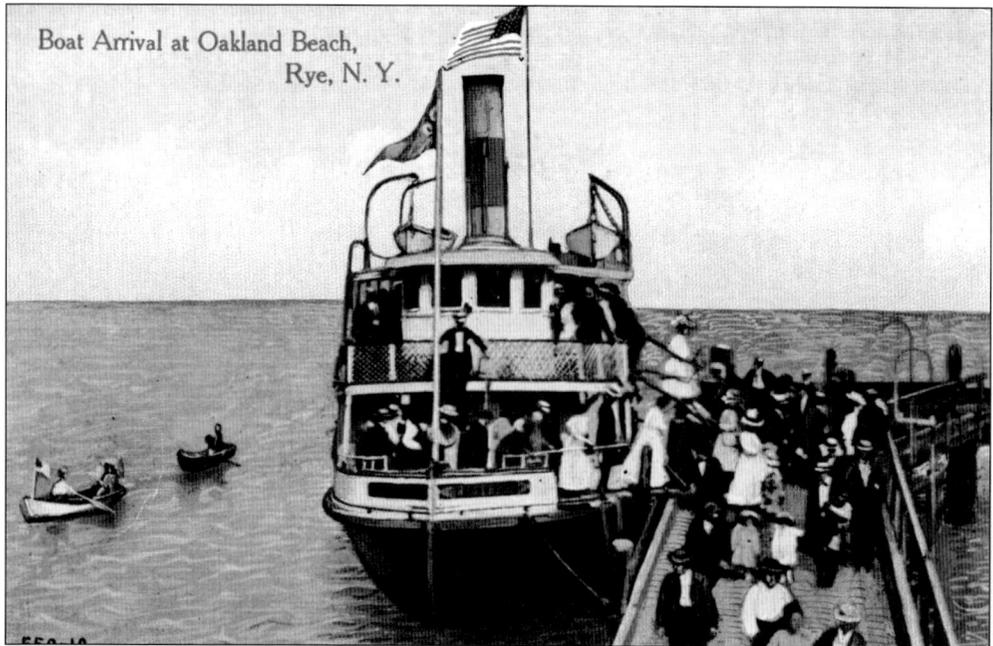

Boat Arrival at Oakland Beach, Rye, N. Y.

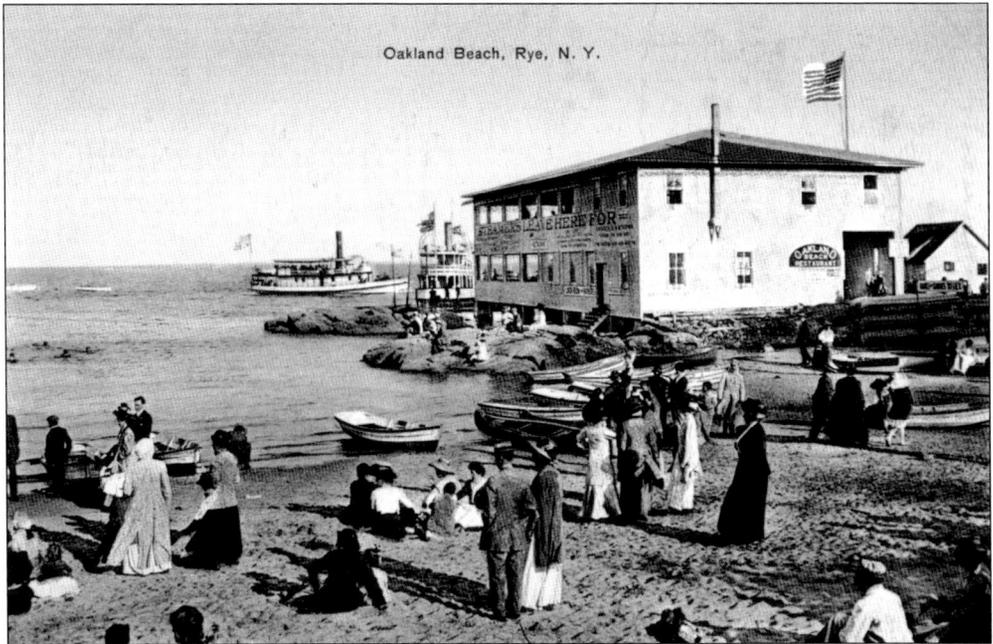

Oakland Beach, Rye, N. Y.

As the view above shows, the beach next to the dock was filled with people. One can observe the clothes worn in the early 1900s, a mixture of Sunday dress and bathing attire of the extremely modest type. Signs on the pier indicate the presence of a lunchroom. Oakland Beach extended to the north above the piers, and the view below shows it early in the 20th century before the Oakland Pavilion was built. The large structure in the center is for lockers and changing into a bathing costume. Just to the right is the start of the bungalows and tents.

Pavilion and Bath Houses, Oakland Beach, Rye, N. Y.

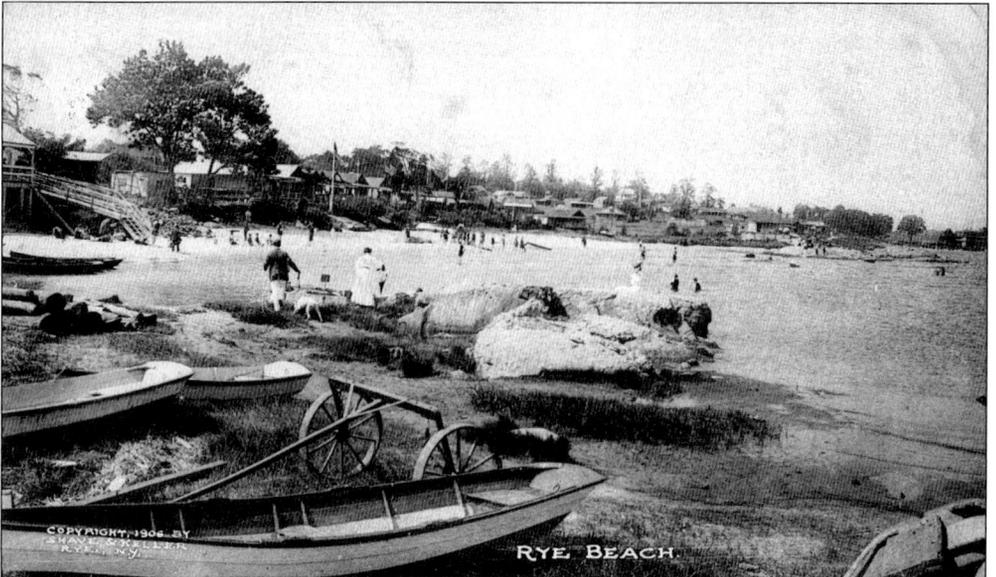

RYE. N.Y. 11, 14, 06 Dear Genevieve, Received letter and shall answer soon. Cannot be with you all at Thanksgiving ... Affectionately Mamie.

The rent for Augustus Halsted's bungalows ran $60 to $90 a year. There were about 200 of them, accommodating some 900 people. The Seventh New York Regiment had a row of tents near the beach. Renters came from a wide area, including New Jersey, New York City, and Long Island. Many of the cottages had fanciful names, such as Gitchee Gumee, the Roost, San Souci, and the Rest. The beach was available to the renters, as shown in these views. See page 122.

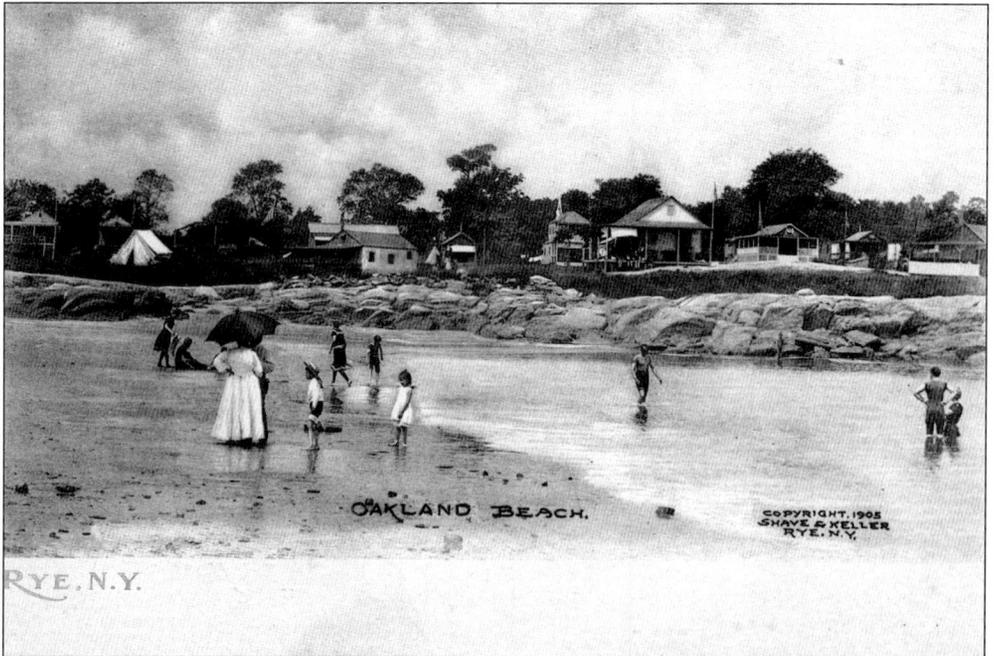

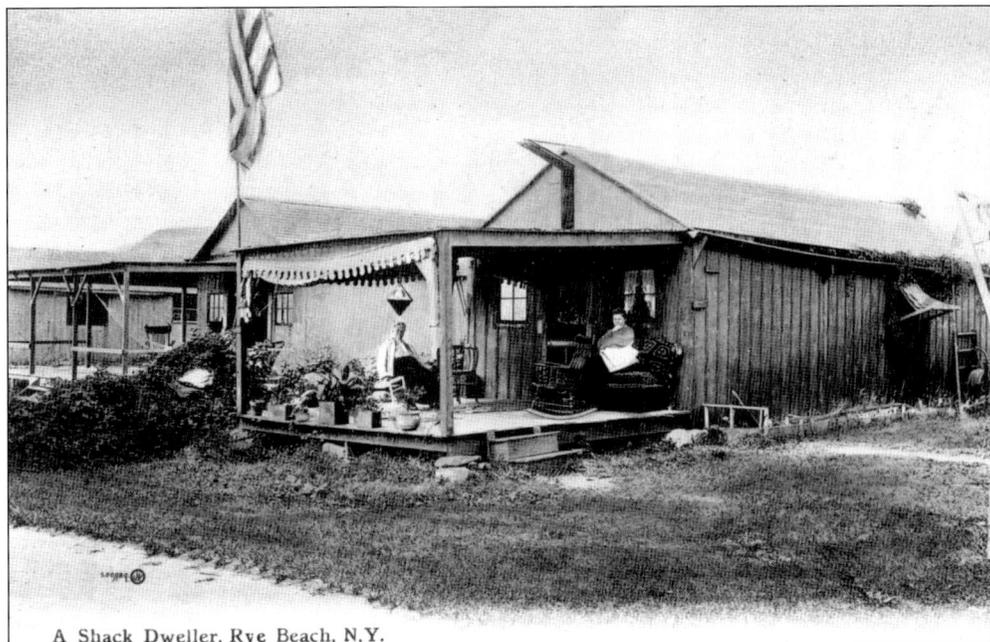

A Shack Dweller, Rye Beach, N.Y.

Here is a lovely view of one of the many bungalows on Halsted's property. One might long to join the two ladies on the porch today. Leisure is not what it used to be. Perhaps the term *shacks* is not pejorative. Some of these were rented to Rye residents, who then rented out their more substantial houses for the summer.

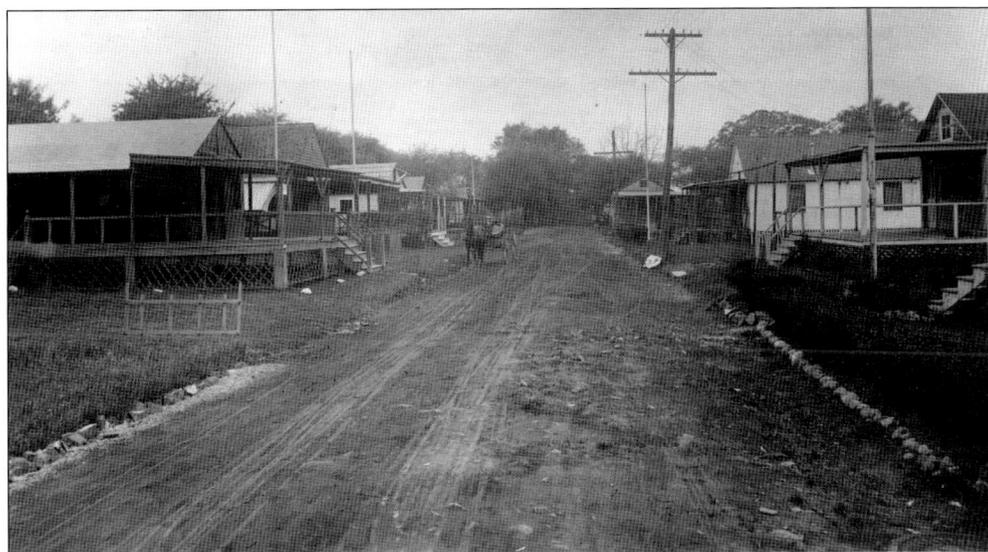

P1999 Bulkley Manor, Rye, N. Y.

When Rye Town Park was created in 1909, the Halsted property was cleared of its bungalows. These were moved to various locations close by, creating new streets. The move was easy as there were no basements. Many of the shacks of those days have been greatly improved and today are year-round houses. One of the streets to which the structures were moved is Bulkley Manor (named after Josiah Bulkley, the creator). Please see page 123.

79

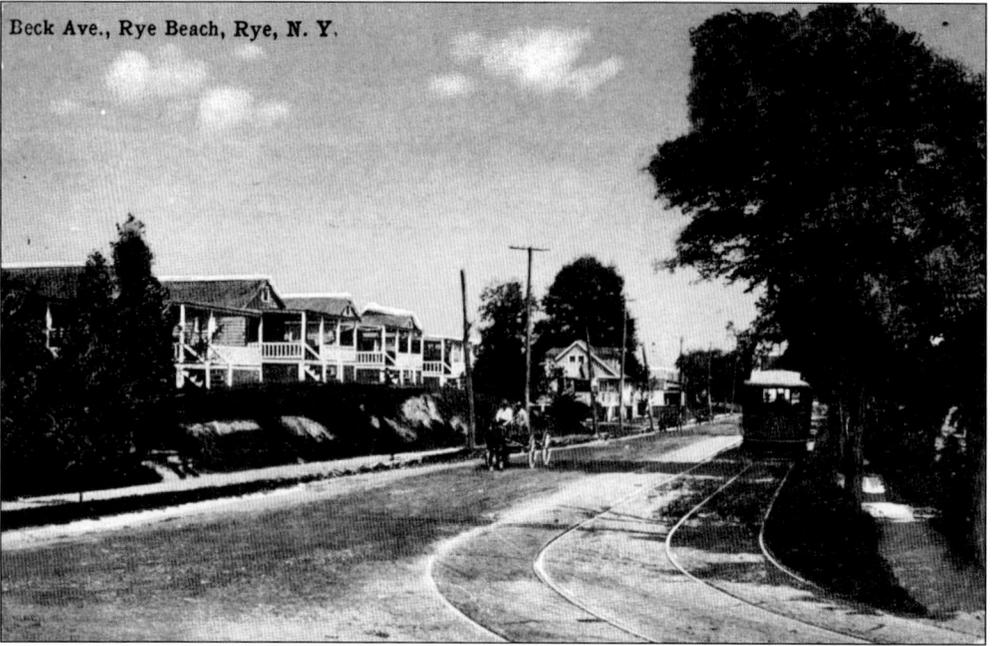

Beck Ave., Rye Beach, Rye, N. Y.

One stretch of summer bungalows did not have to be moved—Ward's Park, lining Beck Avenue, as shown here. Over the years, these bungalows were also winterized and modernized and still exist on Beck Avenue (for example, 21 Beck Avenue). At one point, the National Trust for Historic Preservation took an interest in the designs of all these bungalows, with their distinctive features of exposed rafters and tile roofs. Note the trolley line in the view above. This ran along Meadow Street to an amusement park that had an entrance and turnaround at the foot of Beck Avenue. See the map on page 125.

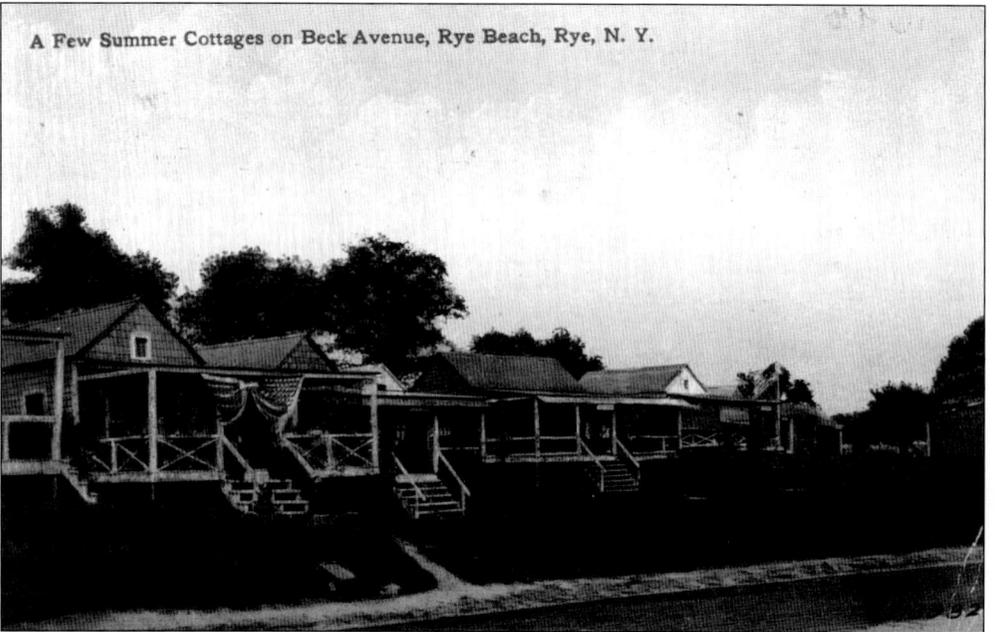

A Few Summer Cottages on Beck Avenue, Rye Beach, Rye, N. Y.

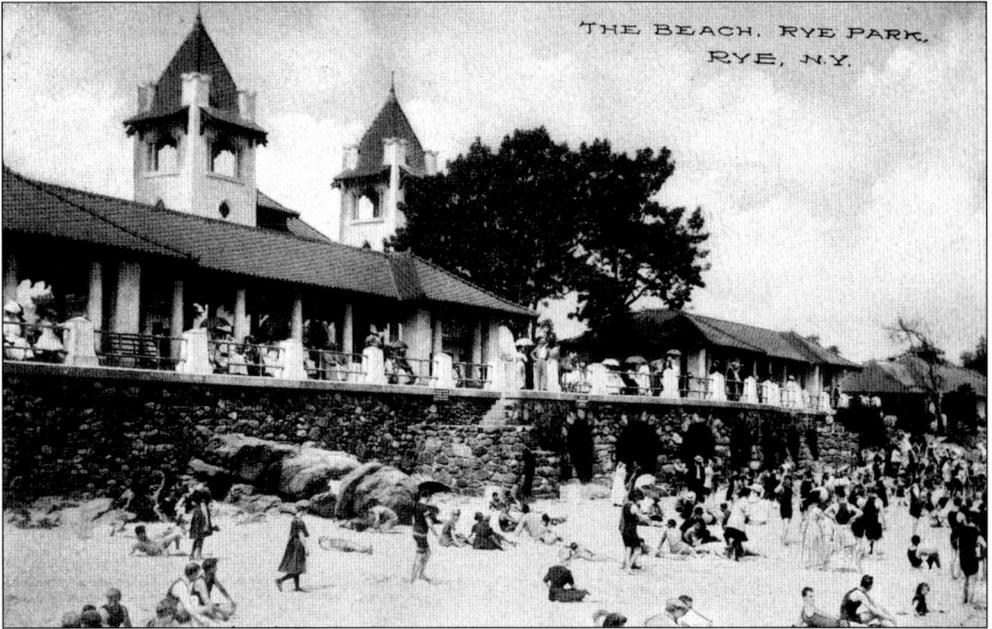

THE BEACH. RYE PARK.
RYE, N.Y.

Major change of Rye's waterfront came in 1909 with the construction of the Oakland Pavilion and Rye Town Park on the site of the Augustus Halsted bungalows shown above. The change was destined to be long lasting—the scenes shown here can be seen a century later. The base stonework is still identifiable. Rye residents in the early 1900s proposed that the town of Rye (then encompassing the villages of Rye and Port Chester) acquire the Halsted property and create a park in part to get rid of the eyesore bungalow crowds. After a lot of political machinations, the land was bought. These pictures show the Oakland Pavilion portion of the development at the southern end of the park where it touches Dearborn Avenue. See page 123.

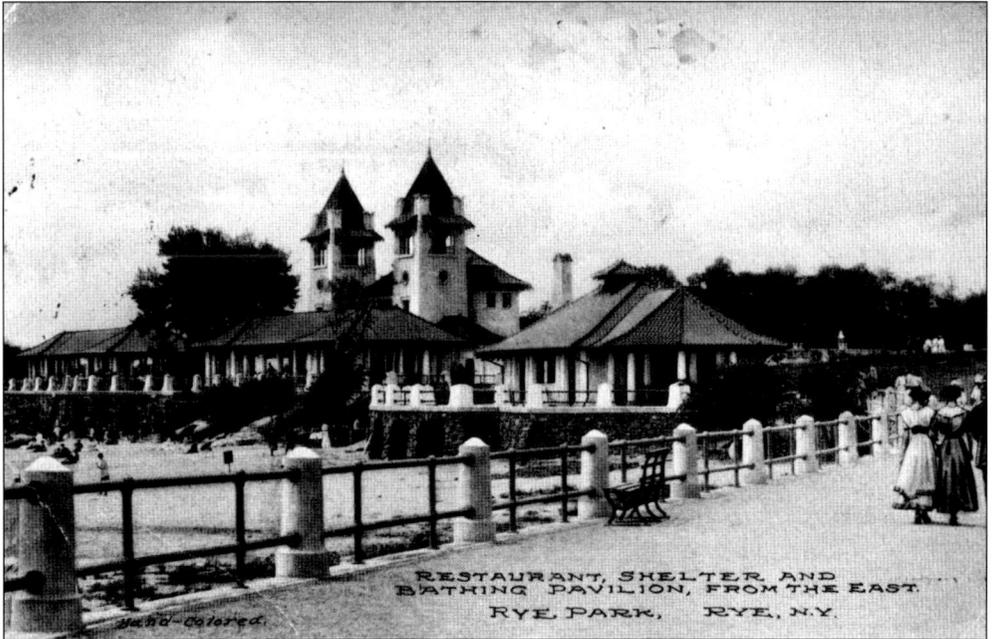

RESTAURANT, SHELTER AND BATHING PAVILION, FROM THE EAST.
RYE PARK, RYE, N.Y.
Hand-Colored.

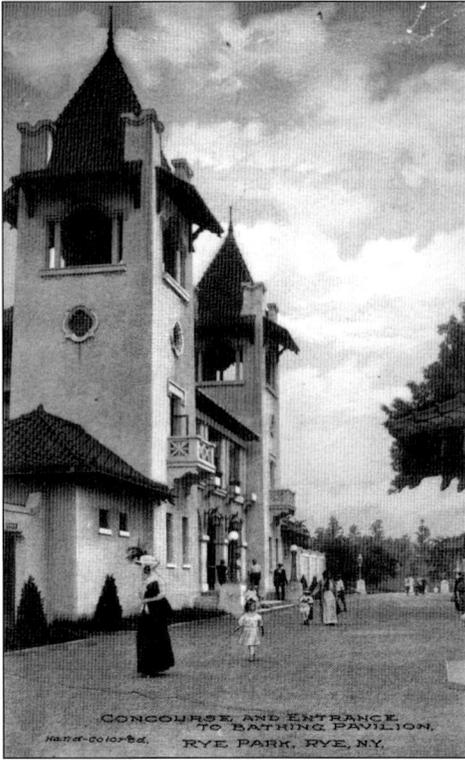

CONCOURSE AND ENTRANCE
TO BATHING PAVILION,
Hand-colored. RYE PARK, RYE, N.Y.

The Oakland Pavilion, illustrated in the two views here, was built in 1909. Upjohn and Conable, the architects, adopted a Spanish mission style, or something approximating it. The structure itself is dominated by two towers, pictured at left. In the front of it was a restaurant, and behind the main building and stretching up to Forest Avenue were wooden bathhouses, now torn down. In the decades following the construction of the Oakland Pavilion, the automobile arrived, as shown in the view below of the entrance from Dearborn Avenue. By then, the place was being run by J. P Manger, who modestly called it the handsomest bathing pavilion in the country.

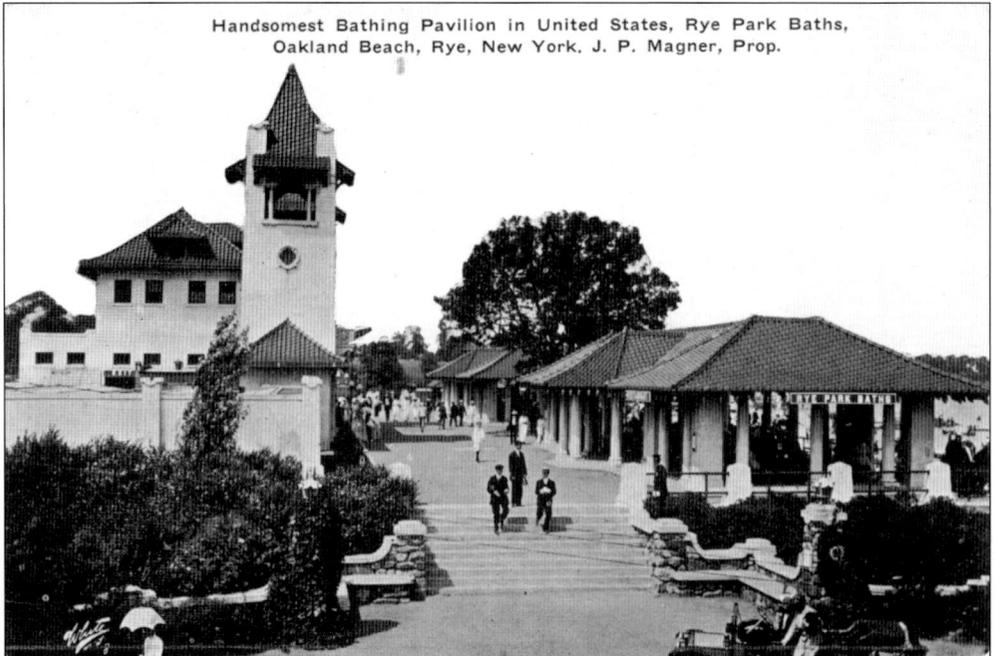

Handsomest Bathing Pavilion in United States, Rye Park Baths, Oakland Beach, Rye, New York. J. P. Magner, Prop.

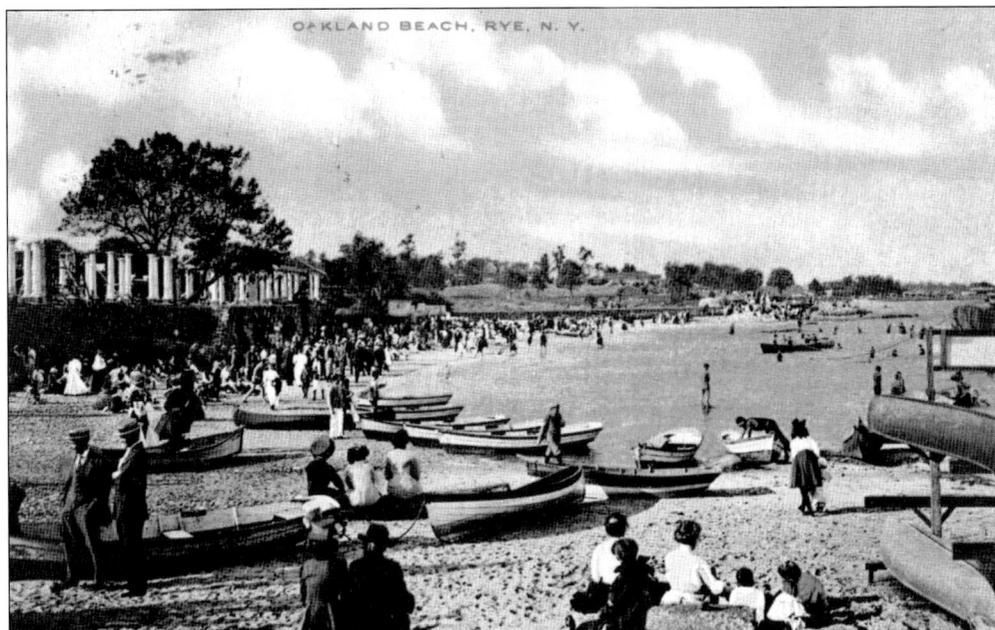

This view is of special interest as it shows the colonnade portion of the Oakland Pavilion under construction. The roofs have yet to be placed on. The picture is also noteworthy as it shows a large amount of rowboats, which were popular at the time. In the distance is Rye Beach with its amusements.

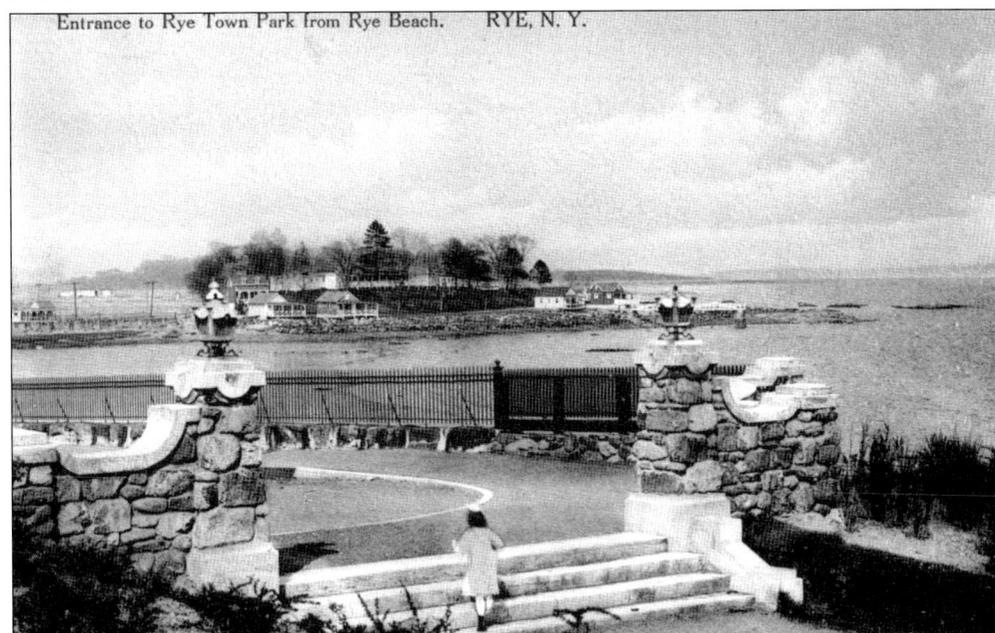

Entrance to Rye Town Park from Rye Beach. RYE, N. Y.

Pictured here is another entrance from the south to the Oakland Pavilion and Rye Town Park. The stonework still stands a century later. The tot has moved on. Of great interest is the far view, which shows the hotel at the north end of the shore and various bathing shacks. Seen beyond that is the southern end of Manursing Island, which is where the Rye founders arrived in 1660.

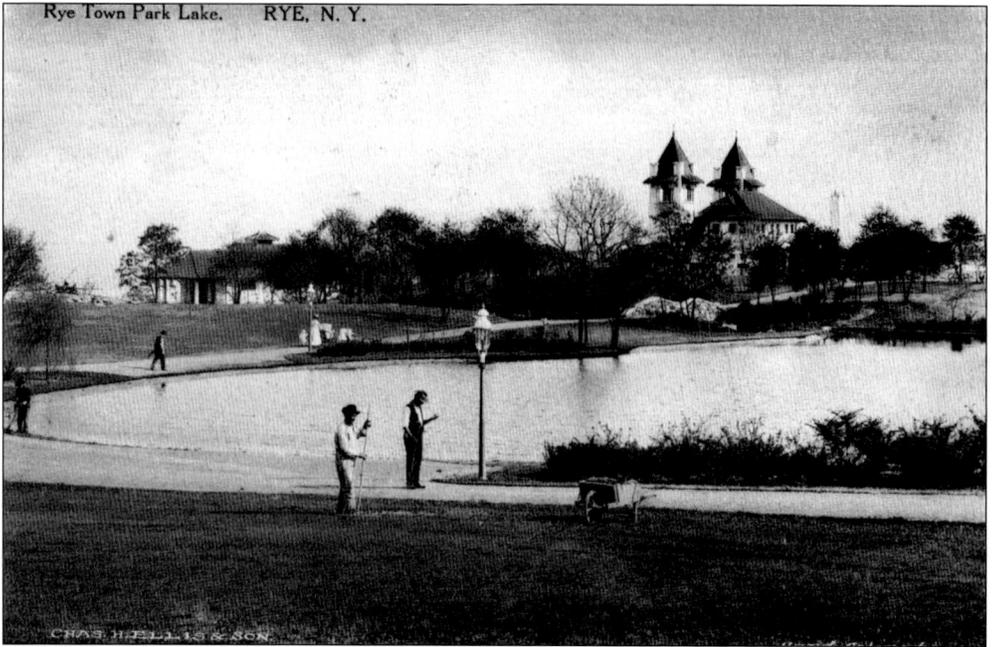

Rye Town Park Lake. RYE, N. Y.

Rye Town Park was created in 1909 by clearing Augustus Halsted's cottages, 62 acres in size. It was the first public park in the county along Long Island Sound. The park was laid out with many walks above the beach and in the interior (see pages 123 and 124). In the view above is the large pond in the middle of the park in the foreground. Wanting to get some action in the picture, the photographer got some workers posed. Below is a view from the 1930s showing the feeding of the ducks that lived in the pond year-round. Over the years, the pond shrunk in its outer dimensions, but after 2000, it was restored to its former size.

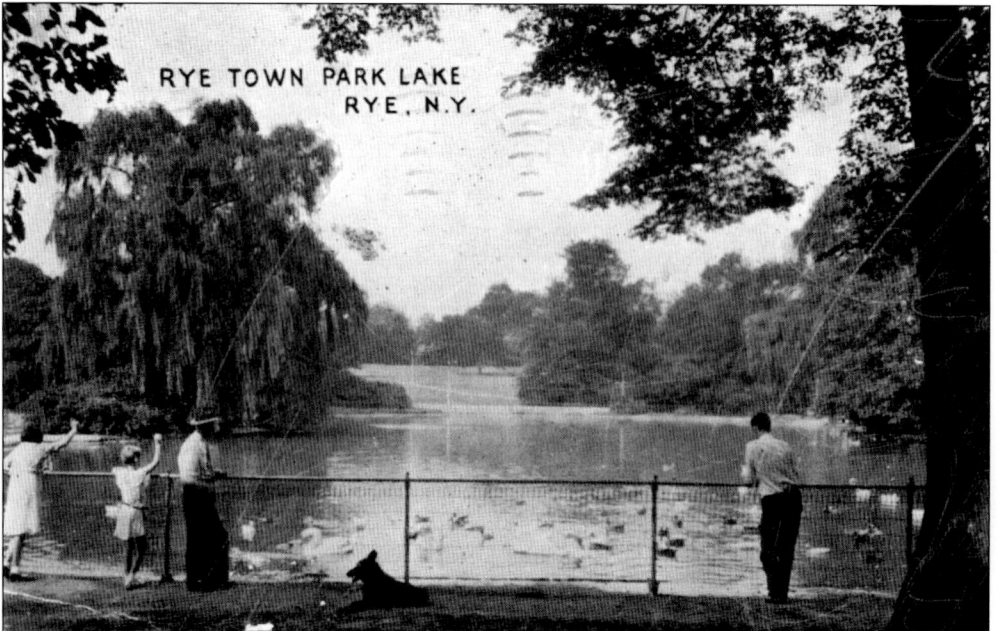

RYE TOWN PARK LAKE
RYE, N.Y.

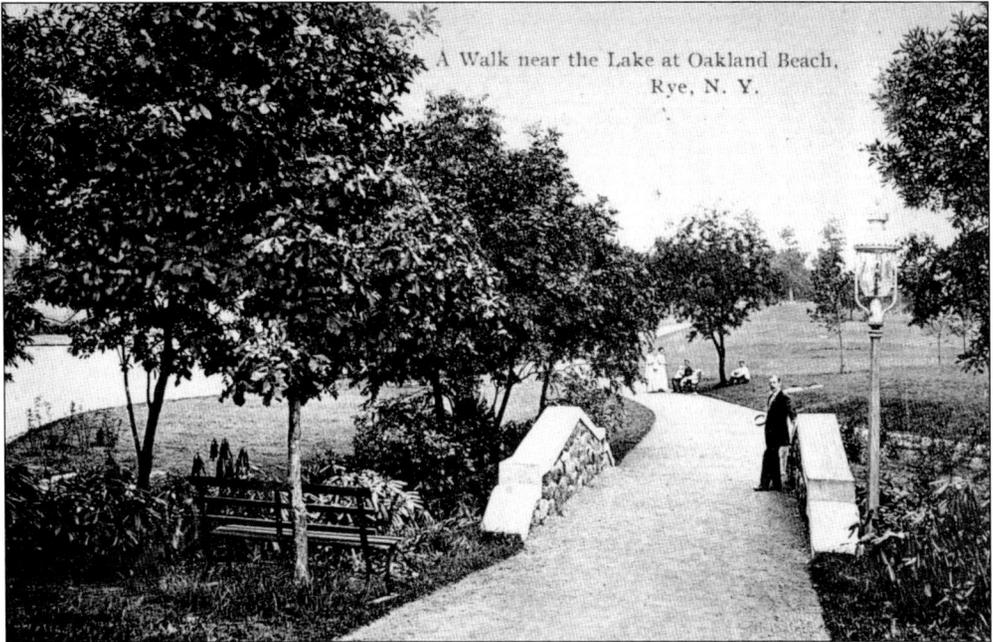

A Walk near the Lake at Oakland Beach,
Rye, N. Y.

Here are two more views from Rye Town Park. Above is a gent resting on a little bridge soon after the park was created. Below, in a view from around 1924, a youth is getting a drink of water. The fountain building still stands, as does the bridge, but there are no longer any bubblers. Since 1942, when the City of Rye came into being, the park has been managed jointly by officials from Rye, Port Chester, and Rye Town. Oakland Beach is part of Rye Town Park, and one has to pay today to park a car and enter the beach, but the park area itself is open to all.

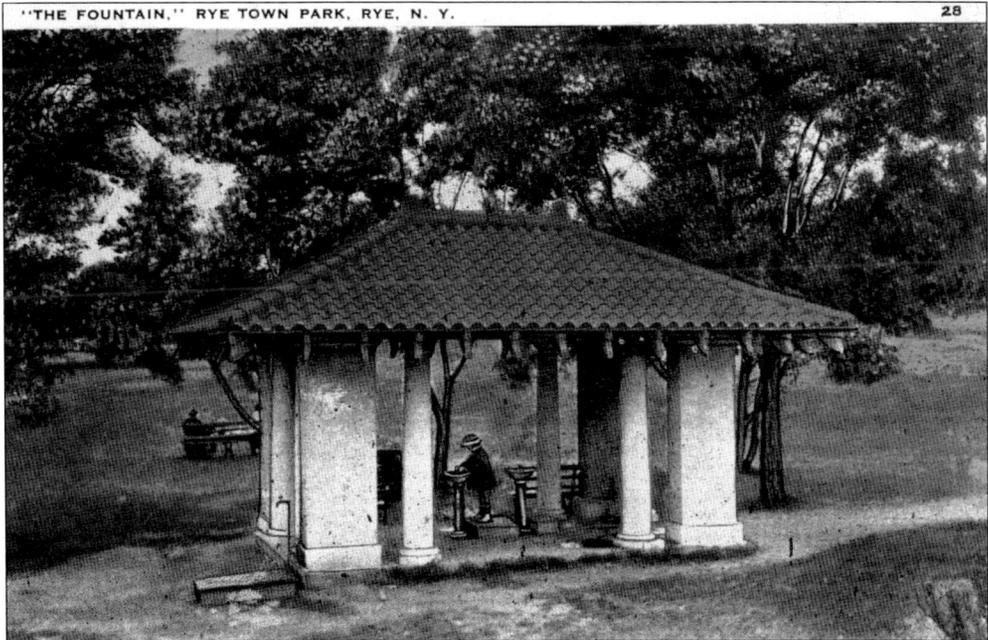

"THE FOUNTAIN," RYE TOWN PARK, RYE, N. Y. 28

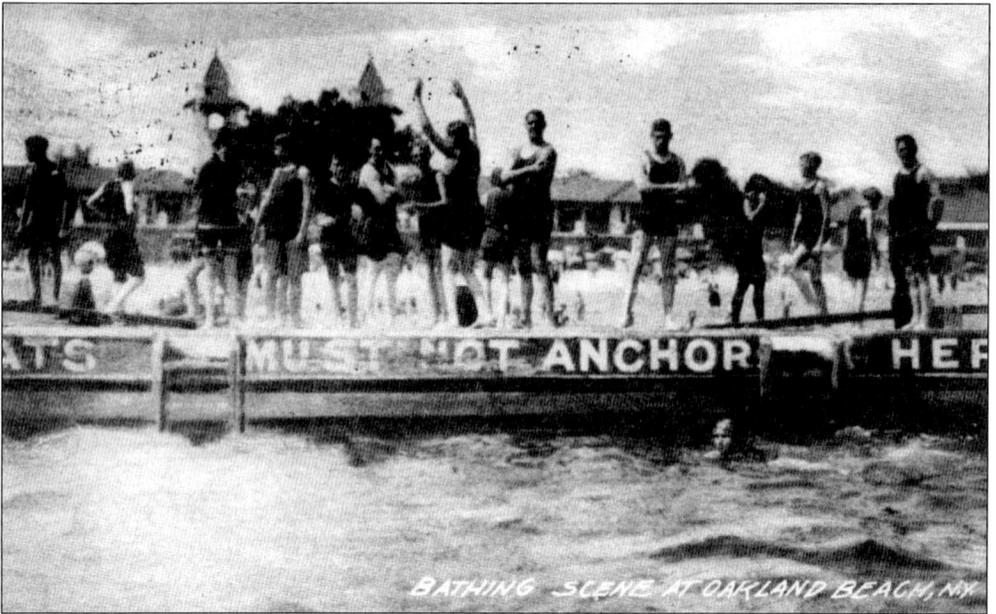

BATHING SCENE AT OAKLAND BEACH, N.Y.

After Rye Town Park was created, a pier for swimming and for landing smaller boats was developed farther north from the one at Dearborn Avenue. This view is from 1922, and the Oakland Pavilion is in the background. One may note that bathing costumes have become a little less prudish, but men still had to cover their chests.

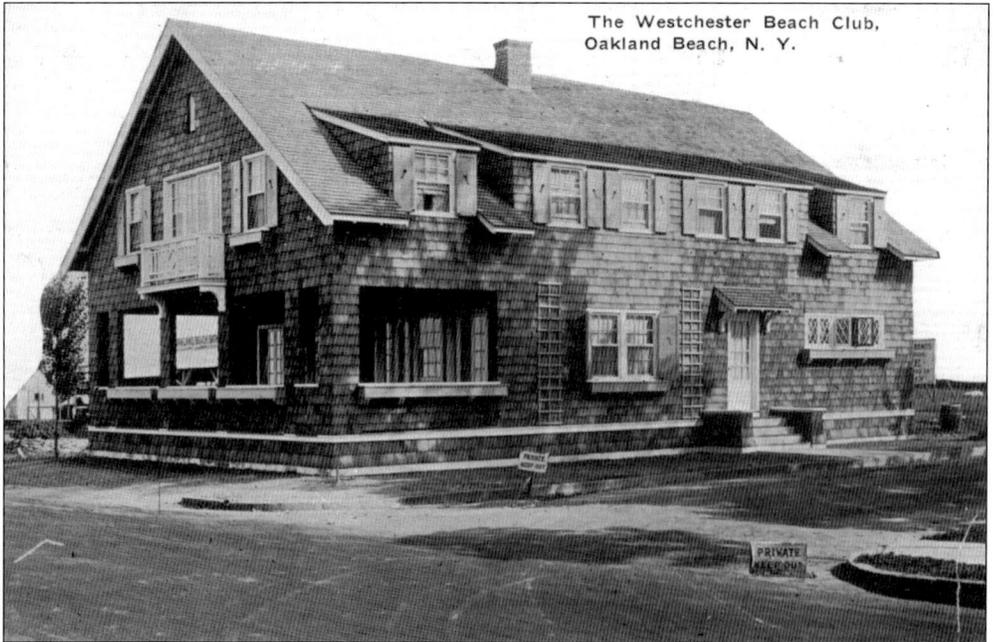

The Westchester Beach Club,
Oakland Beach, N. Y.

On Dearborn Avenue was the Westchester Beach Club (not to be confused with a later Westchester Beach Club on Manursing Island). The private club offered seven sleeping rooms, separate locker and shower rooms for men and women, and a large dining room—all according to information on the back of this card. It is now a private home at 124 Dearborn Avenue (see page 123).

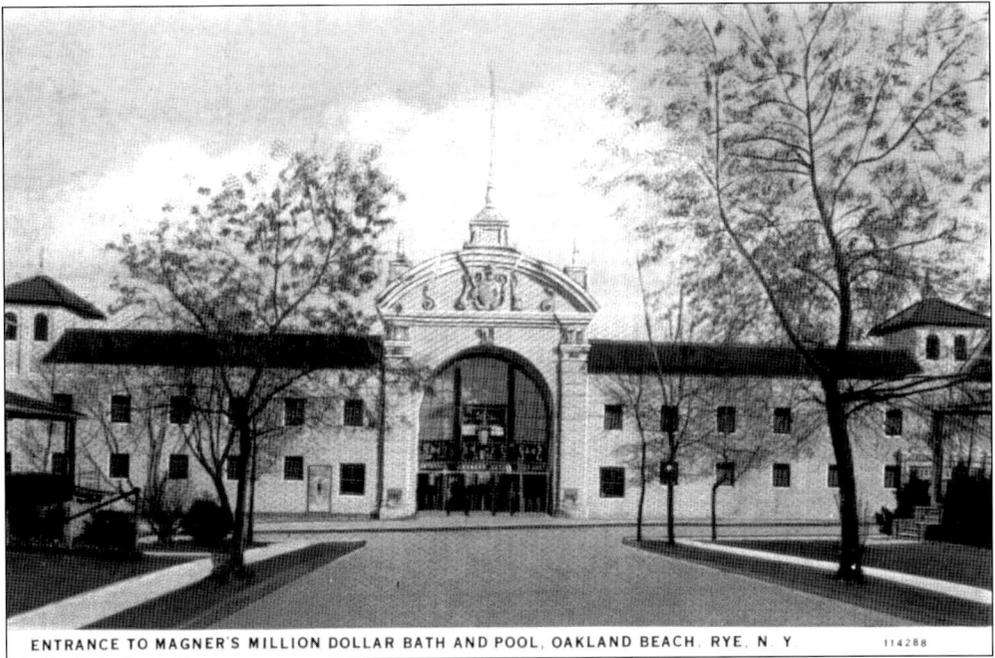

As time passed, a major, new development appeared at the southernmost end of Oakland Beach south of Dearborn Avenue (see page 125). In 1928, J. P Manger opened his "Million Dollar Bath and Pool." It contained a giant swimming pool (advertised as the biggest in the East), as shown in the view below. The establishment also had courts for basketball and handball, as well as a space for dancing. It had a high diving board, and Johnny Weismuller and Buster "Flash Gordon" Crabbe led exercises. Crabbe liked the place enough to become a Rye resident for awhile.

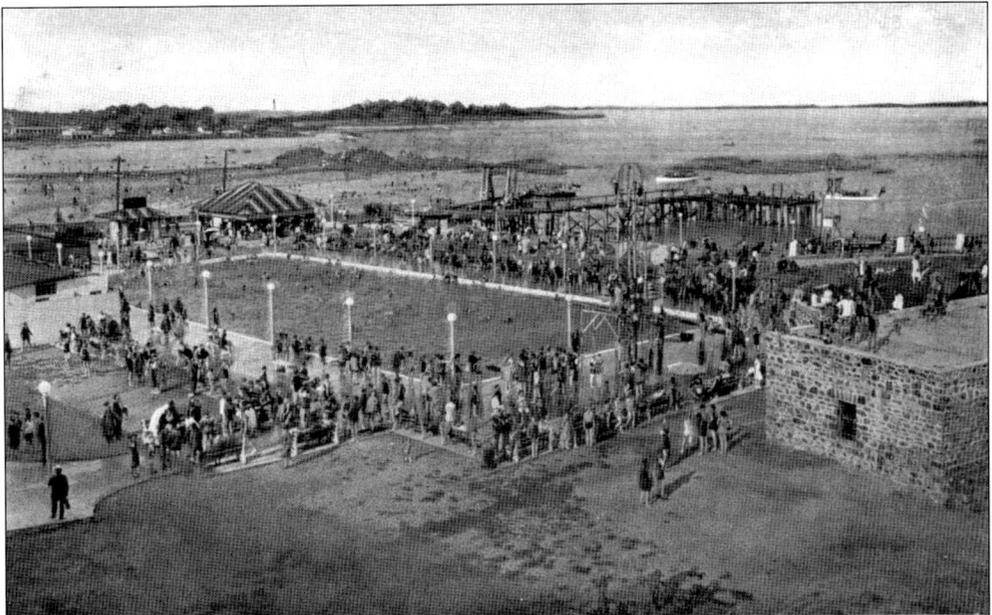

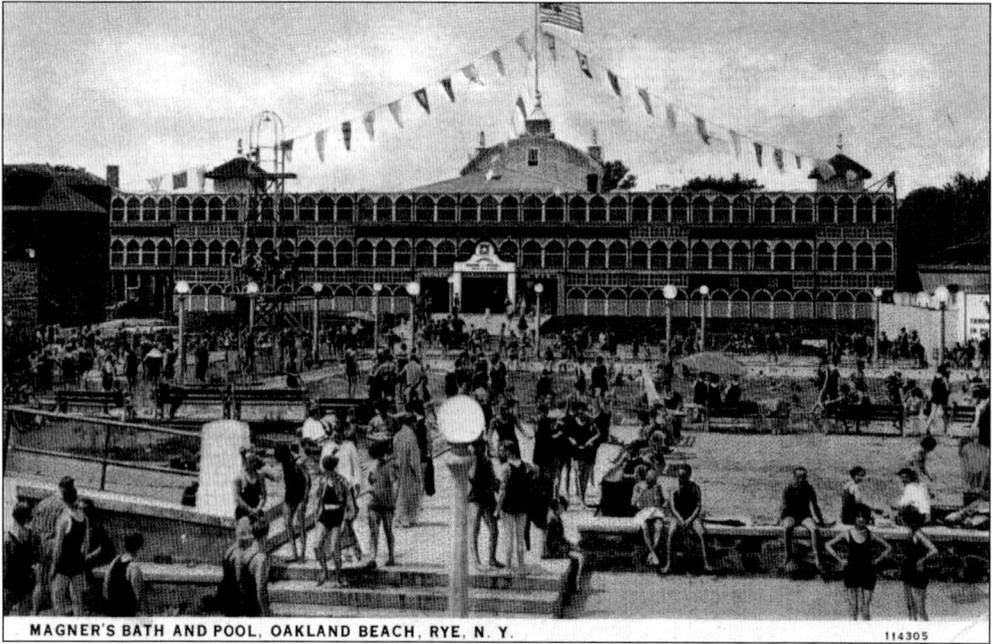

MAGNER'S BATH AND POOL, OAKLAND BEACH, RYE, N. Y. 114305

J. P. Manger ran the pavilion just to the north of his new edifice, but he lost control of the pavilion, and perhaps in retaliation he began his "million dollar" bath complex. He ran it profitably, but new owners came along, and over time the complex became run down. Eventually the baths came down in 1968 and were replaced, as shown below.

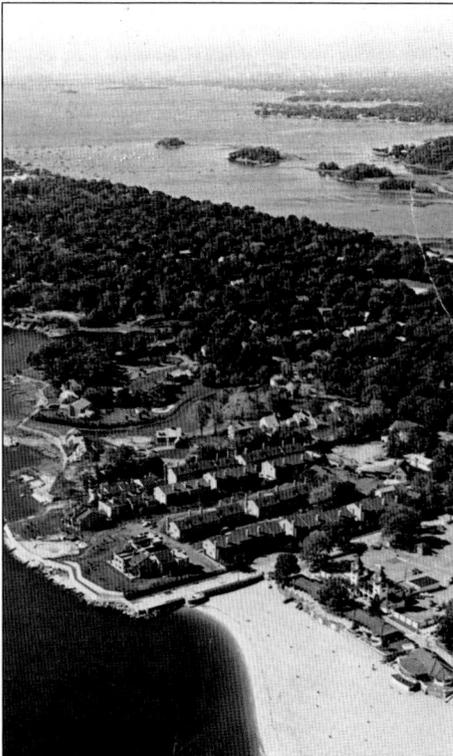

In the place of Manger's baths and related structures came condominium development, Water's Edge in the late 1970s. This aerial view, looking southwest, shows the development in the center, and to right are the Oakland Pavilion and Rye Town Park. Above to the left is a large stretch of Milton Point; just beyond the inlet is where the Ford estate sat. Beyond that is the outer reach of Milton Harbor and Hen Island.

Eight

RYE BEACH, INNS, AND RESTAURANTS

Rye Beach, a strip about 1,500 feet long, had a varied entertainment history. There have been three amusement parks, hotels, restaurants, dance hall casinos, theaters, and bathing pavilions. And in its early history, it was used for horse racing on what was known as the flats. All of this was swept away in 1927 when Playland was built, as shown in the maps in the end of the book.

Along the shore ran Rye Beach Avenue, which over time became known as Auto Boulevard because of its use. Even before the dawn of the 20th century, small hotels and inns began to appear above the beach. The best known of these was Rye Beach Hotel, illustrated here in its various ownerships, which served as a hotel, restaurant, dance casino, roller rink, and bowling alley. While the history of this structure is somewhat confusing, it seems that it began as Rye Beach House before 1872 on a 50-acre plot, which later became an amusement park. See pages 122–124.

Shoehorned between these shorefront buildings were bathhouses. Here one rented a suit and had a place to change for 25¢. In those days, one did not wear swimming clothes when coming to the beach. In addition to these freestanding bathhouses, there were the ones at the Oakland Pavilion and later at Playland. Besides bathhouses, there were dance casinos and a shopping area developed with a drugstore, groceries, and the like. At the northern end of Rye Beach Avenue was a hotel also of long standing, showing up on an 1872 map as Cedar Grove House.

People from communities near and far thronged to the Rye Beach area in ever-increasing numbers. All of this uncontrolled development along the waterfront and the amusement parks behind it ultimately led to public outcry about the crowds and the noise. To resolve the situation, the county stepped in, demolished all of the Rye Beach development, and created Playland.

Rye Beach. Rye N. Y.

North of the Oakland Beach area was Rye Beach, which, from as early as the 1870s, was developing into a row of hotels, inns, and other structures. Indeed, the crowds coming on the ferries were as much intent on going to the inns as they were to the beach. The view above, taken soon after 1900, shows the bungalows to the left, but on the right are the early inns. As time went along, Rye Beach Avenue was extended to run in front of the inns. The scene below shows some houses that lined the curve before reaching the inns. It appears that the milkman has been making deliveries.

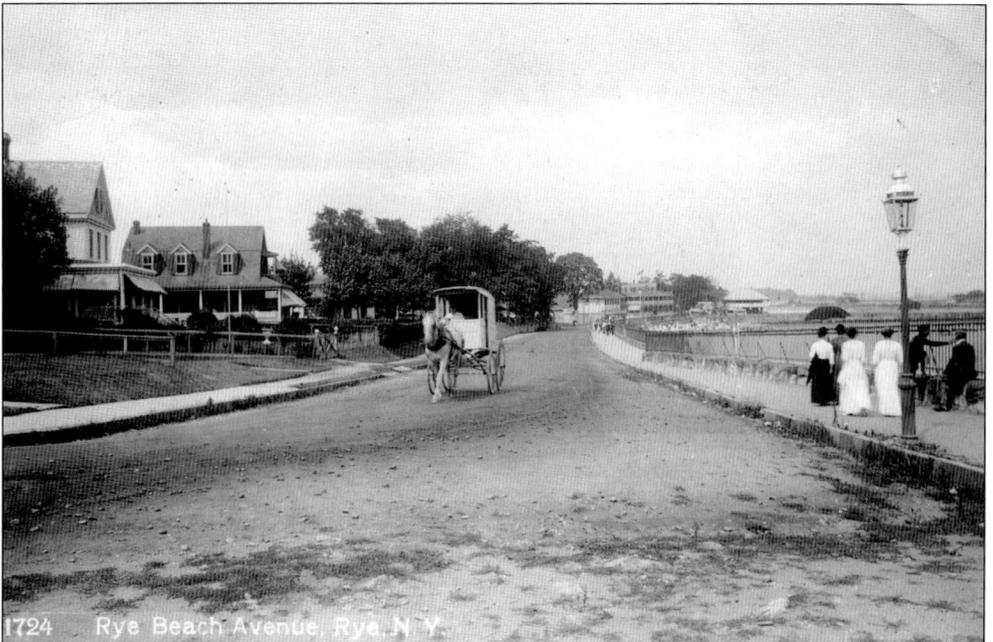

1724 Rye Beach Avenue, Rye, N. Y.

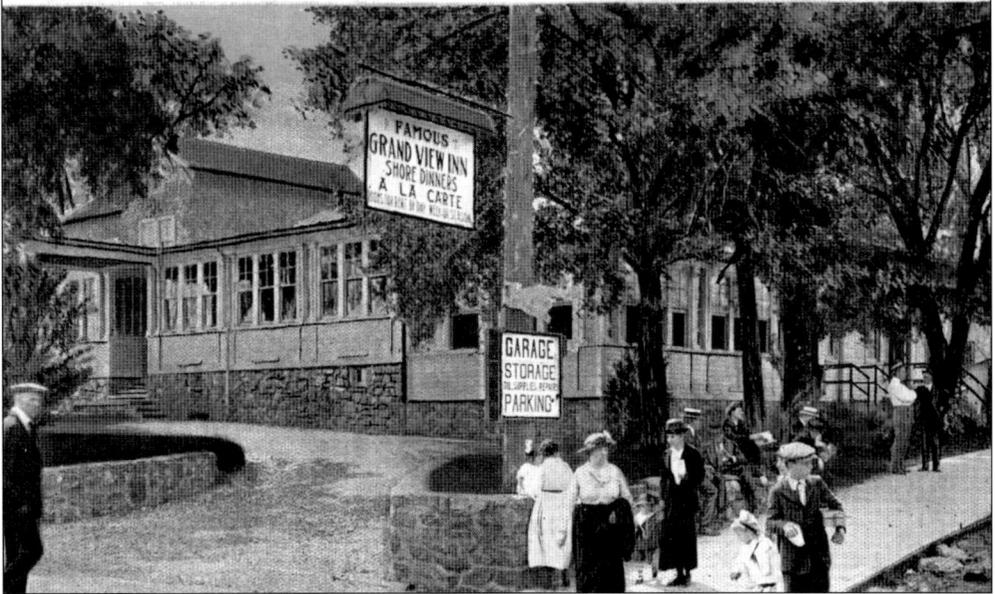

The first inn one would encounter heading north along Rye Beach Avenue was the Grand View Inn (see page 122). Like the other inns, it provided both rooms and meals. Like the other restaurants, it specialized in "shore dinners," or seafood. By the time of this picture, probably in the 1920s, the automobile was the way to arrive, but it was new enough so that one thought in terms of storage, not just parking.

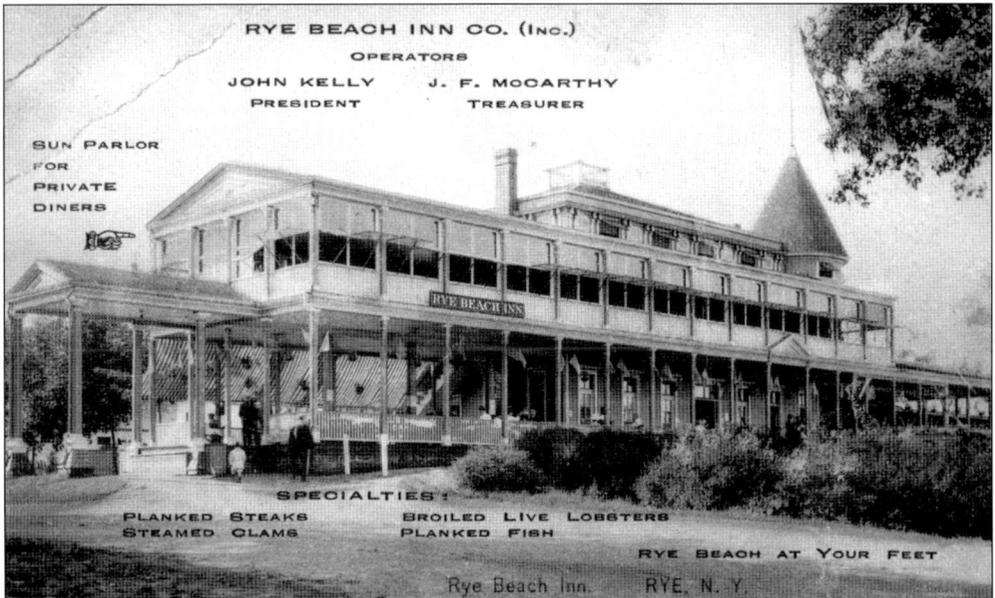

The Rye Beach Inn was for many years a well-known restaurant. Although old maps are confusing, it appears from the views in this book that it stood between the Grand View Inn and Rye Beach Hotel (see page 122). What one might eat is not left in doubt in this picture. The same meal could be ordered in restaurants today. In later years, it was perhaps made into a dance pavilion.

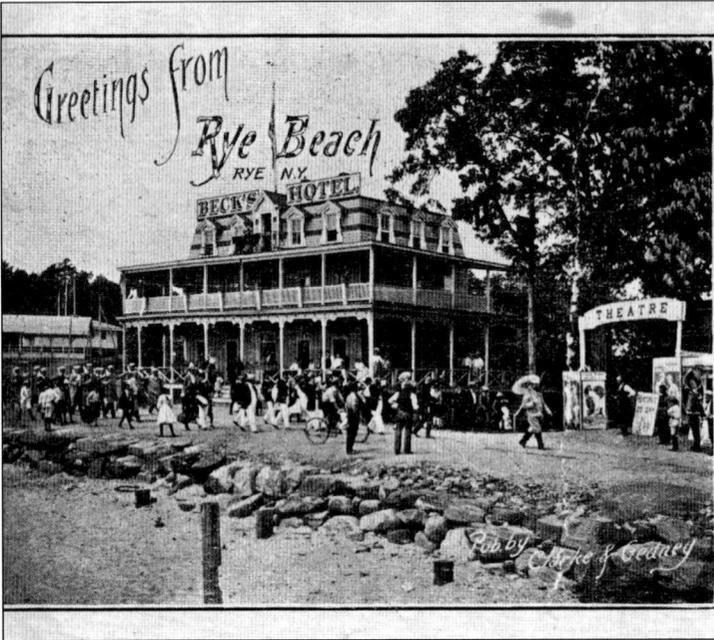

Greetings from Rye Beach RYE N.Y. BECK'S HOTEL THEATRE Pub. by Boyle & Gedney

Hoping you are well with love to Russel N. M

The best-known structure on Rye Beach was the Rye Beach Hotel, and it appears on maps as early as 1872 (see page 122). It was located midway along Rye Beach Avenue at the foot of Beck Avenue. It is pictured below in a beautiful photograph with some summer guests on the veranda. In photographs taken before the postcard era, it lacked the two-story porch. In the early days, it was also known as Becks—owned and operated by William Dixie Beck (who was said to be a Civil War Confederate general), which is how the street got its name. At this stage in its existence, it had a pool hall and a bowling alley. The theater to the right, shown in the view above, was not the same as the one in the amusement park. Also note the parade.

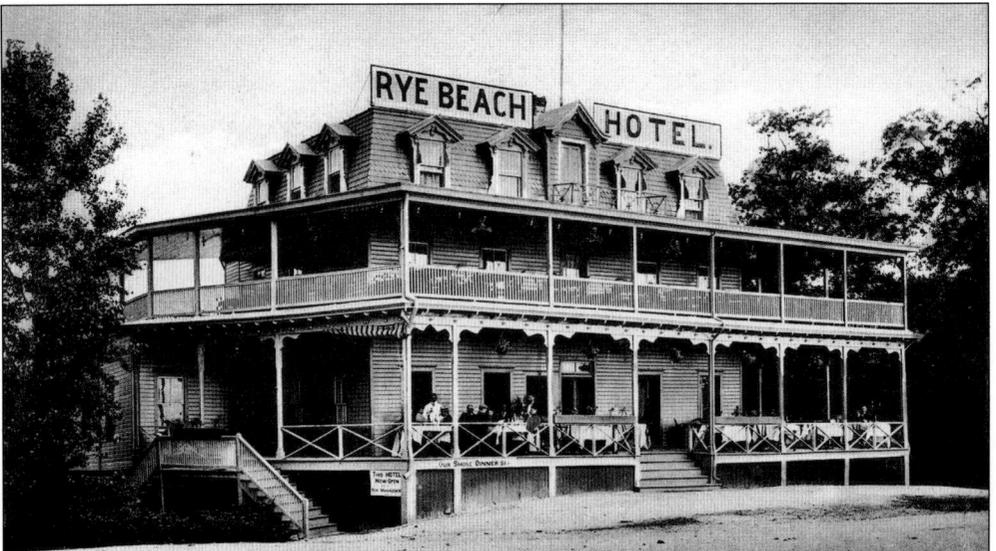

Rye Beach Hotel, Rye Beach, N.Y.

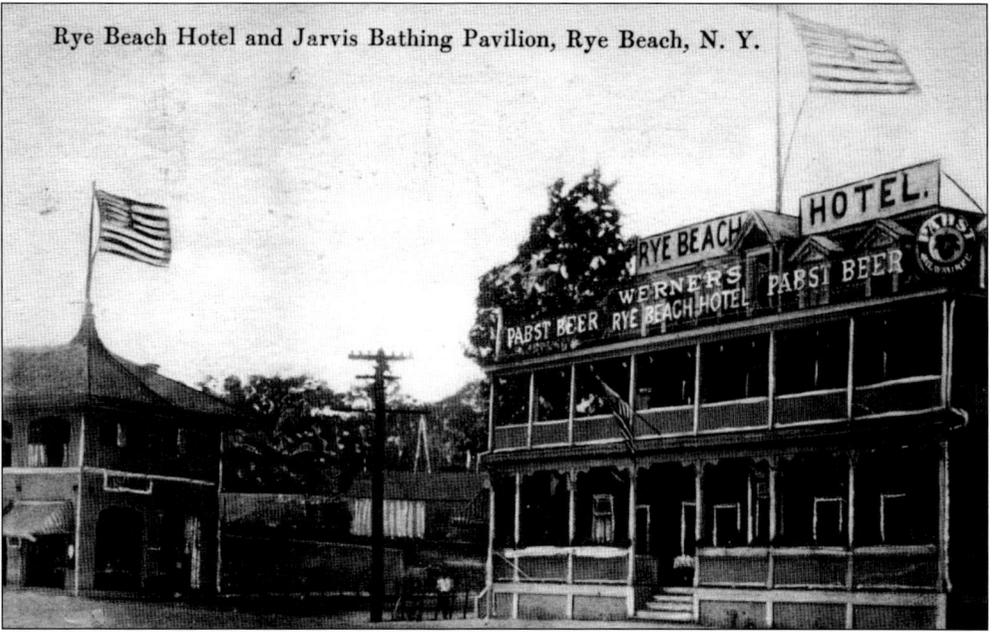

Rye Beach Hotel and Jarvis Bathing Pavilion, Rye Beach, N. Y.

In the 1920s, the Rye Beach Hotel became Werners, seen above, and sprouted some advertising for Pabst Beer. The new name came from manager Richard Werner. In the above view, Beck Avenue is to the left and beyond that is one of the several bathhouses that lined Rye Beach Avenue, this one known as Jarvis Bathing Pavilion (with the ubiquitous American flags drawn on). The scene below portrays a more extended view of Rye Beach Avenue, showing the gradual overcrowding of structures.

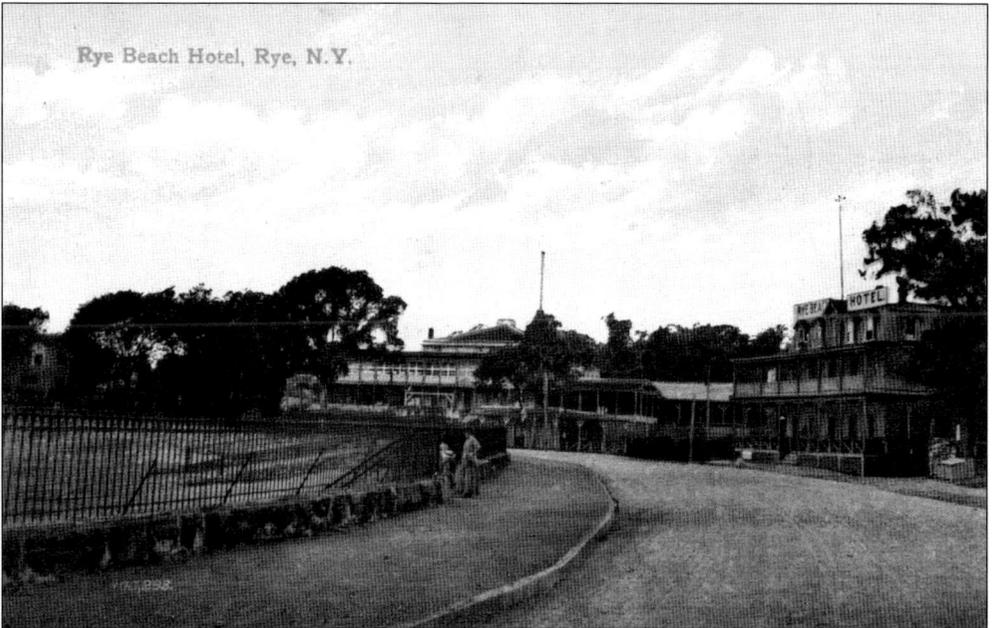

Rye Beach Hotel, Rye, N.Y.

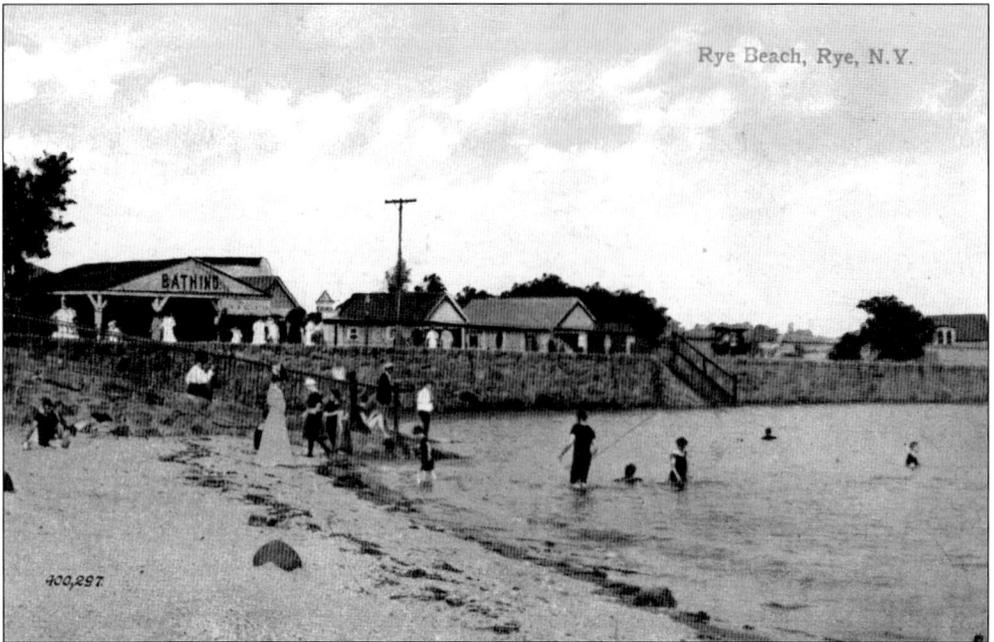

As one moved farther north along Rye Beach Avenue in the era from 1900 to the late 1920s, there were additional bathing houses. Shown above is the Dawani bathing pavilion, also called Big Star, and other small change places. Beyond that was the Cowles property, later to be developed into an amusement park. At this point (before Playland was built), Rye Beach ended, and a stone wall was built on the water side of the road. Below is a 1906 view of the structures at the northern end of Rye Beach Avenue circling around to Edward's on the Hill Hotel.

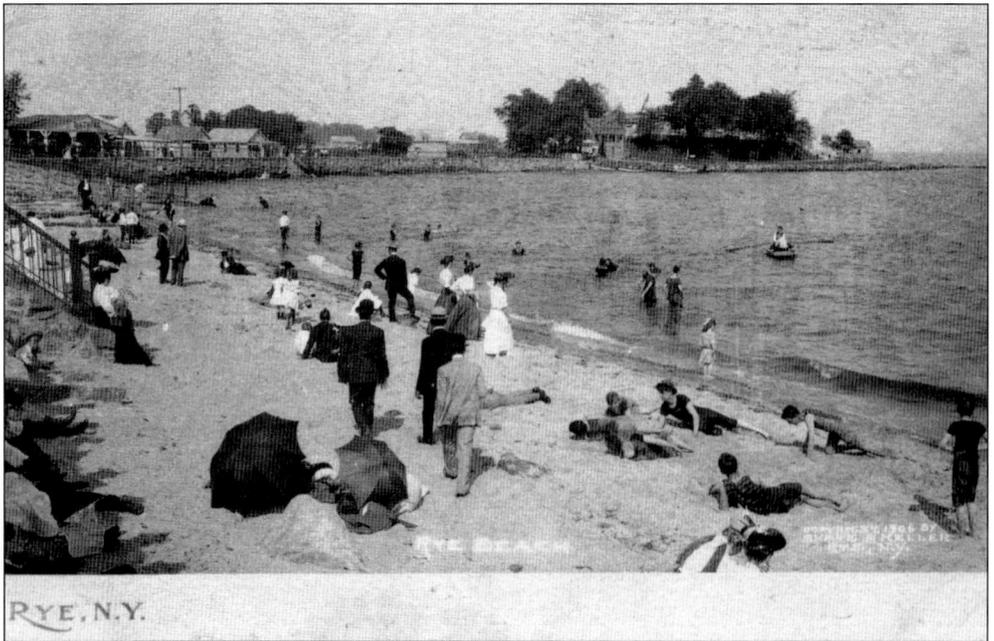

RYE, N.Y.

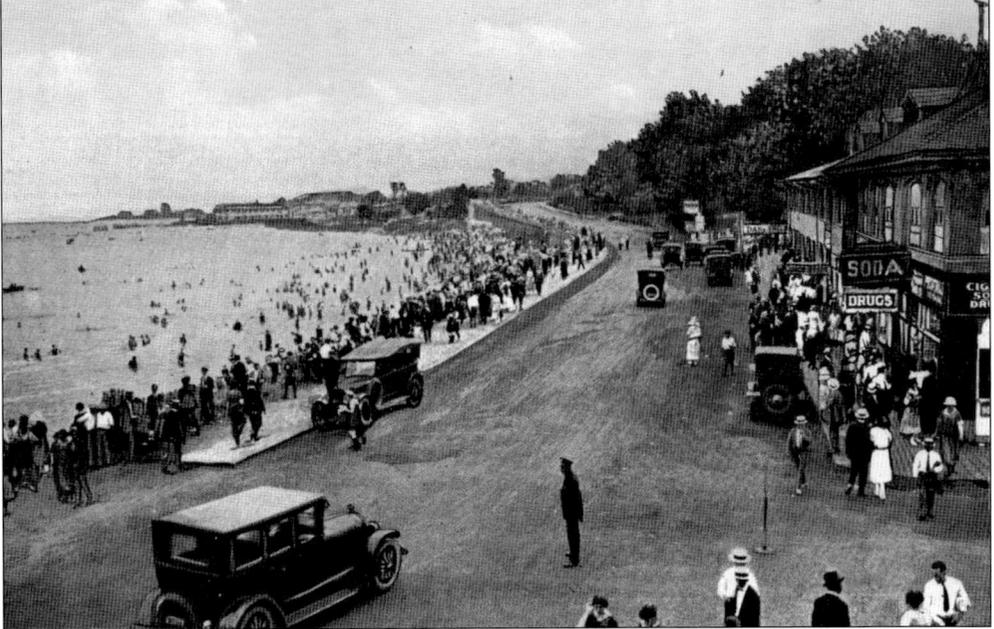

Over time and no doubt leading to its eventual demise, the structures along Rye Beach Avenue degenerated into honky-tonk places. This and the adjacent amusement parks led to public outcries in the 1920s. Even the street was renamed Auto Boulevard, as is illustrated in the view above. These views show quite a change from the beginning of the century. Visible are a drugstore, grocery store, and fruit and vegetable stand. In the view below, the Grand View Inn has gotten rather hemmed in.

Beach Front, Rye Beach, N. Y.

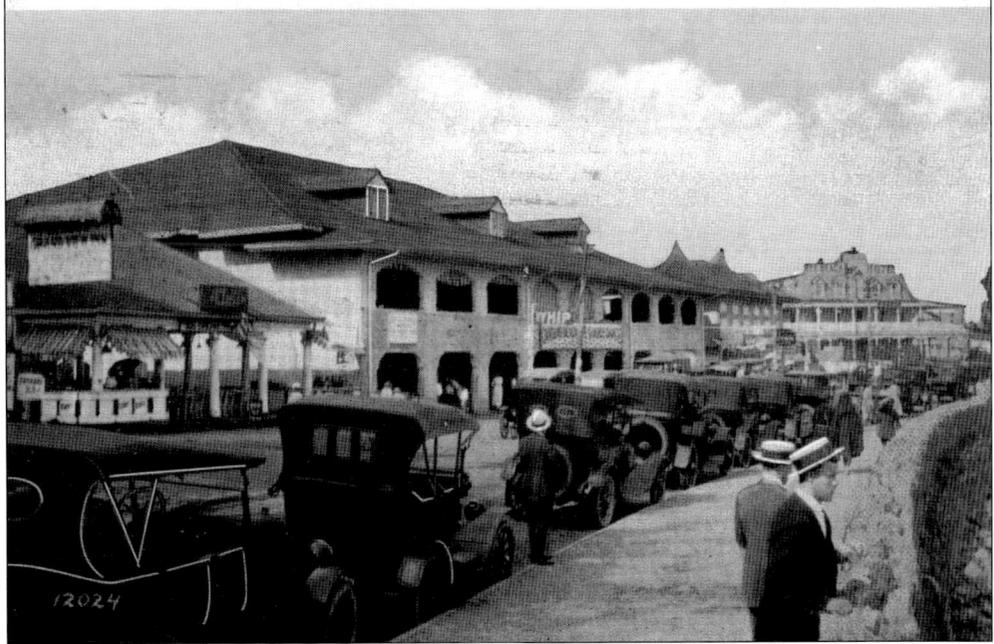

As one came to the northern end of the street and of the mainland (with Manursing Island farther to the north), there was a small hill. On it was Edward's on the Hill Hotel, with predecessors going back to before 1872. Today it is the site of the Playland Casino. The sand beach now at Playland, as seen in chapter 10, can be compared with the rocky area shown here.

Meadow Beach,
Rye, N. Y.

Meadow Beach, long gone, was beyond the tip of land where Edward's on the Hill Hotel sat. The beach was used more by locals than visitors. A float was built in the water by nearby hotel owners and operated under the name of the Rye Beach Club. The area was infamous for its mosquitoes, perhaps in part due to the rear end of it being used as a town garbage dump and sewer system (see page 124).

Nine

EARLY
AMUSEMENT PARKS

The amusement park history of Rye Beach is amply illustrated in the views in this chapter, since it was a major attraction for the postcard sender as well as the public. It began with the Rye Beach Park, also called the Rye Beach Amusement Park, toward the end of the 19th century. As the accompanying maps show, it grew over time to encompass a midway and many attractions. In its early years, it was run by Col. Austin Kelley from Kentucky, who also had another amusement park in Illinois. Later the name was changed to Pleasure Park.

The Rye Beach Park was set just back from Rye Beach. (See the maps on pages 122–124.) It had a midway, numerous rides, and sideshows, not to mention a theater, picnic grove, and dance casino. Its western end was Forest Avenue, and on the north and south, its boundaries were bordered by Beck Avenue and Redfield Street. The main entrance to the area was from Beck Avenue where the trolley from downtown had a turnaround. Later buses brought people from New York City for a day in the park and to picnic and have a swim. There were many rides, including ones for children, such as a merry-go-round, and thrills for adults, including a roller coaster, a Ferris wheel, a waterboat ride, and later an airplane swing.

In 1923, competitors from Port Chester threw up a new park, Paradise Park, just north of Rye Beach Park. (See page 124.) It was built partially on marshy land where the Manursing Gut was filled in. It had an impressive entrance, with rides behind it similar to that of Rye Beach Park. It burned down in 1926 and gave way to Playland Park, which involved even more filling in of land.

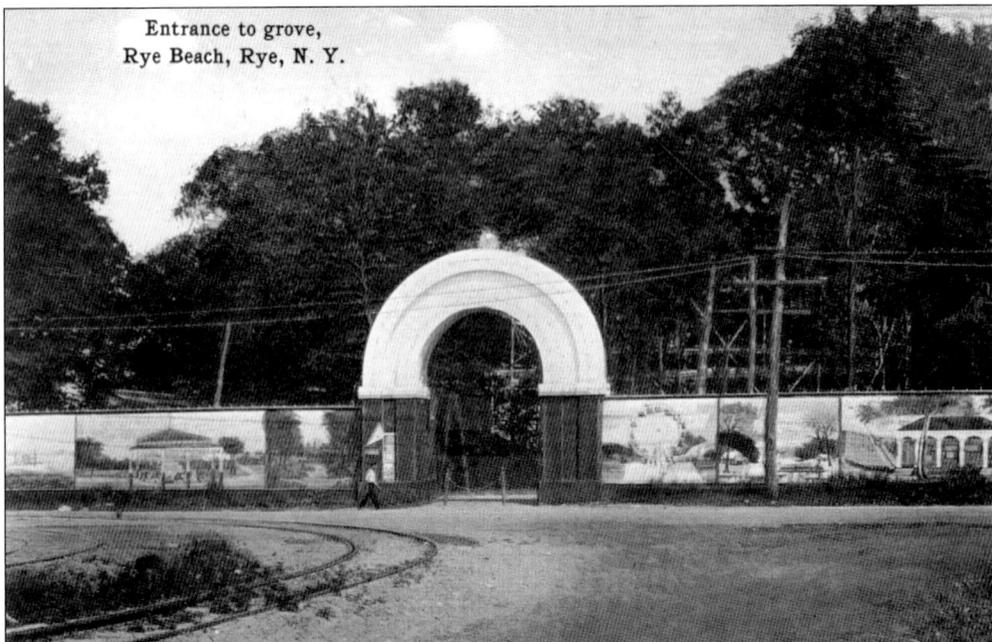

Entrance to grove,
Rye Beach, Rye, N. Y.

The Rye Beach Park was an 11-acre amusement park set just back from Rye Beach. It was begun in the late 1800s and ended in 1927 with its replacement by Playland. The main entrance to the park, above, was from Beck Avenue where there was a turnaround for the trolley. The view below shows a later entrance from Forest Avenue, where one could see "high class motion pictures" at the theater. (RHS.)

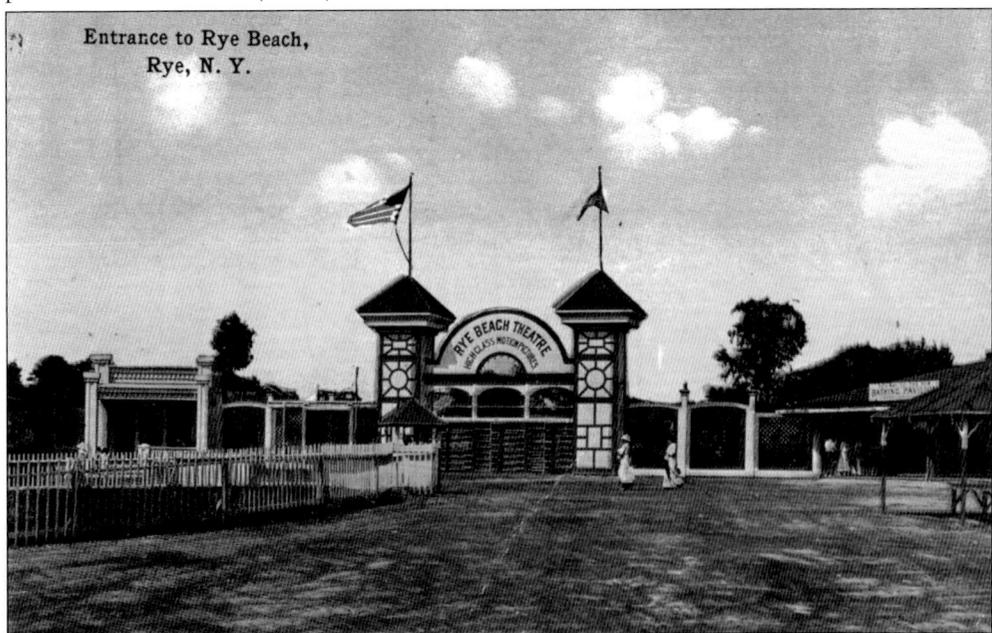

Entrance to Rye Beach,
Rye, N. Y.

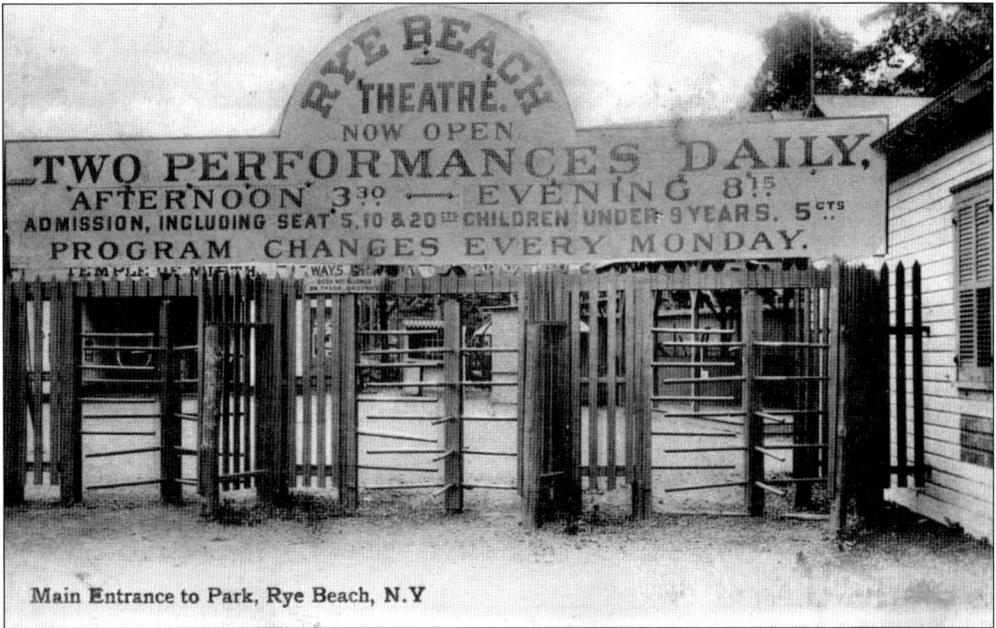

Main Entrance to Park, Rye Beach, N.Y

A major attraction at Rye Beach Park was the theater. Above is the entrance. Below is a view of the theater, as well as the picnic grove that was adjacent. The marquee for the theater shows the performance times and prices—5¢ for children. The picnic grove was another major attraction since visitors to the amusement park could bring their own lunch and find a shady table to enjoy it. Many visitors arrived from cities beyond Rye via trolley. The trolley lines stretched from town to town. A newspaper article in 1899 stated that 4,500 passengers were carried to Rye via trolleys for a summer outing of workers from a Port Chester factory, the Abendroth Foundry.

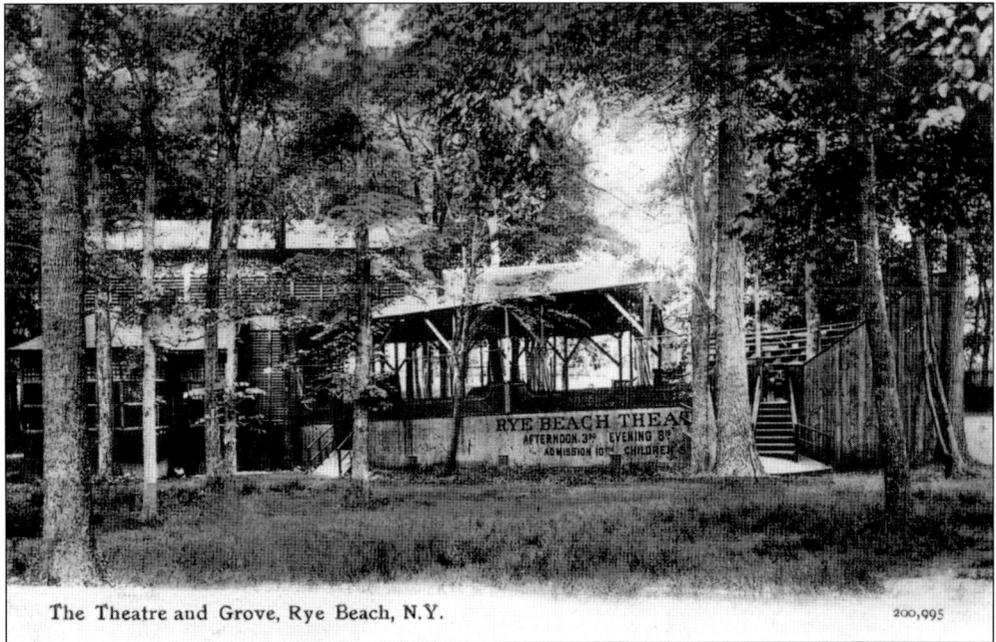

The Theatre and Grove, Rye Beach, N.Y.

200,995

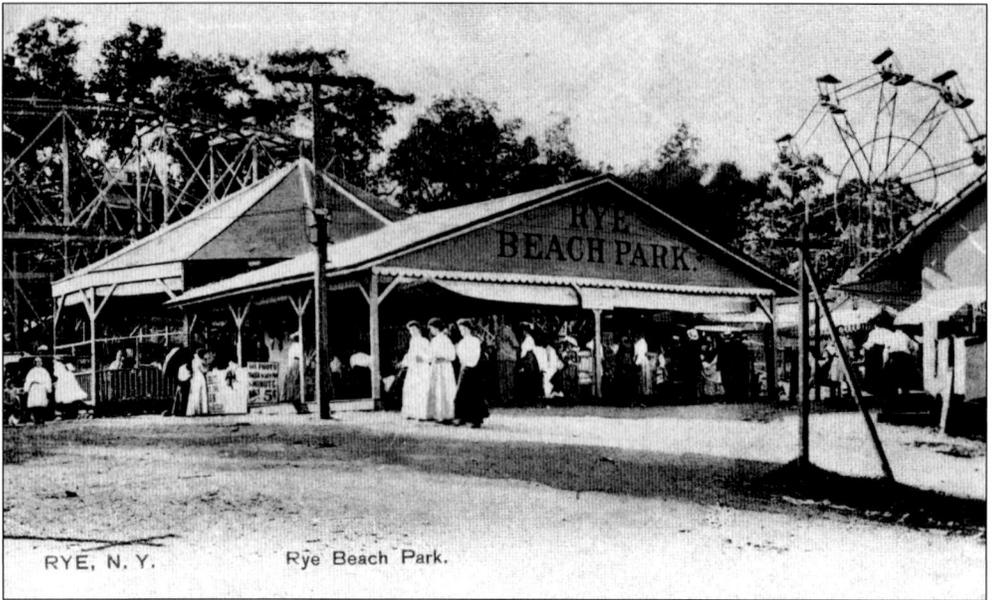

RYE, N. Y. Rye Beach Park.

Weaving down through Rye Beach Park was the midway. Over time, its path changed as new attractions were added. The views of the park above and below are from before 1910, showing people walking along the midway. One can compare the way they dressed with how one dresses today to go to an amusement park. The women were not showing much of their legs. Both views give glimpses of two of the early rides in the park, the Ferris wheel and the roller coaster. The locations of the various rides are shown on page 122. Note the sign in the view above, which states that photographs were "taken in a minute." In the view below, one sees another perennial part of an amusement park, the peanut vendor.

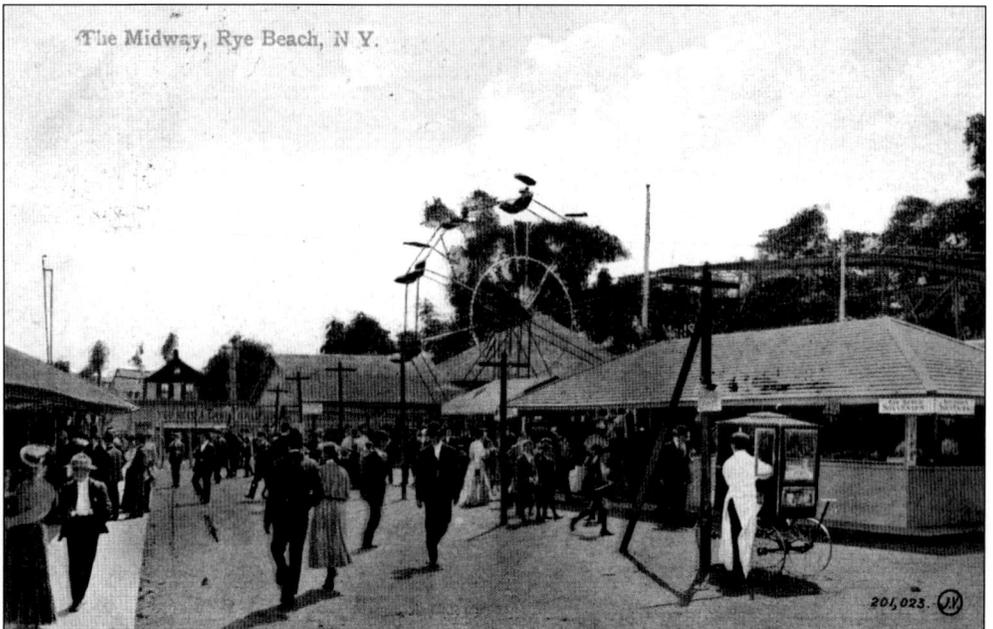

The Midway, Rye Beach, N Y.

201,023.

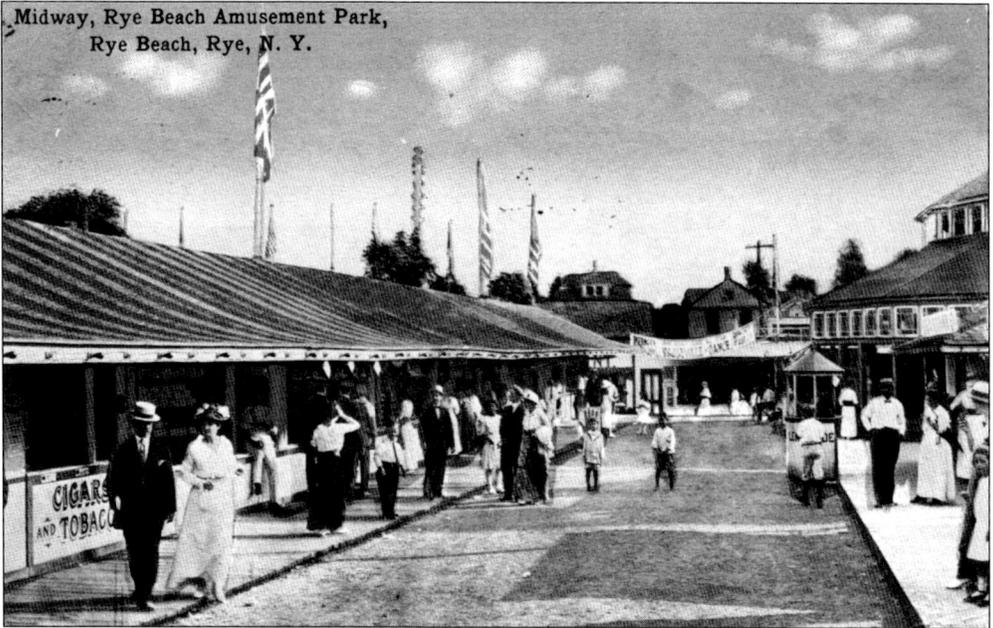

Midway, Rye Beach Amusement Park,
Rye Beach, Rye, N. Y.

These two views are of Rye Beach Park at a later time when it had become more regularized and a more formal name, Rye Beach Amusement Park, had been adopted. Various attractions are shown, including the carousel, above, at the right rear, along with games of chance. The banner in the rear announces vaudeville and dance. Below to the left is a side view of the Kentucky Thoroughbred. The park was part of a national phenomenon in the late 1800s and thereafter to develop local amusement parks; people did not travel to Disney productions.

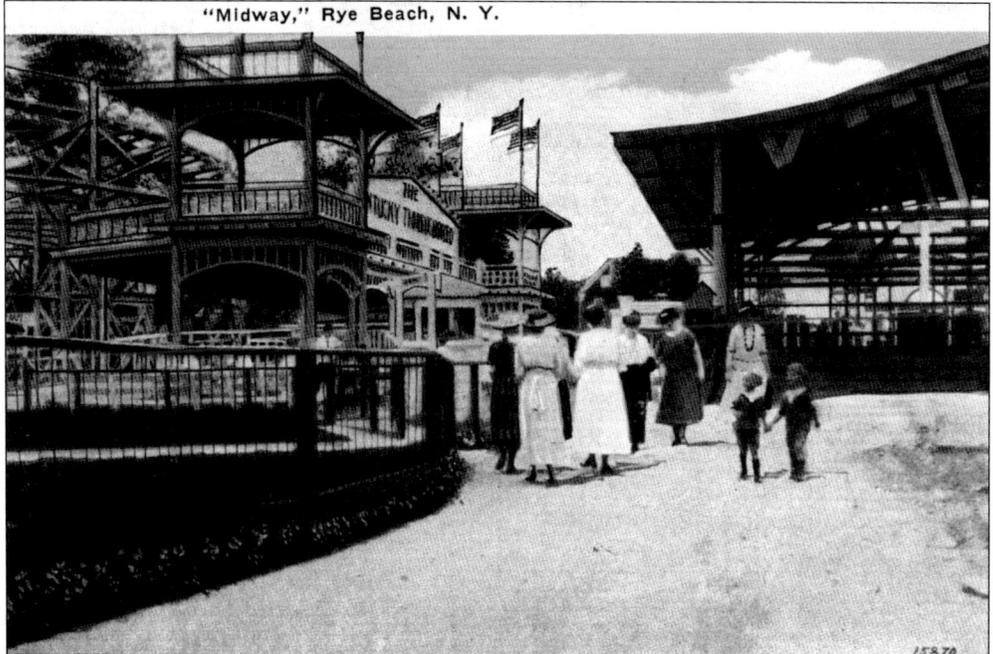

"Midway," Rye Beach, N. Y.

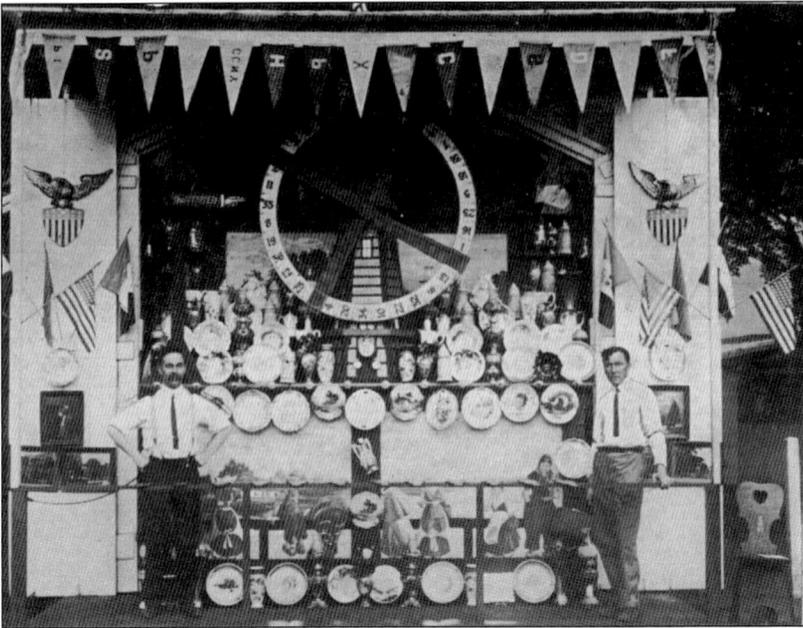

GUS BURNS
Old Dutch Mill,
Rye Beach,
Rye, N. Y.
Established 1906

These two views show individual attractions on the beach after entering the park. Above is the Old Dutch Mill, a game of chance run by Gus Burns (who also produced and sold these cards). With the spin of the wheel after paying, the participant could potentially win one of the many prizes shown (assuming the game was not fixed). The picture below shows one of the standards of amusement parks: the animal ride. In this case, the little girl is in a goat cart. There is no doubt her parents could pay for a photograph to take home as a souvenir.

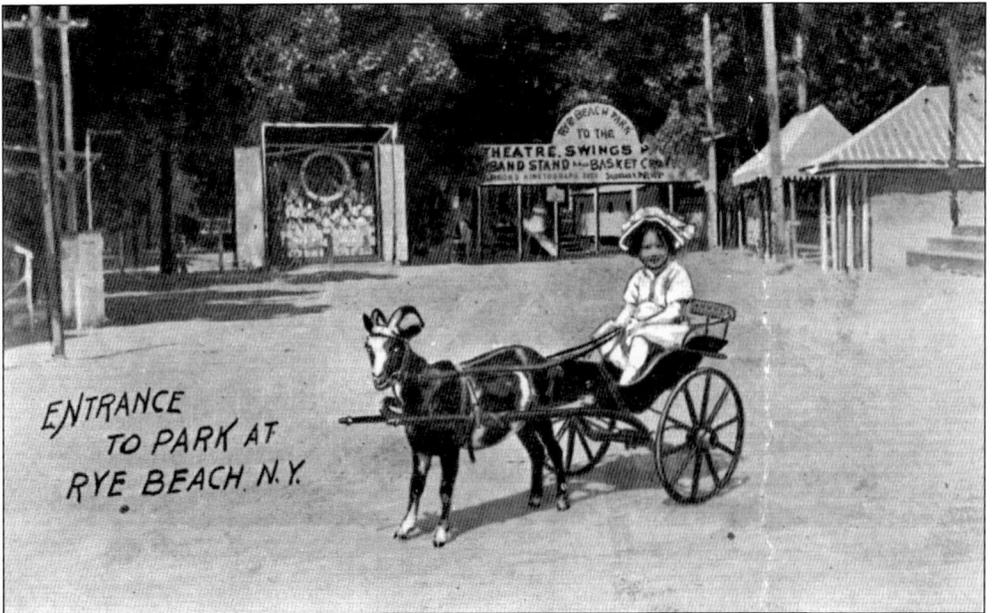

ENTRANCE
TO PARK AT
RYE BEACH. N.Y.

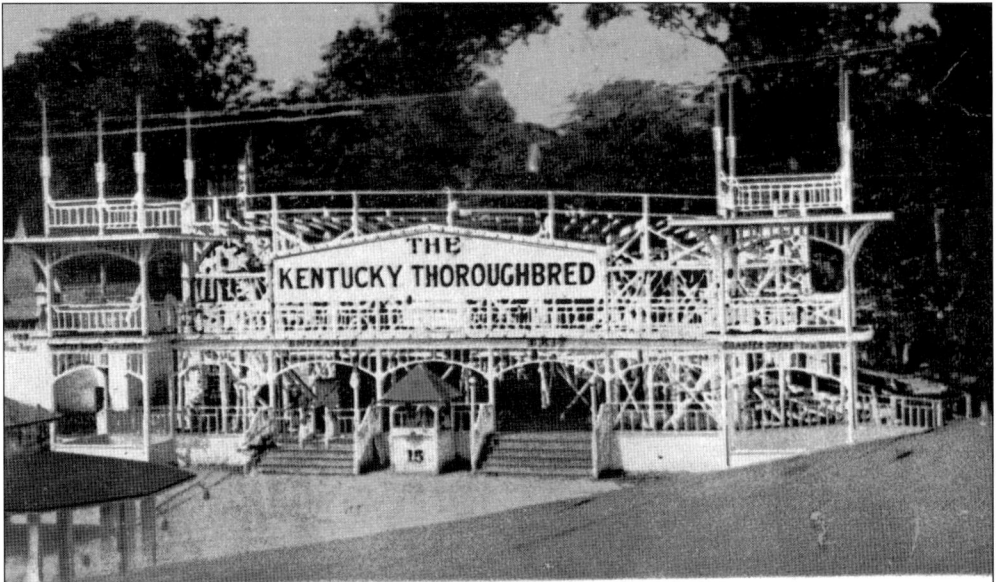

THE ROLLER COASTER RYE BEACH N. Y.

The heart of Rye Beach Park was its rides. What would a park be without a roller coaster? The one at this park, above, was called the Kentucky Thoroughbred, suggesting the speed of wild horses, not to mention Col. Austin Kelley's home state. There are also glimpses of the ride in views presented elsewhere as it wound through the park. Another popular ride, shown below at the rear of the view, was the Panama Canal. It was a boat ride along a watercourse, and at the end, the boat slid down a hill with a splash. The name was probably popular given the recent digging of the Panama Canal.

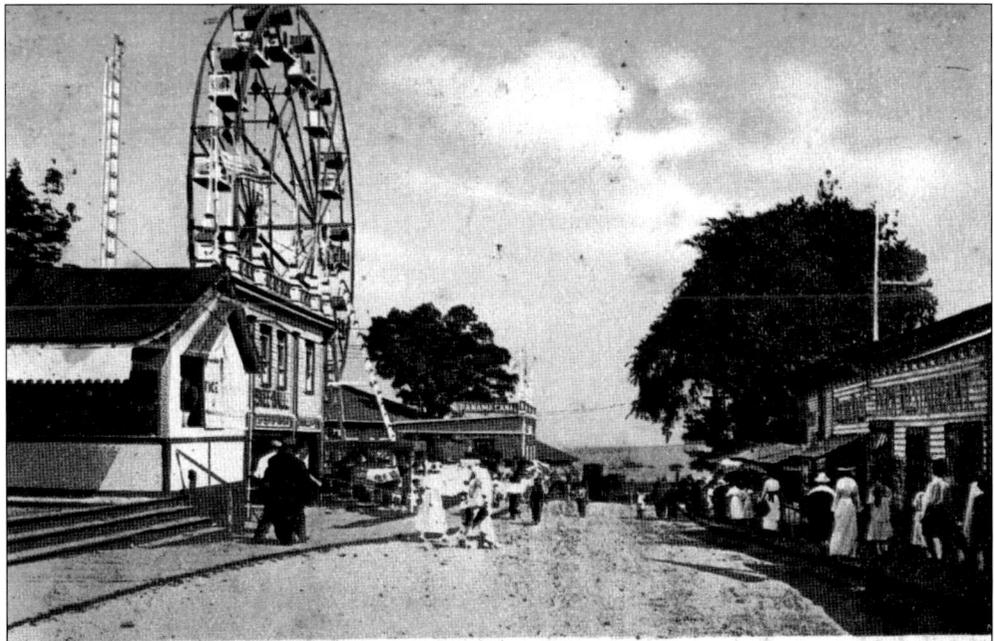

THE MIDWAY AT RYE BEACH N. Y.

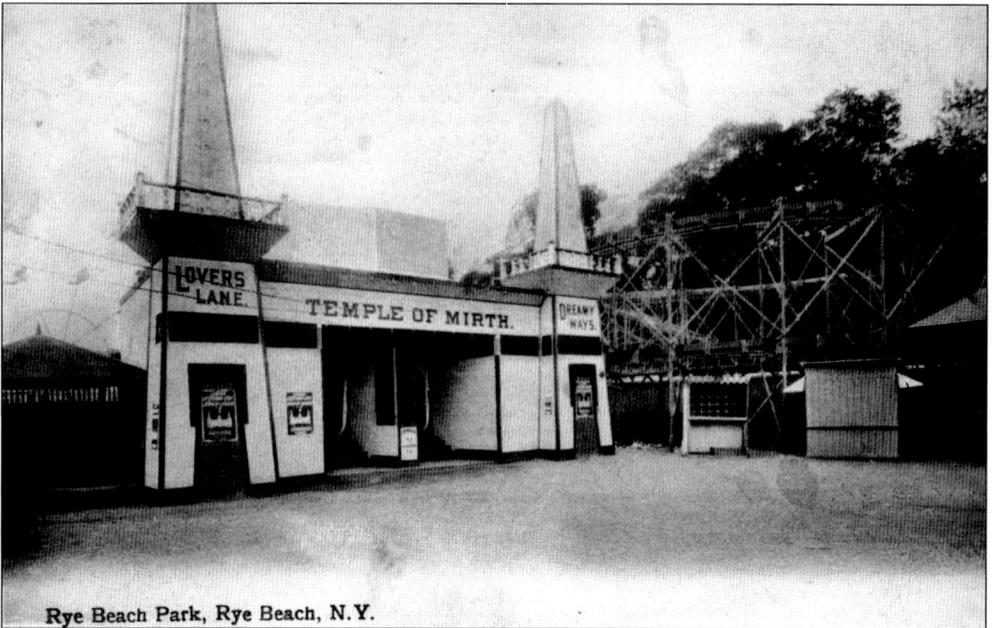

Rye Beach Park, Rye Beach, N.Y.

The Temple of Mirth was one of the most popular attractions at Rye Beach Park. It would be called a fun house today. As the signage points out, the attraction also housed Lovers Lane and Dreamy Ways. In the background is a section of the roller coaster. Some of these attractions were carried over into Playland when it was created.

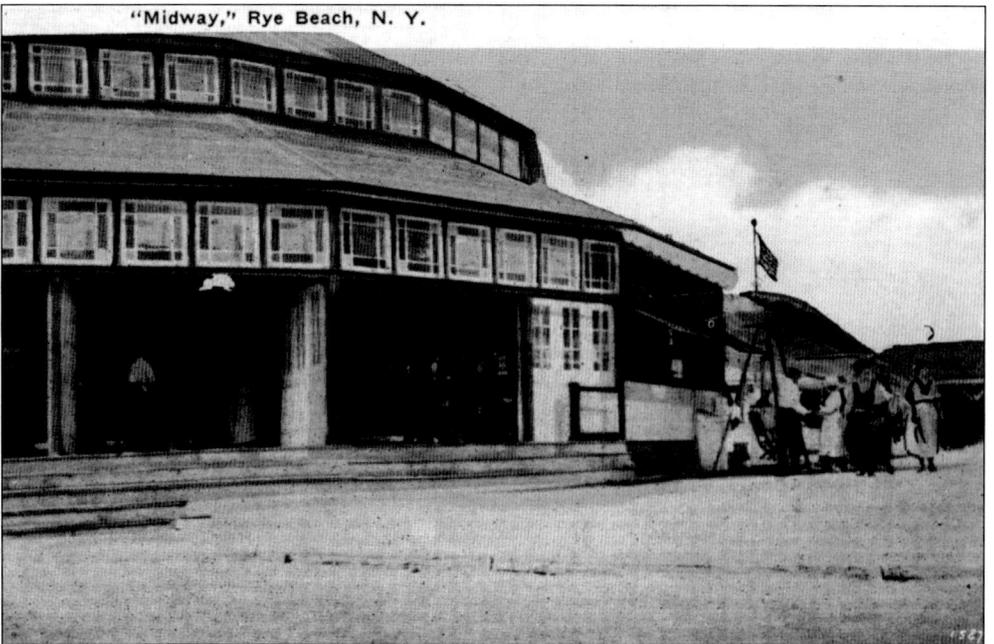

"Midway," Rye Beach, N. Y.

Every self-respecting amusement park had to have a merry-go-round—and they still do today. Research so far has failed to find out the actual ride that was inside. It evidently was not transferred to Playland when that park was constructed, since its famous merry-go-round came out of storage in Connecticut.

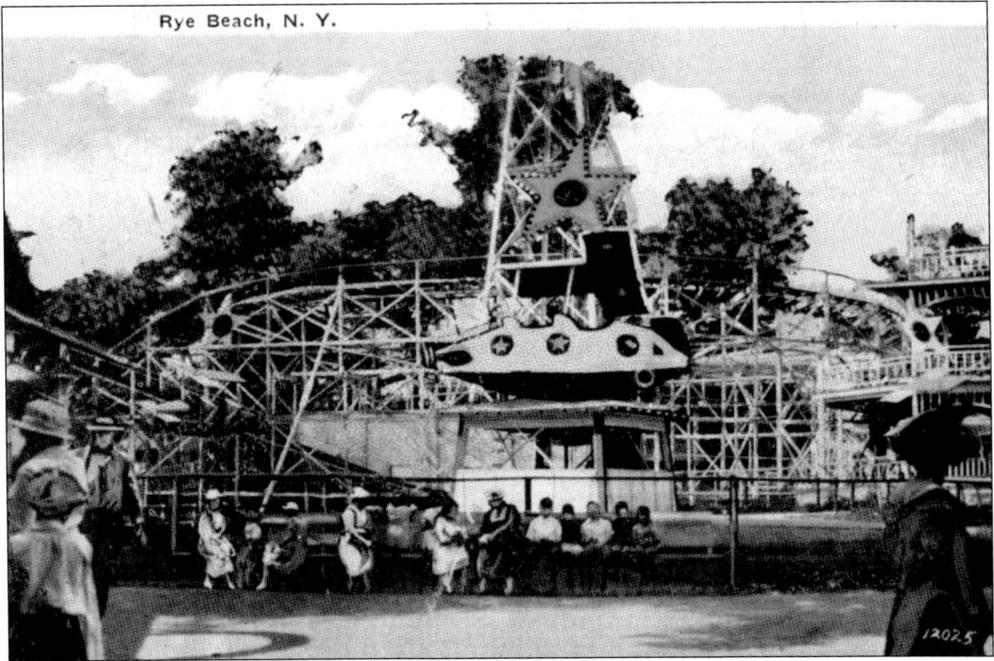

A major part of Rye Beach Park and every amusement park is Kiddyland, simple and safe rides for children. This particular ride looks a little advanced for that group, however. Perhaps that is why children and their parents are just sitting on the benches.

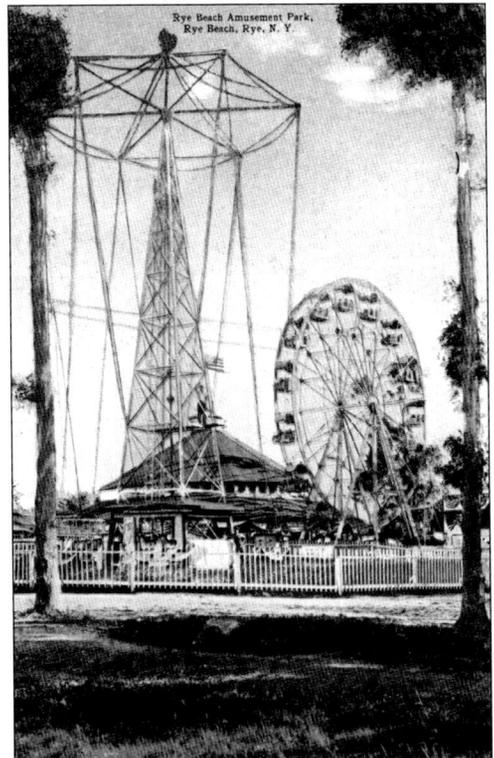

Rye Beach Park added attractions over the years, and this view shows two of the last added before the park was condemned (see page 124). The Ferris wheel is much larger than the one shown in pictures of the park above. The ride on the left was called the Airplane Swing.

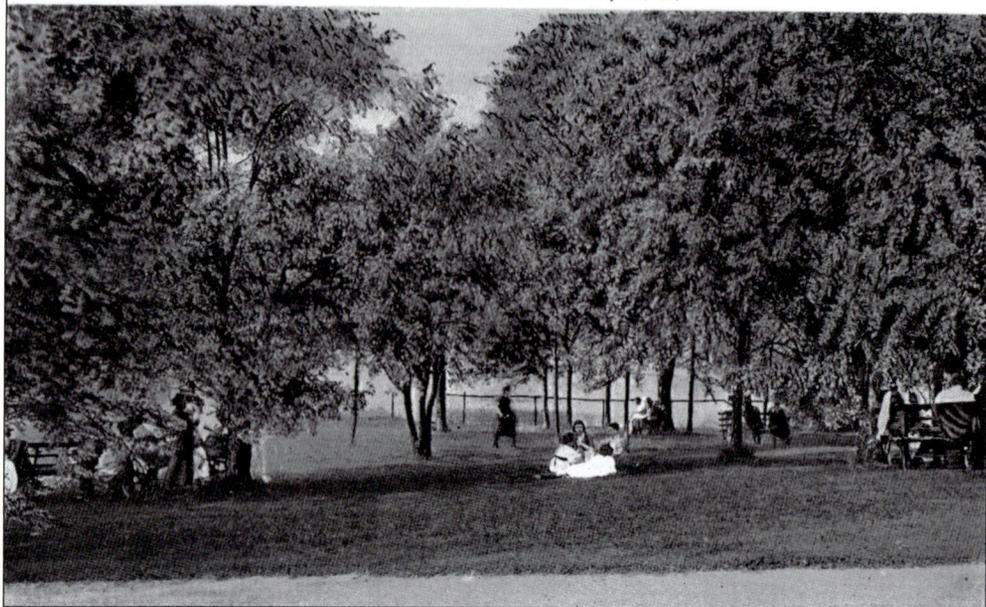

A later name for the amusement area was Rye Pleasure Park, as illustrated in this card. The section shown is the picnic groves, which lay just off Forest Avenue. Coming to the area with a picnic was indeed a major part of the trip. Even when the park was replaced by Playland, a picnic grove was maintained.

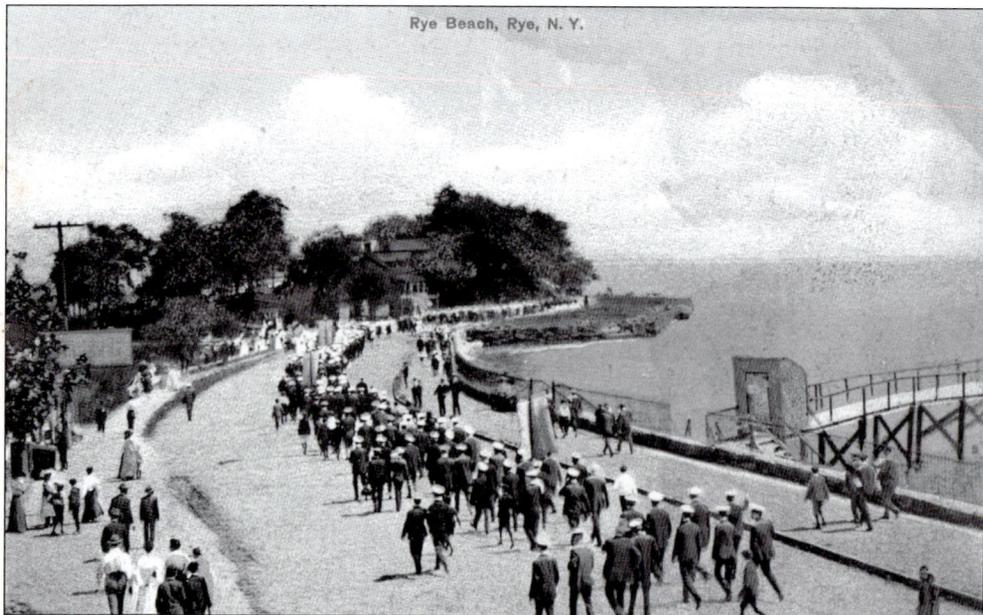

Rye Beach, Rye, N. Y.

All the entertainment was not in the park. Pictured is a parade, headed toward Edward's on the Hill Hotel. Parades were a major form of summer entertainment in Rye and around the country. This parade could be for the Merritt Association, which had set out from Port Chester according to an old photograph. From the lack of spectators at this point, one can assume the fun was in the parading itself.

In 1923, Rye got a second amusement park, a competitor to Rye Beach Park called Paradise Park. It was on land to the north of Rye Beach Park in the area where Playland is today as well as the marshy areas of what was called "the Gut" (see page 124). The park was built by Fred H. Ponty and Joseph Haight. Ponty was a Rye resident who lived on Rye Beach Avenue and had a photography studio in Port Chester. The park had a grand entrance, fronting Rye Beach Avenue, as pictured above. This was now the era of arriving by automobile or bus. The park had its merry-go-round, roller coaster (the Blue Steak), and dodge-em cars. Rides were 5¢ and 10¢. A scene from the park is below with the large roller coaster at the right rear.

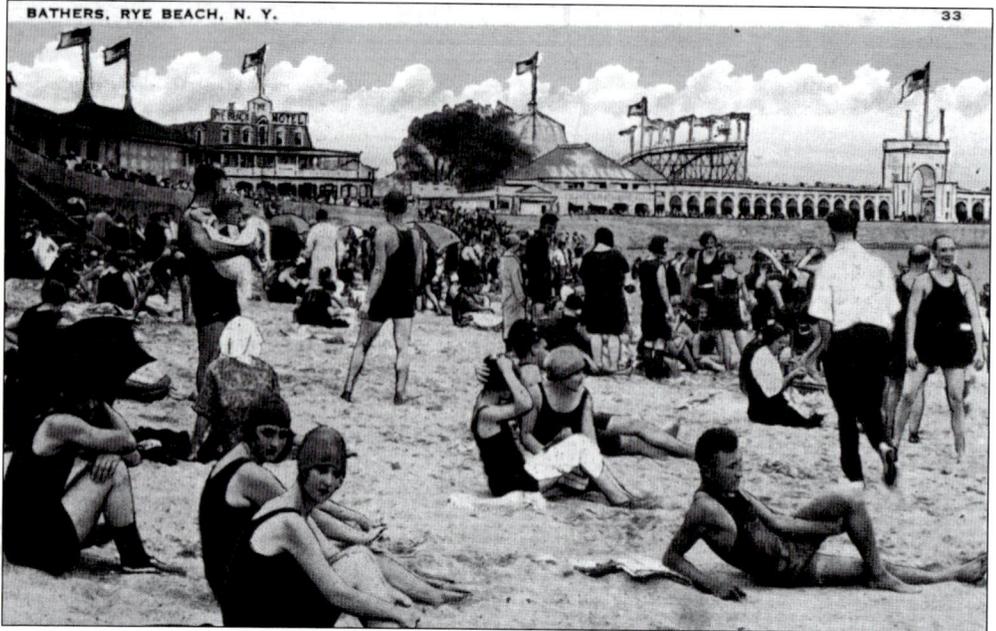

One should not forget with all the attention paid to the development of the amusement parks and the inns that the beach remained a primary attraction for visitors. The view above shows the bathers, with Paradise Park in the background (as well as Rye Beach Hotel). By the mid-1920s, the rules on men's bathing attire had loosened up to the point where they could wear a singlet. Below is a night view of Paradise Park. It came to a disastrous end when it was engulfed by a major fire in 1926. Most of the structures were wooden. This cleared the way for the development of Playland.

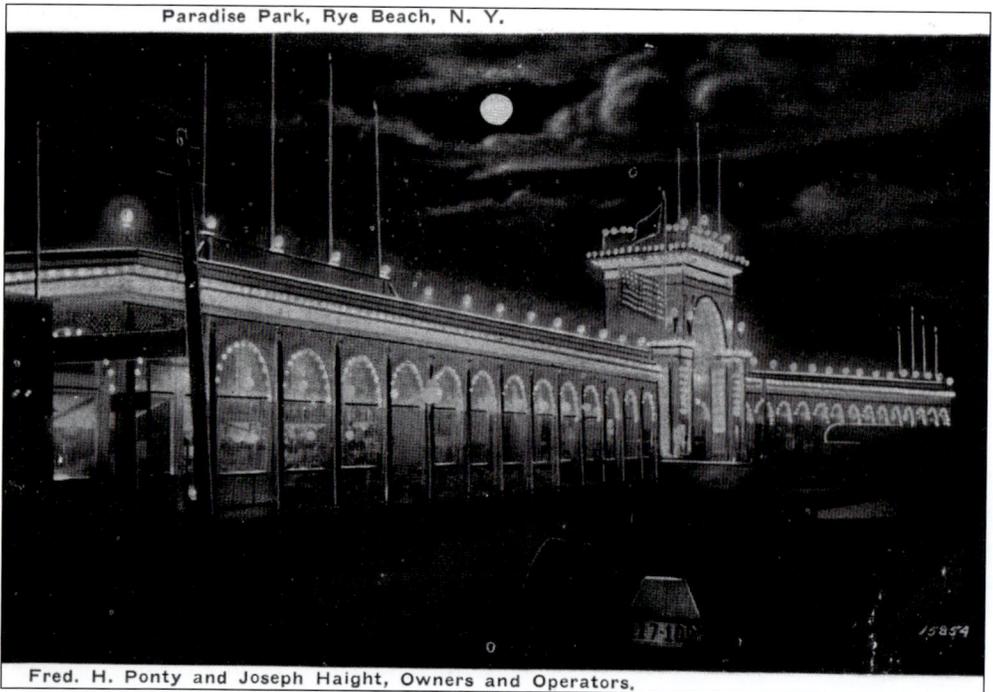

Paradise Park, Rye Beach, N. Y.

Fred. H. Ponty and Joseph Haight, Owners and Operators.

Ten

PLAYLAND

In 1927, Playland replaced Rye Beach Park, Paradise Park, the inns, the bathing pavilions, and the outer end of Rye Beach Avenue, and it modified the geography of a major segment of Rye. The scene has remained unchanged for 80 years, and it draws 800,000 to 1 million visitors a year. (See map on page 125.)

How the land was assembled is a story in itself, a tale of some foresight on the part of Westchester County. In 1923, the county purchased 160 acres on Manursing Island for $600,000. In 1925, the county purchased 54 acres on the mainland for $2.5 million, and then after the fire, it purchased the additional amusement park land. In all, the county ended up with 280 acres.

Perhaps the most astonishing feat of the park is that it was done in one winter season. After Rye Pleasure Park closed on Labor Day in 1927, the winter was spent removing all the old structures, filling in the area needed for the new buildings, and creating the lake, the sand beach, and massive parking area. A gigantic park with a midway, tower, bathing pavilion, pool, and numerous rides were also built. There was a workforce of over 1,000 people. Only the Playland Casino and a few rides were built in the following off-season.

This project was overseen by Frank W. Darling, a man experienced in the construction of amusement parks around the world, including in London, New Zealand, and Paris. It was the first amusement park in the country built in its entirety. Opening day was May 26, 1928, and now 80-plus years later, it has lasted on as the oldest county-run amusement park in the United States.

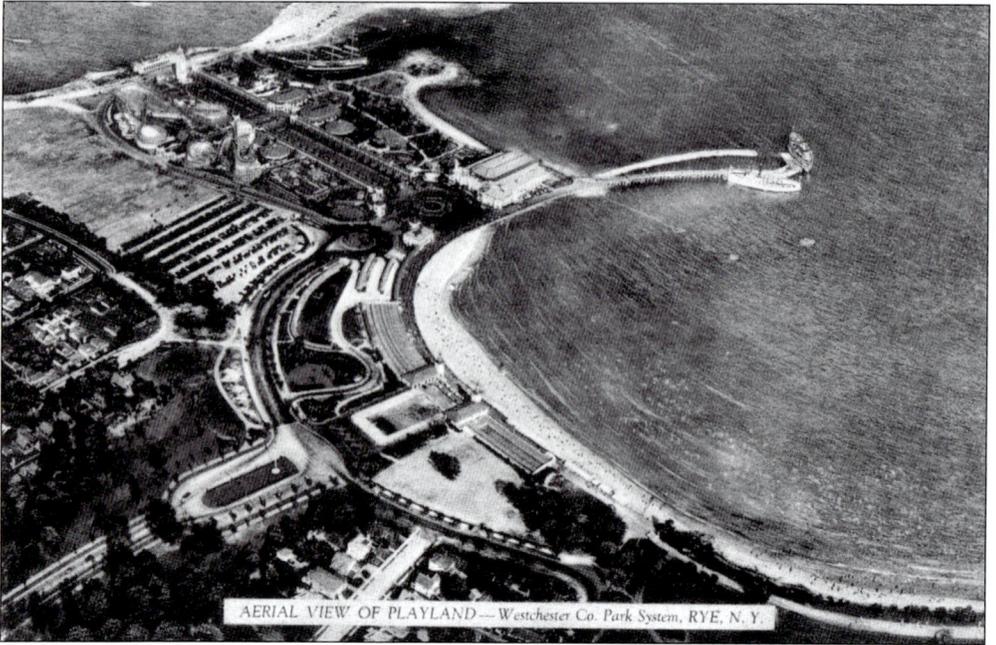

AERIAL VIEW OF PLAYLAND — *Westchester Co. Park System, RYE, N.Y.*

Pictured here are aerial views of Playland. Contrasting the map on page 125 with the others and examining these aerial views confirms what was swept away and what replaced it. Most notable is the creation of a beach and a large lake and the filling in of marshland where the parking lot is. The main part of the park is 54 acres. Counting land on Manursing Island, it is a total of 280 acres.

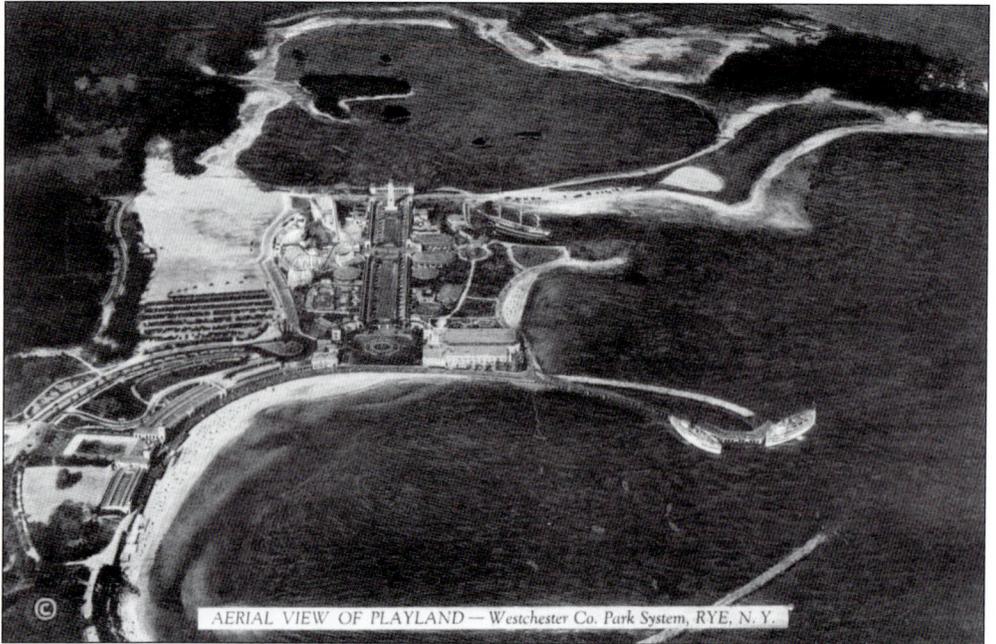

AERIAL VIEW OF PLAYLAND — *Westchester Co. Park System, RYE, N.Y.*

110

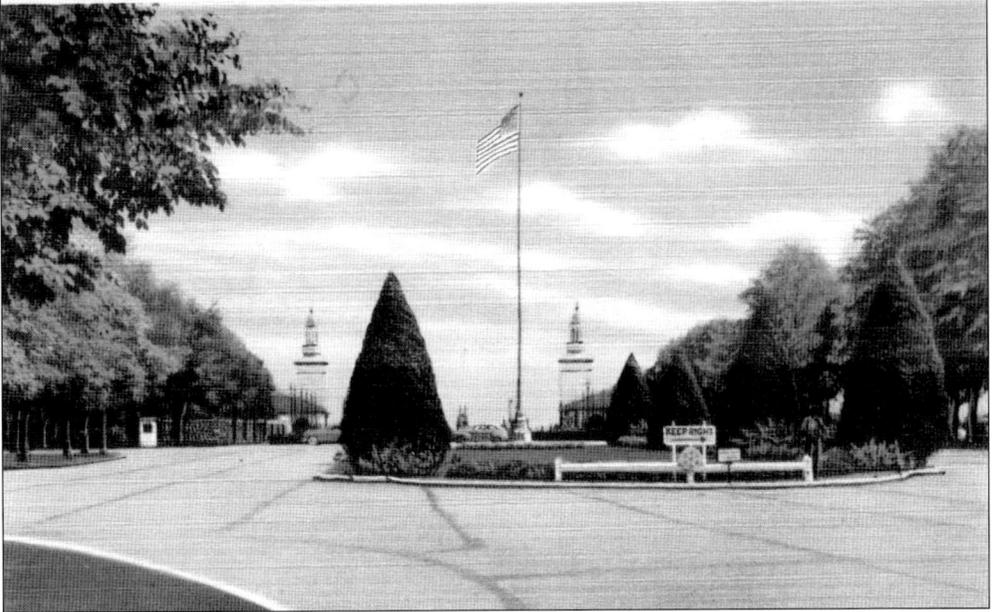

Playland is reached by a long drive off Forest Avenue, as illustrated. The drive is an extension of Playland Parkway, which now runs out to Interstate 95. From this exact perspective in the old Rye Beach Amusement Park, one would run into the dance pavilion and see the theater on the left and carousel on the right.

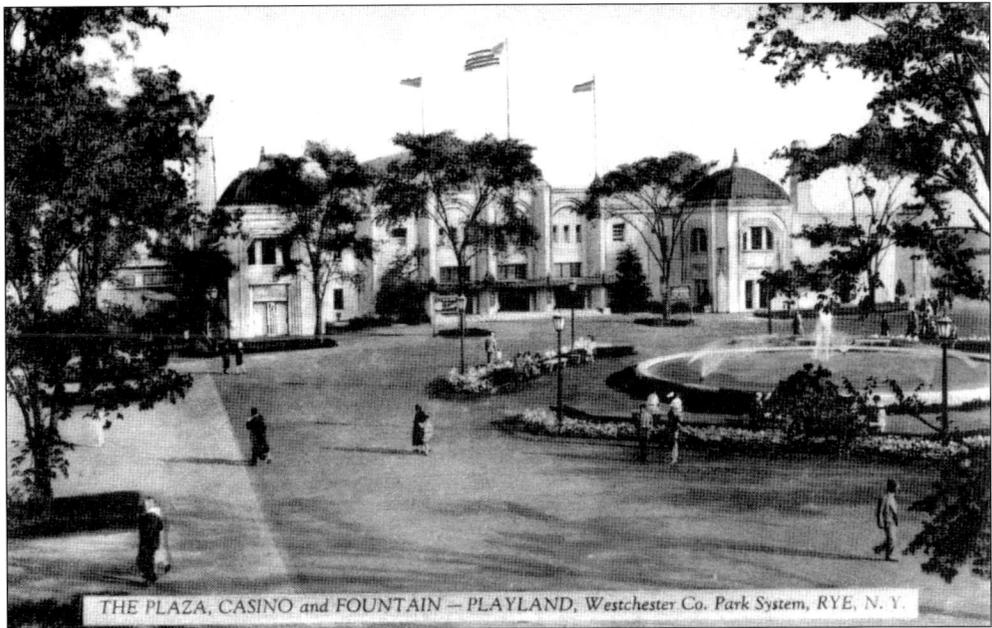

THE PLAZA, CASINO and FOUNTAIN — PLAYLAND, Westchester Co. Park System, RYE, N.Y.

The plaza or main entrance for visitors is shown as it was soon after Playland opened. There is a central fountain. To the right is the boardwalk, and to the left is the main midway. In the rear of the view, one can see the Playland Casino. This is where Edward's on the Hill Hotel stood. The plaza itself is situated where portions of Paradise Park were.

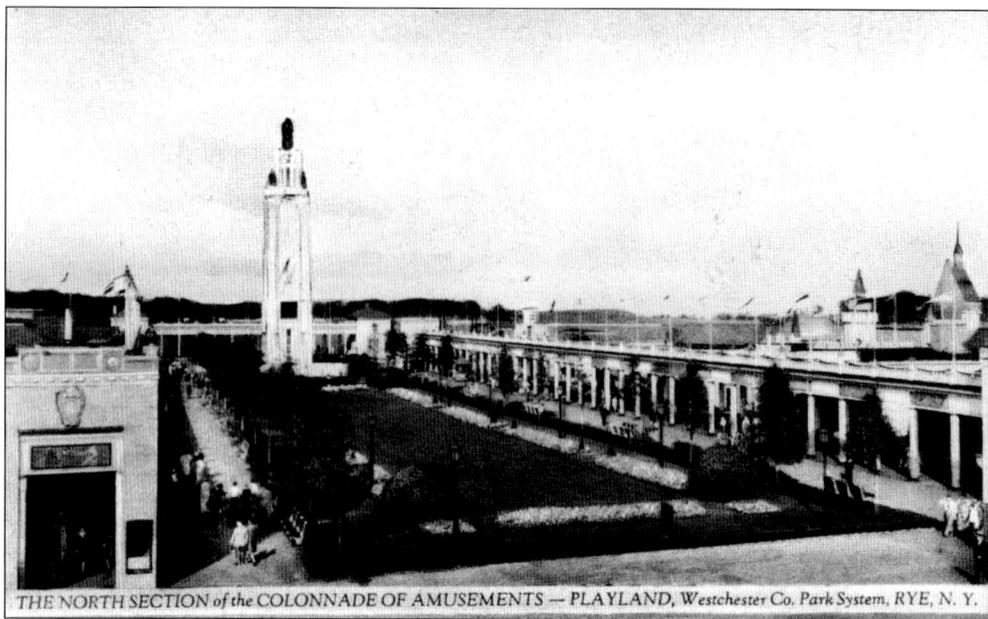

THE NORTH SECTION of the COLONNADE OF AMUSEMENTS — PLAYLAND, Westchester Co. Park System, RYE, N. Y.

The midway or colonnade of Playland is the heart of the park. The rides and other attractions are to the sides. The overall architectural style of the structures in the park can be called art deco; the architects were Walker and Gillette. The introduction to this chapter describes the massive project of taking down the old structures and creating a completed, new park, lake, beach, and the like, all in a nine-month off-season.

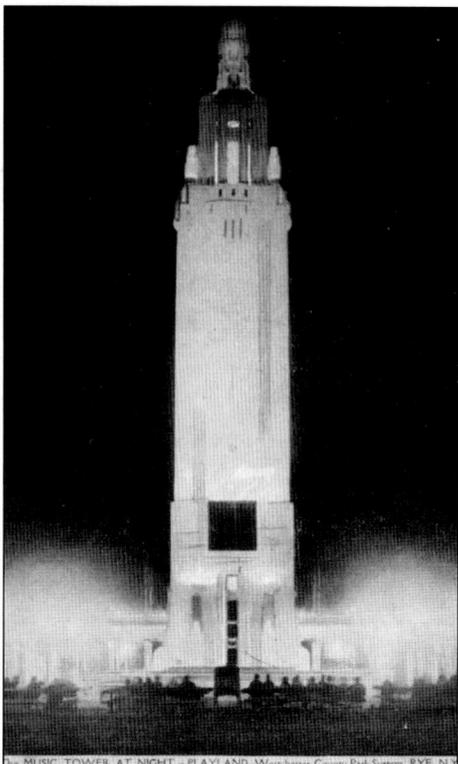

Dominating and defining the midway is the music tower, some 100 feet high. Since it was built on filled-in marshland, poles were driven into the muck to support it. It had a carillon in the tower. In the midway space in front of it, many summer evening music events and plays have been performed over the years.

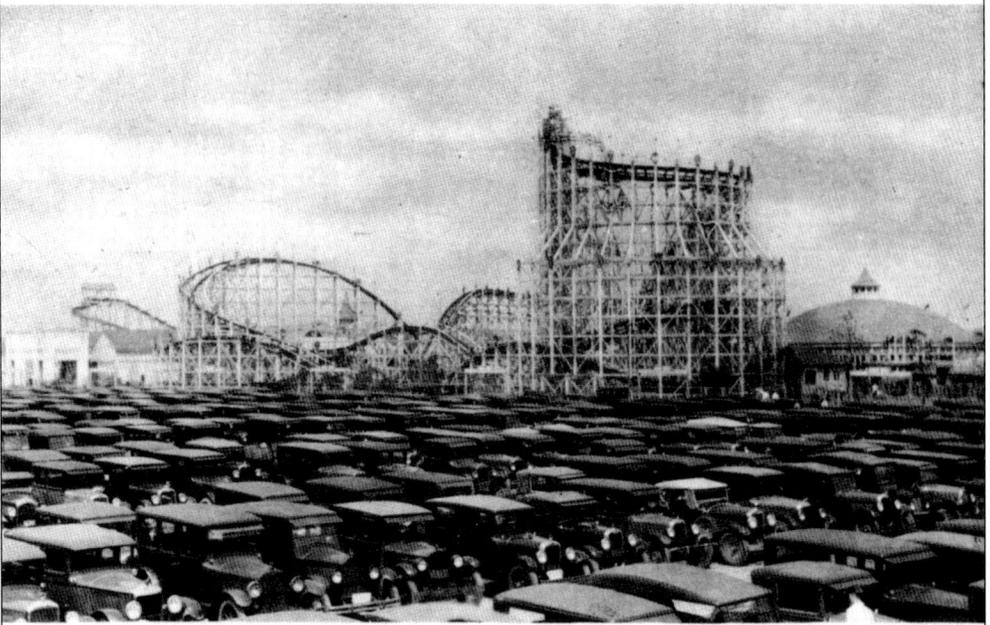

THE AIRPLANE COASTER (FROM PLAYLAND AUTO PARK) © PLAYLAND, W. C. P. C

The predominant means of coming to Playland since its opening is by automobile. A large parking lot was created partially from dredging and filling, a portion of which is shown here. Its location shows on the aerial views. How owners found their cars from all the similar-looking vehicles is a question that comes to mind. In the background are the two roller coasters then in the park.

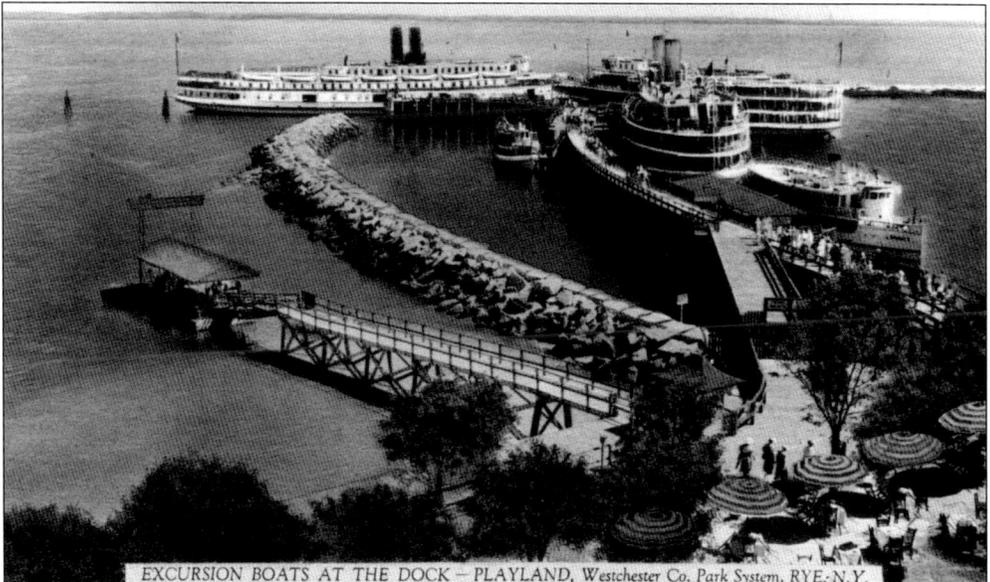

EXCURSION BOATS AT THE DOCK — PLAYLAND, Westchester Co. Park System, RYE, N.Y.

Another way to come to the park was via boat. Before small ferries came to the shorefront of Rye landing at Dearborn Avenue, but now people came by much larger boats, almost liners in size, to Playland's own pier. The back of a card showing one of these large boats advertises daily service to Playland from New York City and Jersey City. Round trip was $1.75 for adults and 70¢ for children.

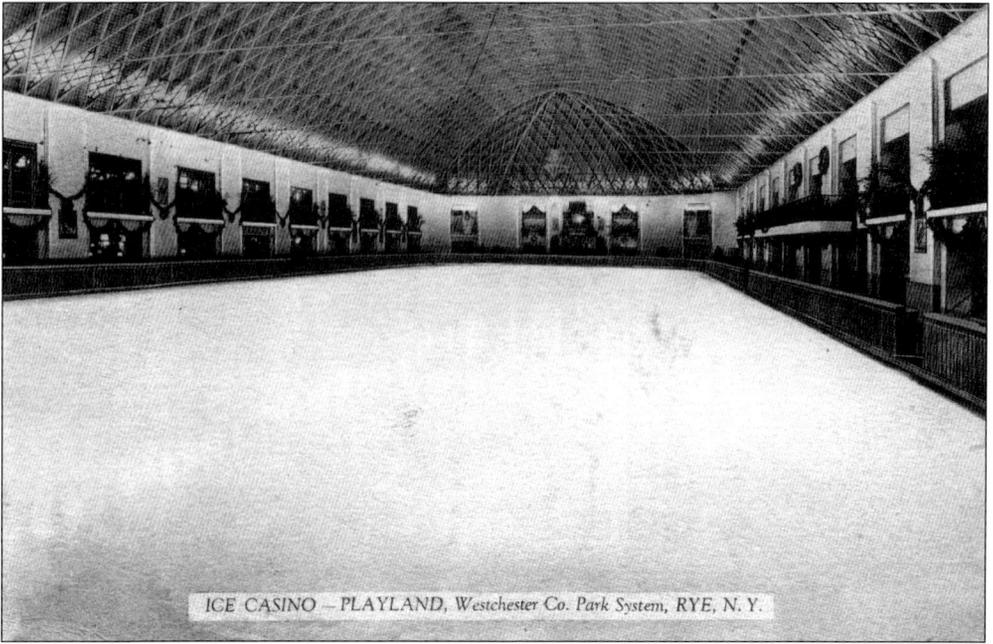

ICE CASINO — PLAYLAND, *Westchester Co. Park System*, RYE, N.Y.

The Playland Casino, built in 1929, served several functions. Downstairs during the cold seasons was a very large ice-skating area, as shown above. During the summer months, the space was converted into the game room, which is shown below. Pictured are the usual arcade games of rifle shooting and miniature bowling. Upstairs was a large ballroom where many famous bands played. The Playland Casino boasted "unsurpassed dining facilities," especially for "epicures of sea food." In the 1990s, the New York Rangers hockey team used the rink for practice.

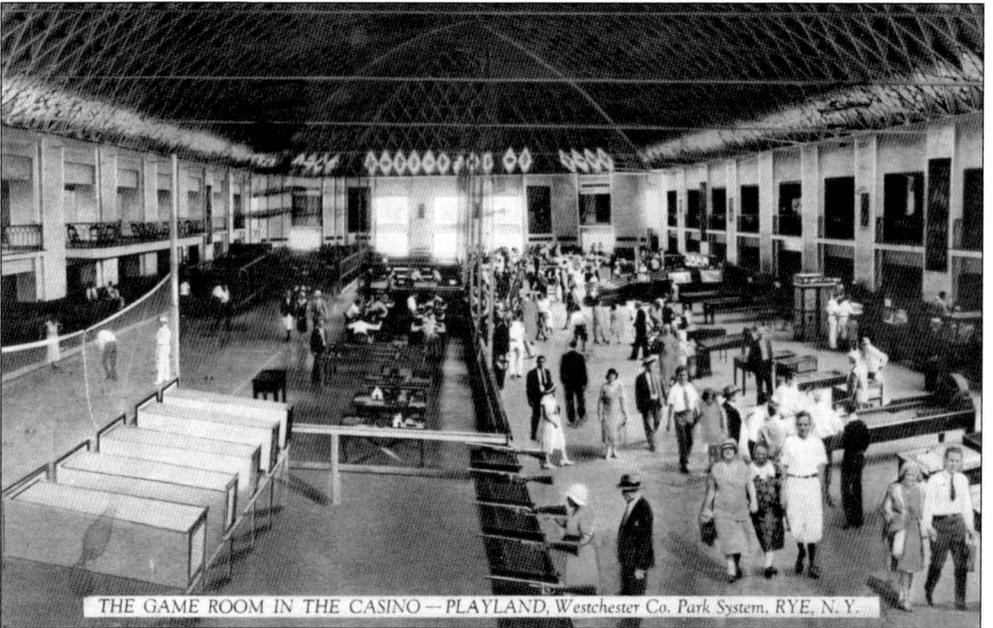

THE GAME ROOM IN THE CASINO — PLAYLAND, *Westchester Co. Park System*, RYE, N.Y.

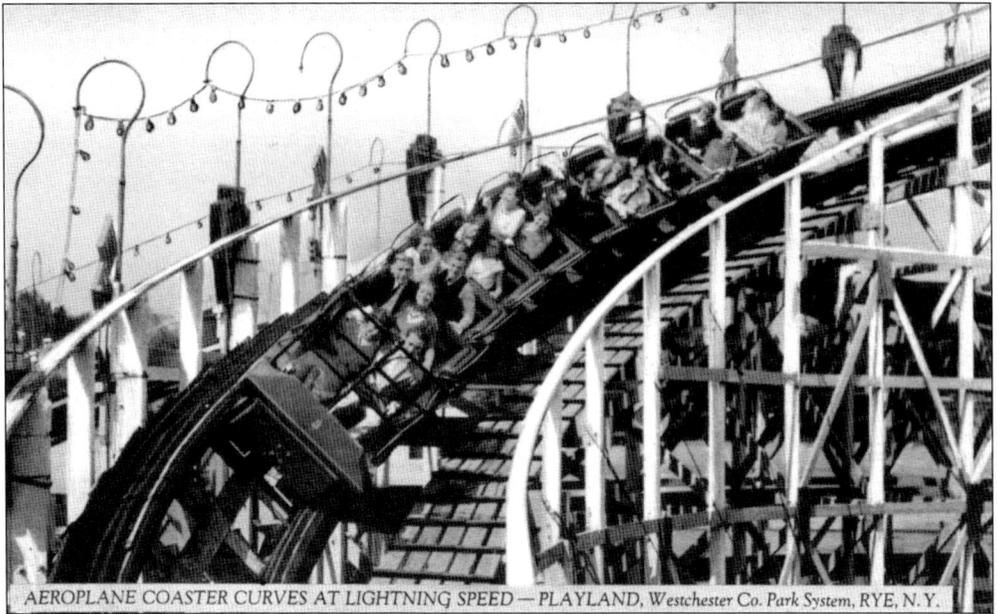

AEROPLANE COASTER CURVES AT LIGHTNING SPEED — PLAYLAND, Westchester Co. Park System, RYE, N.Y.

Roller coasters at Playland began with the very large Aerocoaster (also called the Airplane Coaster), pictured above. With bobs-type coasters, it was the largest wooden one in world. It was too overwhelming for some who favored a smaller coaster behind it called the Dragon Coaster. Over time, the Aerocoaster became rickety and was torn down in 1958. The Dragon Coaster continues today, still thrilling many. See page 125 for their locations.

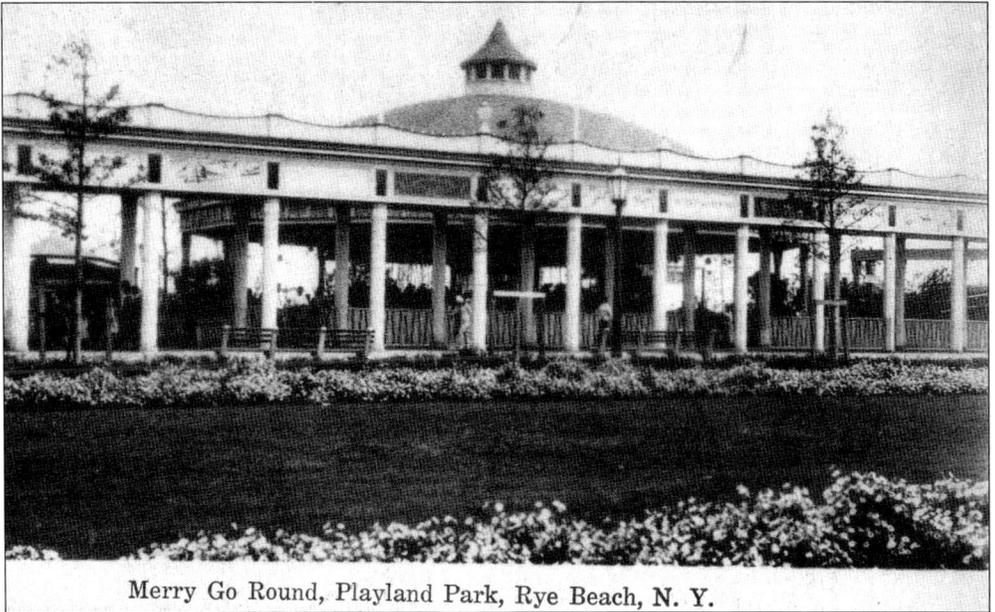

Merry Go Round, Playland Park, Rye Beach, N. Y.

The carousel that was installed in Playland and is still there today is a famous one. It is a 1915 Mangels-Carmel. The mechanism is by Charles Mangels, and the horses and other animals were hand carved in the Brooklyn studies of Charles Carmel. It has four rows. The band organ by Gavioli is equally famous. The park also has one of the three operating derby racers in the world.

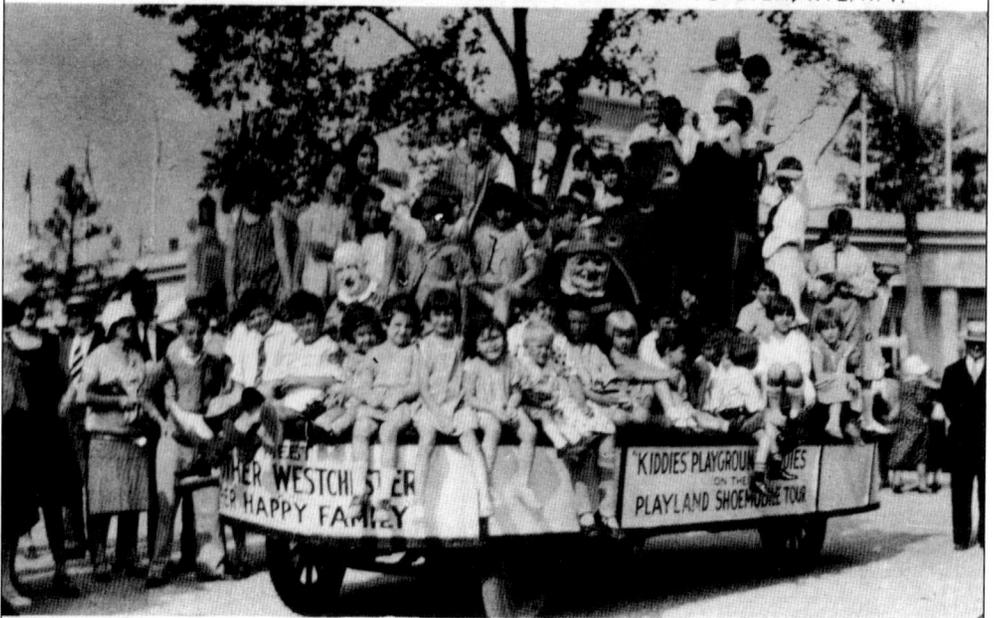

PLAYGROUND KIDDIES DAILY SHOEMOBILE TOUR © PLAYLAND. W. C. P. C.

A major part of Playland from opening day until now has been Kiddyland, with many rides and events. Going back to a somewhat more innocent period, the view above shows the Shoemobile, bringing Mother Hubbard to life. There would be more concern today for a child falling off the ride and getting hurt. Below is one of the popular rides in the park, Silver Bells and Cockle Shells. The sign on the post reminds one that the name is from "Mary Mary Quite Contrary." Many of the rides and attractions shown in these pictures were operated as concessions, often held in the same family for years.

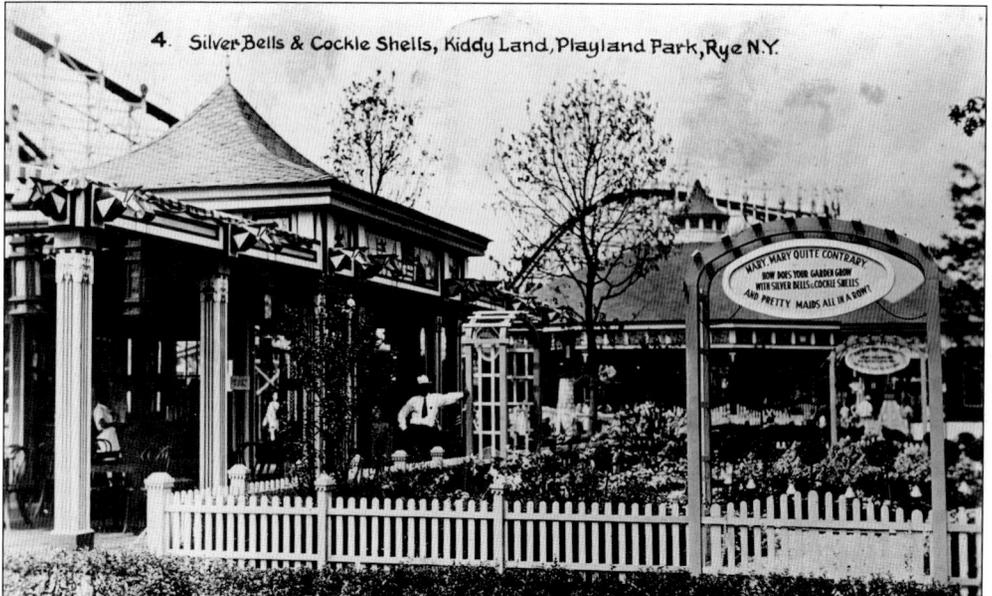

4. Silver Bells & Cockle Shells, Kiddy Land, Playland Park, Rye N.Y.

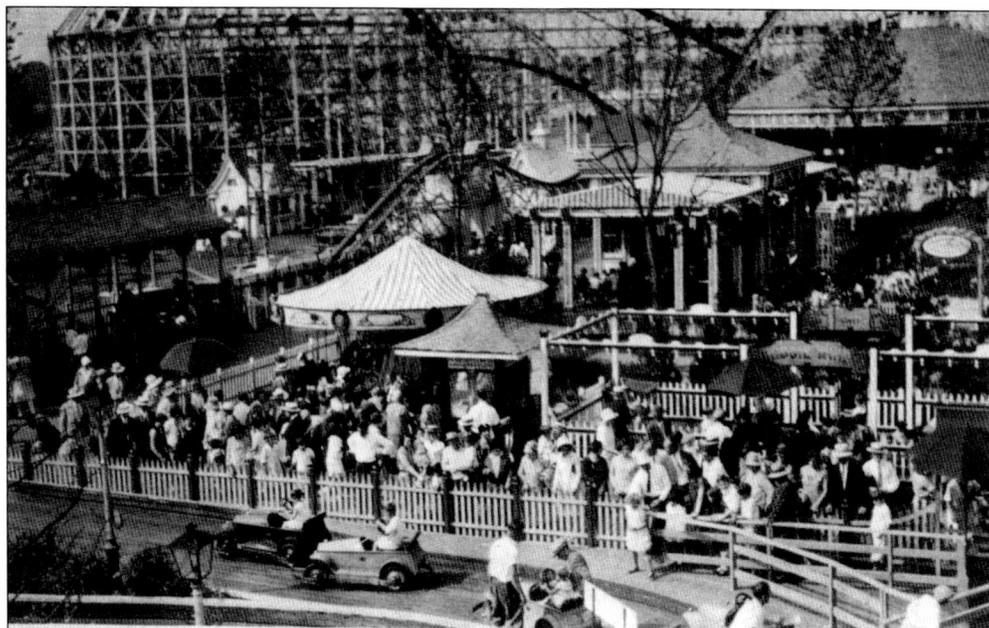

This broader view shows the various rides in Kiddyland, with one of the popular rides shown in the foreground. The vintage automobiles help date the period. To the rear is the Airplane Coaster. There was also a miniature train that wound around the children's section, and it still huffs through today.

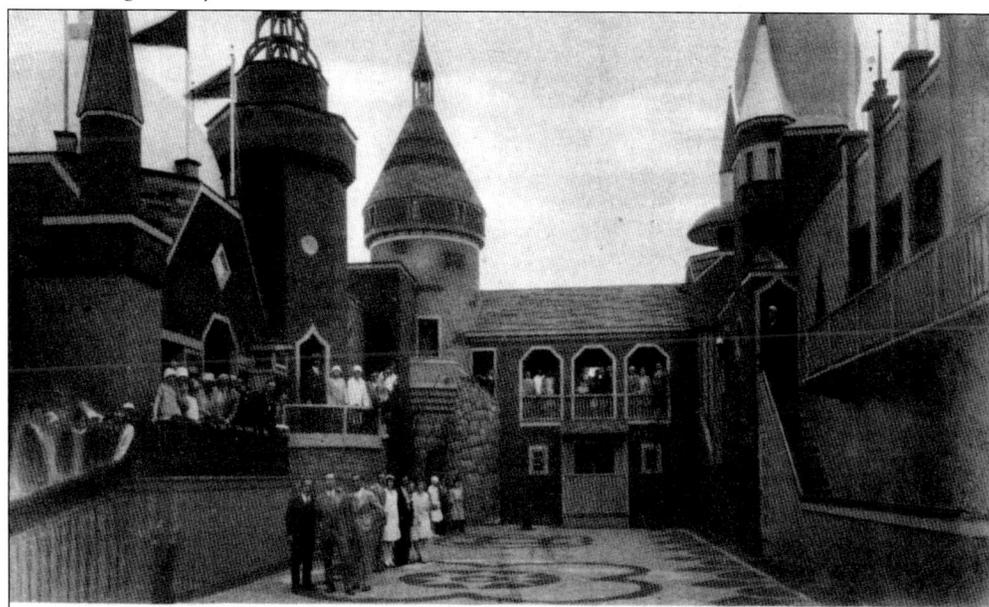

In addition to rides, Playland had a number of other amusements, such as taking a walk through Blue Beard's Palace. This was a combination fun house and scary place. Other popular dark buildings through which to walk or ride were the Magic Carpet, Zombie Castle, Laff in the Dark, and the Old Mill.

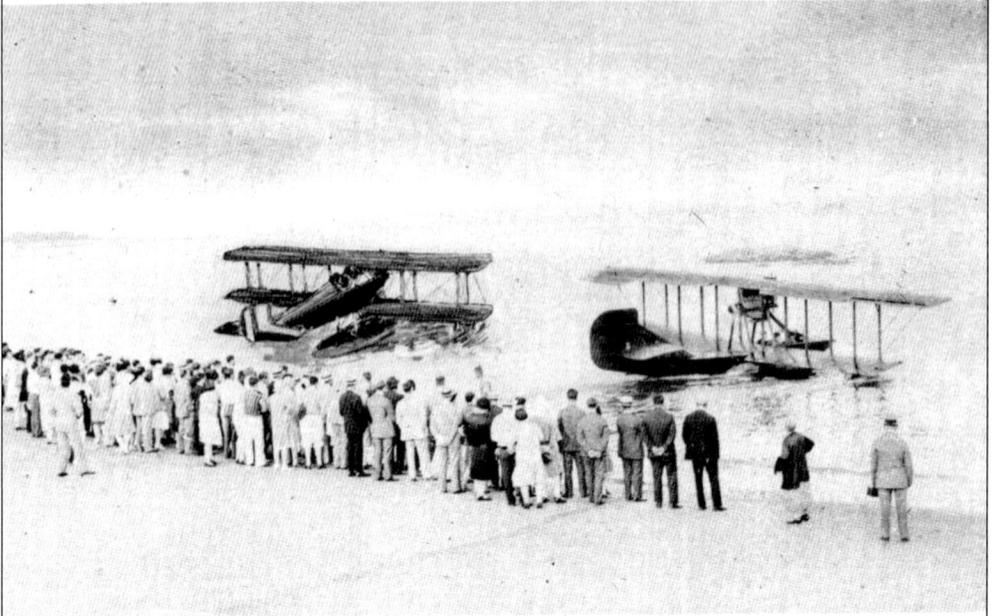

PLAYLAND AIRPORT AND FLYING BOATS © PLAYLAND, W. C. P. C.

The event pictured here is unknown, but the seaplane on the left has been drawn in, no doubt to make it more interesting. In the early history of Playland, wealthy people could arrive by seaplane (and also land light planes in the parking lot), but perhaps this was some special event, given the crowd. (Steven Feeney.)

THE CLIPPER SHIP "BENJAMIN F. PACKARD" — A CARGO OF FUN
PLAYLAND, Westchester Co. Park System, RYE, N. Y.

An early major attraction in the park was the clipper ship *Benjamin F. Packer*, one of the last of the wooden square-riggers, built in Bath, Maine, in 1883 and brought to the park in 1931. For a small price, visitors could walk the gangplank and view the ship. Aboard there was a pirate show, aquarium, and even a naval museum. The infamous hurricane of 1938 damaged it beyond repair.

118

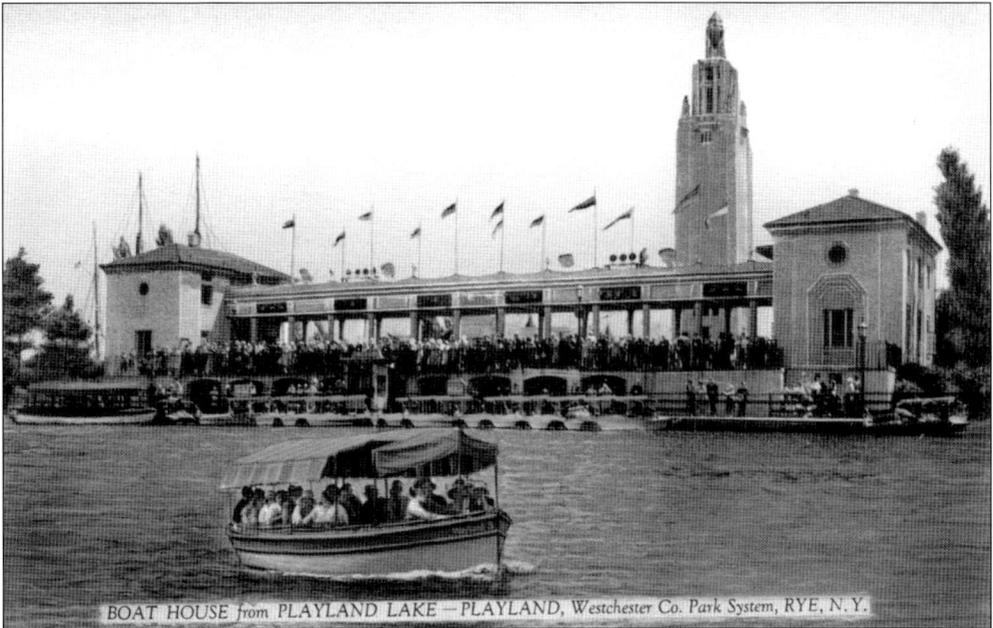

BOAT HOUSE from PLAYLAND LAKE – PLAYLAND, Westchester Co. Park System, RYE, N.Y.

One of the major changes of geography in Rye wrought by Playland was the creation of Playland Lake, dredged out of the marshy "gut" area between it and Manursing Island (see page 125). The aerial view on page 110 shows the lake. Just beyond the tower, a large boathouse was built, which provides boat rides around the large lake and its island.

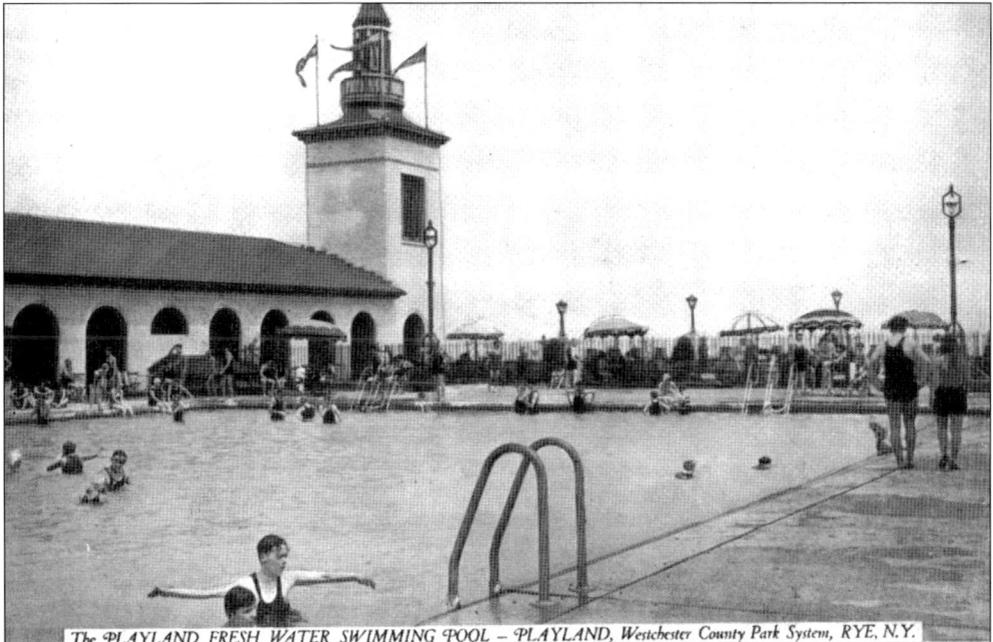

The PLAYLAND FRESH WATER SWIMMING POOL – PLAYLAND, Westchester County Park System, RYE, N.Y.

For fans of freshwater, Playland had its own pool, located above the bathhouses and visible in the aerial view. The pool is quite large and has demarcated lanes. It had competition from J. P. Manger's baths until the latter closed, and now Playland's is the only outdoor public pool in Rye.

119

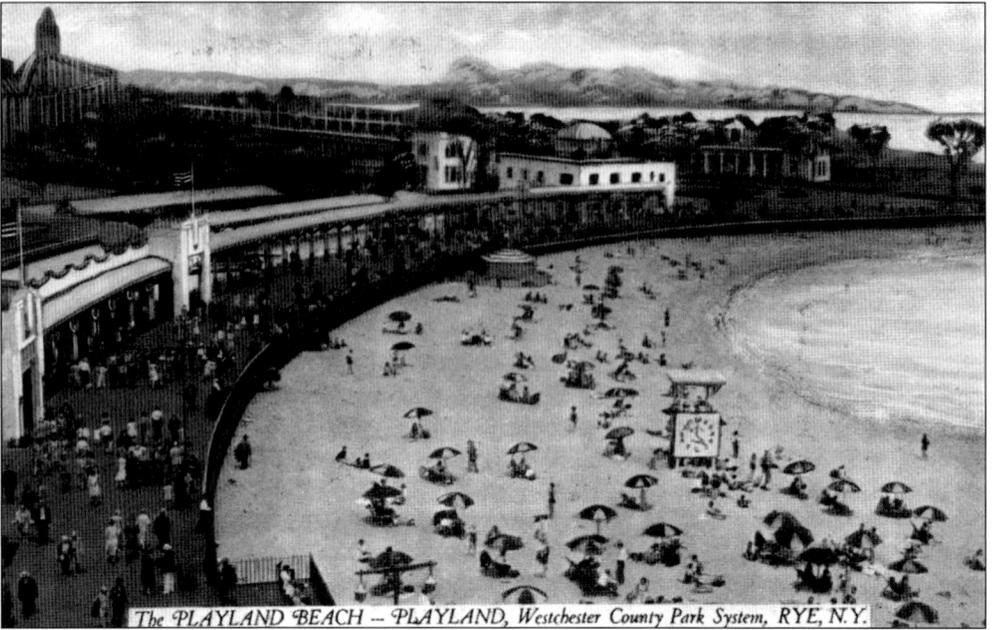

The PLAYLAND BEACH -- PLAYLAND, Westchester County Park System, RYE, N.Y.

Here are views of the beach at Playland. Tons of sand were dredged elsewhere and brought in to create it, replacing the rocks seen in earlier pictures of the area. Above the beach was and is today a boardwalk. As the pictures show, both were crowded during the summer. The view below also shows the bathhouses under the colonnades. This was still the era when one did not come to the beach in beach attire but changed in a bathhouse. Indeed, there was a sign at the Playland gate that changing in one's car was against the law. And one can notice that the bathing suits of the 1930s—bloomers for women—were finally dispensed with.

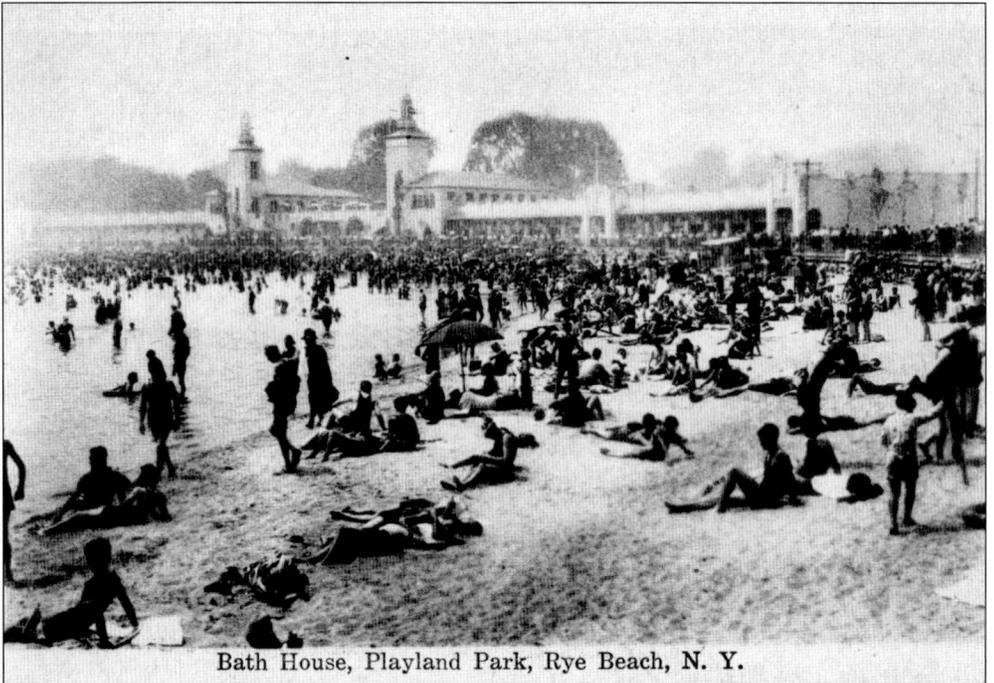

Bath House, Playland Park, Rye Beach, N. Y.

120

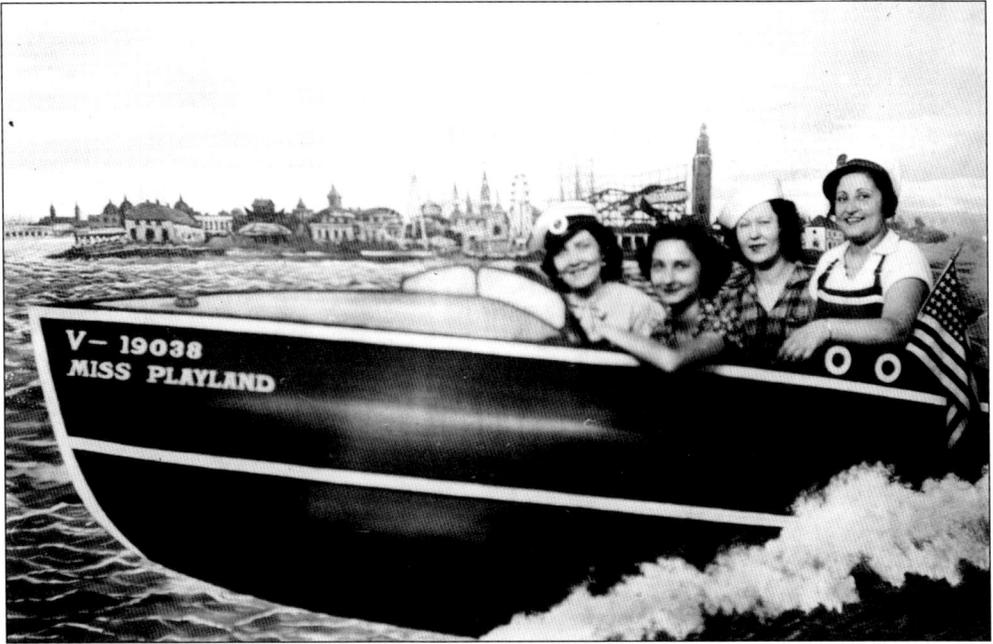

Photograph studios were commonly found at amusement parks in the 1930s, in large part because few people had cameras. The day of the digital camera is far away at the point shown in the pictures. The happy ladies, who seem to be the same in both pictures, are posing with set stages at the Tropical Photo Studio concession at Playland. The picture below must have seemed especially risqué for those days, drinking at a bar in Havana. The photographs were placed on cards and mailed to friends to show what a wonderful time one was having.

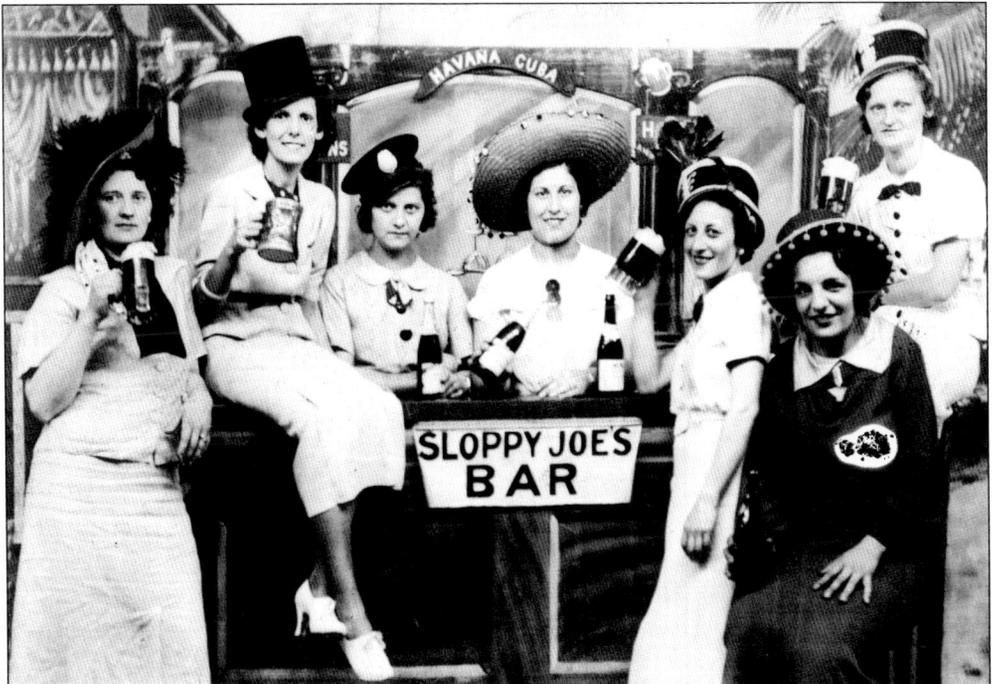

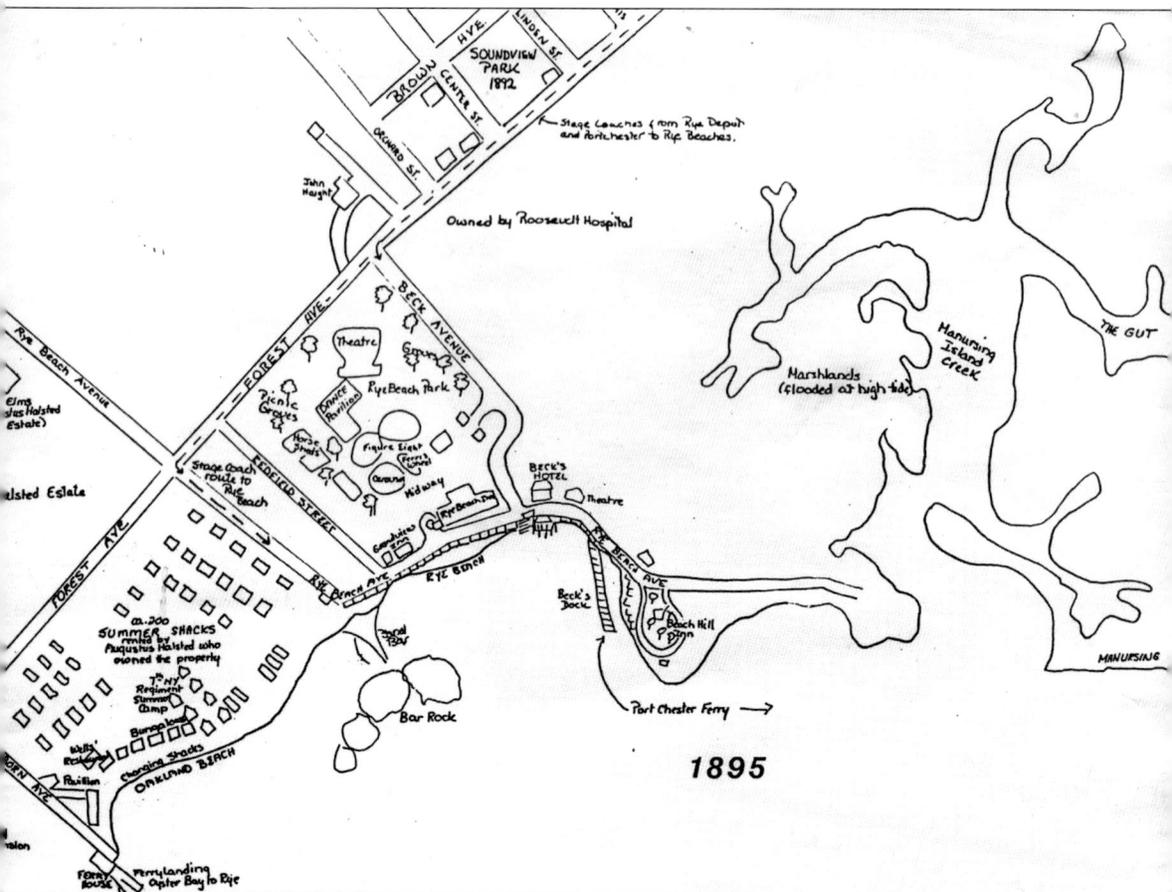

Map labels (1895): SOUNDVIEW PARK 1892, RYE AVE, LINDEN ST, BROWN ST, CENTRE ST, ORCHARD ST, John Haught, Stage Coaches from Rye Depot and Portchester to Rye Beaches, Owned by Roosevelt Hospital, Rye Beach Avenue, Elms (Jules Halsted Estate), Halsted Estate, FOREST AVE, FEDERICO STREET, Stage Coach route to Rye Beach, ca. 200 SUMMER SHACKS rented by Augustus Halsted who owned the property, 71st Regiment Summer Camp, Bungalows, White Rocks, Changing Shacks, OAKLAND BEACH, GLEN AVE, Pavilion, FERRY HOUSE, Ferry landing Oyster Bay to Rye, Bar Rock, Sand Bar, BECK AVENUE, FOREST AVE, Theatre, Swings, Picnic Groves, Dance Pavilion, RyeBeach Park, Horse Sheds, Figure Eight (Ferris Wheel), Carousel, Midway, RYE BRANCH, RYE BRANCH AVE, RYE BRANCH, BECK'S HOTEL, Beck's Pond, Theatre, Beck's Dock, BECKS AVE, Beach Hill Pavilion, Port Chester Ferry →, Marshlands (flooded at high tide), Manursing Island Creek, THE GUT, MANURSING, 1895

These four maps show the changes in the Oakland Beach and Rye Beach sections of Rye along Long Island Sound between 1895 and 1930. These changes coincide with the postcard illustrations in this book. Oakland Beach, the one on the left side of this map, is illustrated on pages 74 through 77. Above the beach are the bungalows (also called summer shacks) on property owned by Augustus Halsted, illustrated on pages 78 and 79. Rye Beach is in the middle of the map, with its early inns, including Rye Beach Hotel, then known as Becks, illustrated in chapter 8. Above the beach is Rye Beach Park in its early stages, illustrated in chapter 9. Farther to the right (north) are a hotel on the hill and Manursing Island Creek. Visitors to these areas at this time arrived by horse and buggy (note the horse sheds), by stagecoaches coming from the train, and by ferry coming to the docks shown on the map.

1915

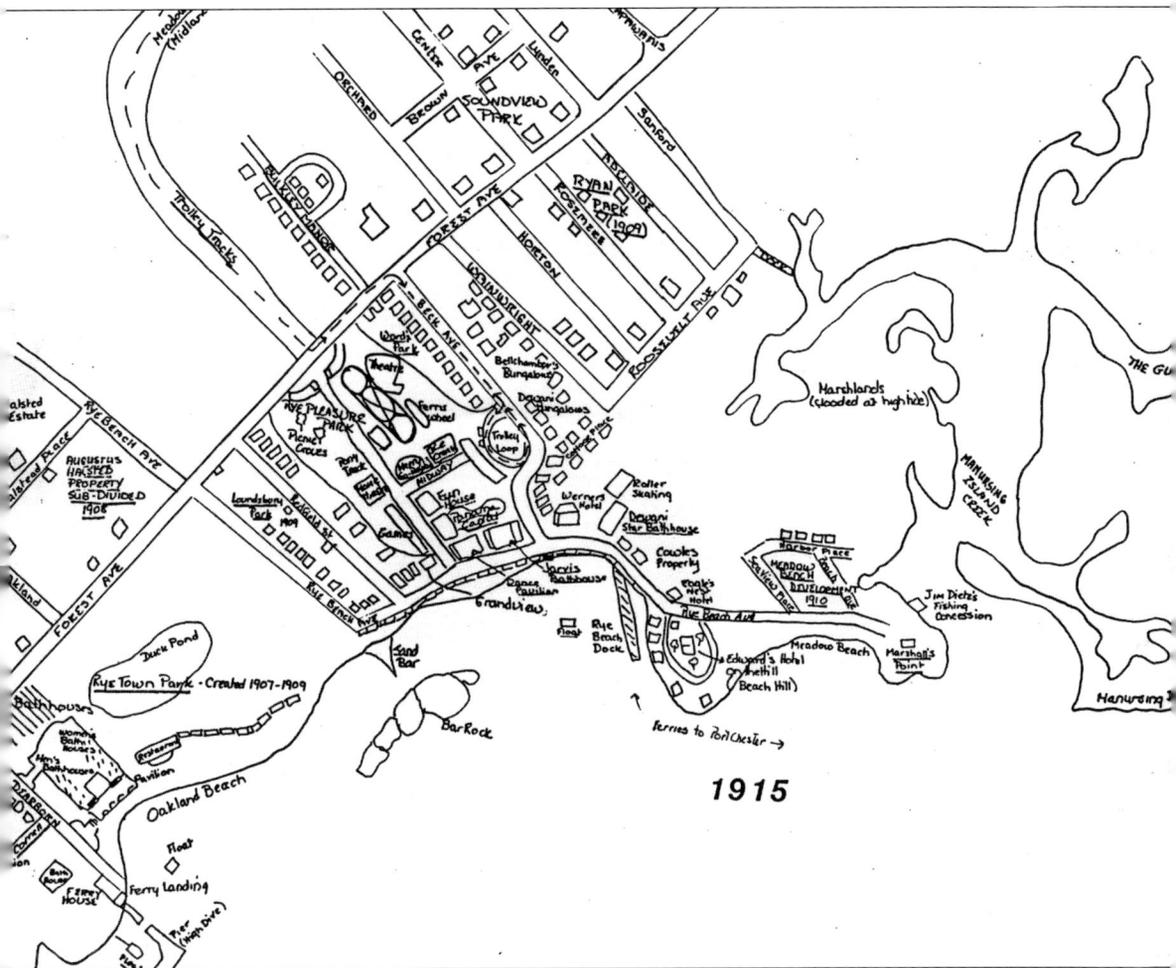

Major changes have occurred in the 20 years since what is shown on the map on page 122. Augustus Halsted's bungalows have been moved off his property to Bulkley Manor (see page 79) and elsewhere. Ward's Park, another set of cottages, has been developed around Beck Avenue (see page 80). Where the bungalows stood, Rye Town Park has been created, a development that lasts to this day (see pages 84 and 85). In its center is the duck pond, and the Oakland Pavilion is at the southern end of the park, with its towers, bathhouses, and outbuildings (see pages 81 through 83). The amusement park above Rye Beach has been greatly expanded and renamed Rye Pleasure Park. A trolley line, coming from downtown Rye and beyond, now arrives at the beach and amusement park via Meadow Street and onto Beck Avenue. More inns and bathhouses have developed, as has Meadow Beach (see pages 93 through 95). In areas farther from the waterfront, there are major subdivisions, including Ryan Park and Soundview Park. Two of these streets are illustrated on page 29.

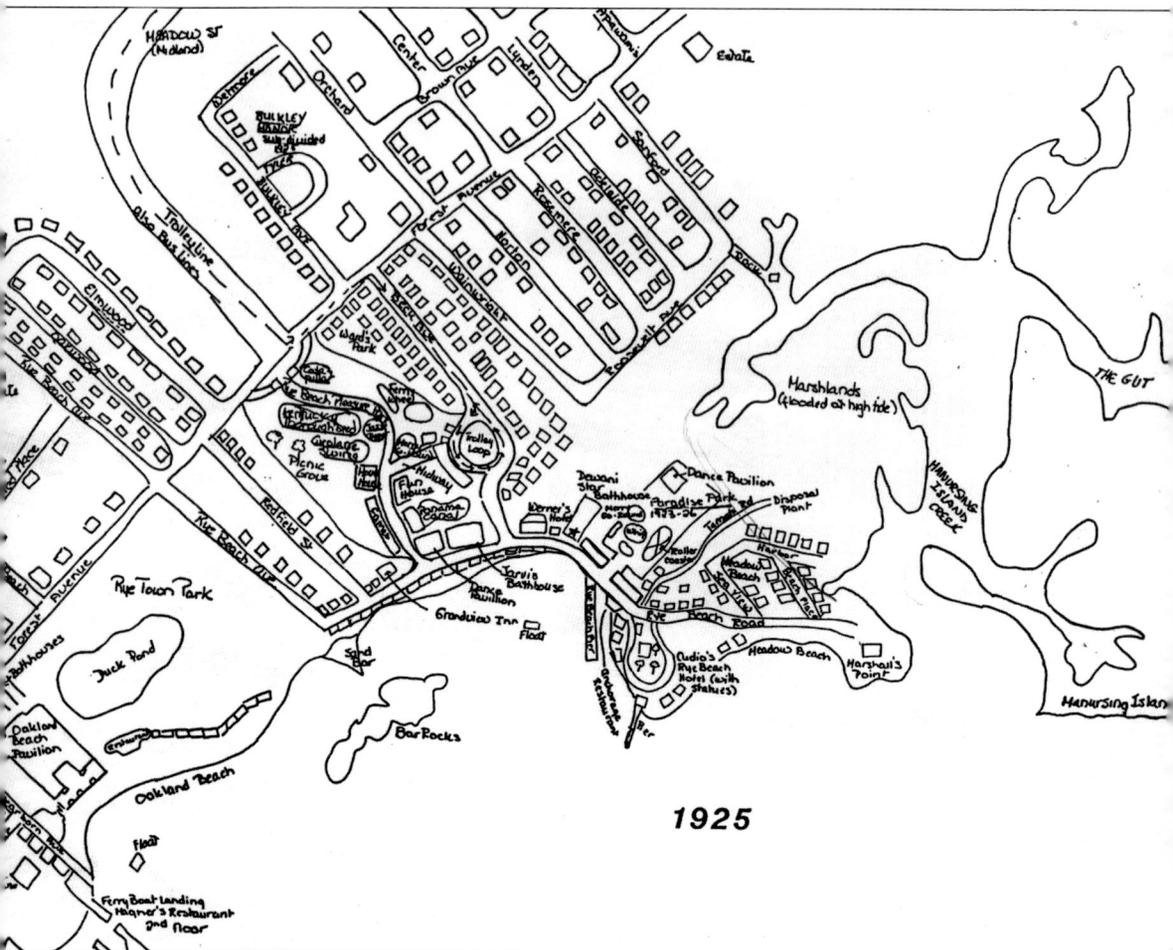

1925

In the 10 years that have passed since the map on page 123 was made, there has been major development of the waterfront and the land behind it. New attractions have been crowded into Rye Pleasure Park (see pages 105 and 106). To its right, the new Paradise Park has arrived with very similar rides (see pages 107 and 108). The buildings on Rye Beach have proliferated, and Rye Beach Avenue has become known as Auto Boulevard. Buses are competing with the trolley line, which was removed in 1927. The map shows more street development away from and also at the northern end of the waterfront in the Meadow Beach area, as well as in surrounding subdivisions. Note the sewage and garbage plant in this area, which was not a popular location.

Playland Parkway

Center

Orchard

Brown Ave.

Lynden St.

Loudon

FOREST AVENUE

Sanford

Oakland

Cremer

Roosevelt

Elmwood

Oakwood

Rye Beach Ave.

Racing Terrace

Forest Terrace

PARKING SPACE

BLOOMER ISLAND

PLAYLAND LAKE

BOAT LANDING

Rockfield

Rye Beach Ave.

FOREST AVENUE

P L A Y L A N D

Parking Exit

Antary Entrance

Bus Terminal

Bath House

BOARDWALK

Playland Beach

Boardwalk

Rye Town Park

Duck Pond

Oakland Beach Pavilion

Oakland Beach

Rock Jetty

CASINO

PICNIC BEACH

Picnic Shelter

Picnic Area

YACHT HARBOR

SOUND BEACH

Benjamin F. Parland

LAKE BEACH

Athletic Fields

1930

Manger's Pool

Ferry

Bar Rock

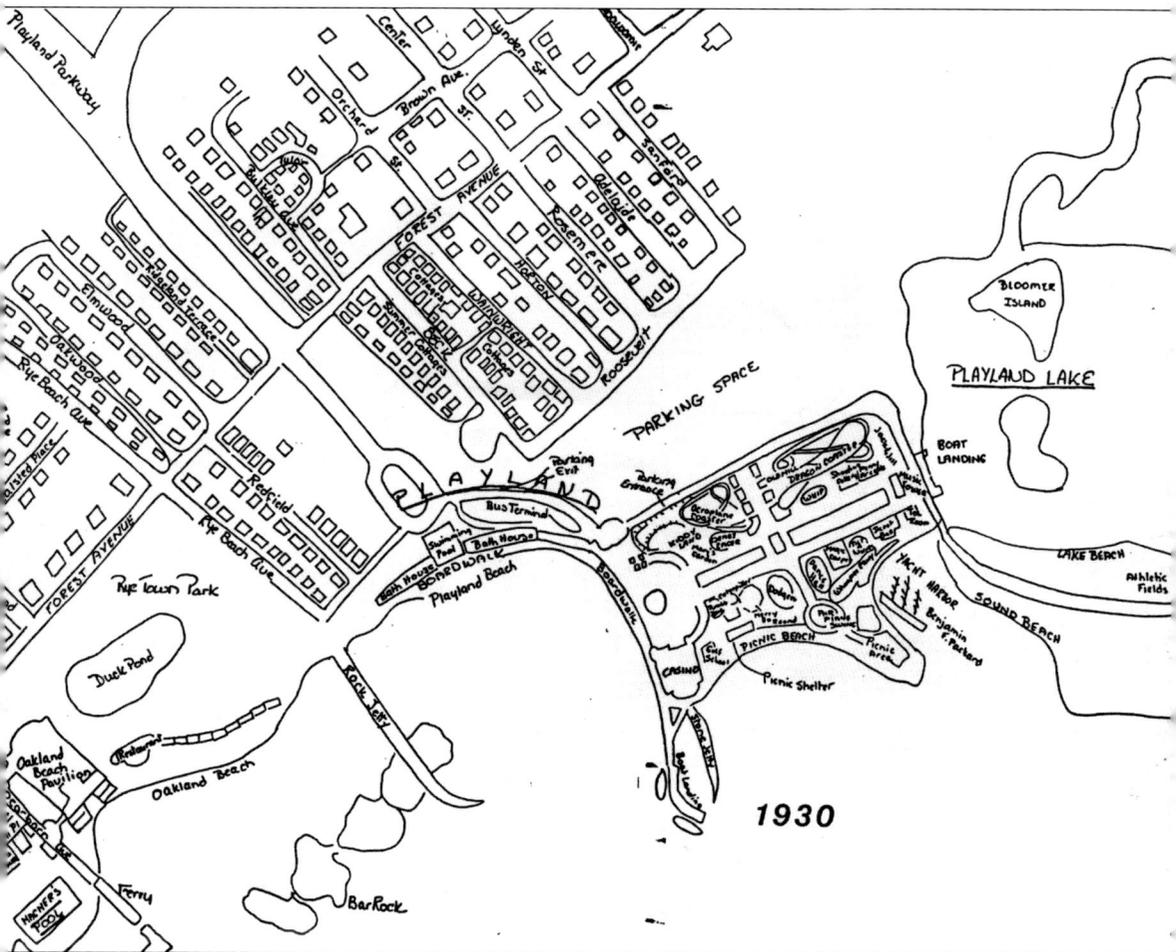

Contrasting this map with the three previous maps, one can see the sweeping land and building changes that occurred when the county of Westchester purchased all of the Rye Beach area, the Manursing Creek, and a large portion of Manursing Island to create Playland. This new park opened in 1928, and a map made today would be virtually identical to this map. The amusement area of Playland is partially laid over the area of Paradise Park and the Meadow Beach development. Great amounts of sand were brought in to create a beach, and bathhouses, a boardwalk, and a swimming pool were added. On close comparison, one will note that the old Rye Beach Park (Pleasure Park) was totally leveled and provides the large entry area into Playland. In the place of Meadow Street is Playland Parkway, connected later to Interstate 95. Another change on this map is the creation of J. P. Manger's "million dollar" baths and pool at the left end of the map (see pages 87 and 88).

BIBLIOGRAPHY

Baird, Charles W. *History of Rye: Chronicle of a Border Town, 1660–1870*. New York: Anson D. F. Randolph and Company, 1871.

Burke, Kathryn W. *Playland*. Charleston, SC: Arcadia Publishing, 2008.

Conway, William H. *Apawamis Club, 1890–1940*. Rye, NY: 1940.

Dalphin, Marcia, *Fifty Years of Rye, 1904–1954*. Rye, NY: 1955.

Dunne, Colin. *Rye In the Twenties*. New York: Arno Press, 1978.

Hawkins, Arlene D. *Read about Rye 1660–1960*. New York: River Edge Printing Company, 1984.

Ives, Chauncey. *The World War History of the Village of Rye, 1917–1918*. New York: The Knickerbocker Press, 1923.

Lederer, Richard M. *The Place-Names of Westchester County*. Harrison, NY: Harbor Hill Books, 1978.

McKay, Ellen Cotton. *A History of the Rye Presbyterian Church*. Rye, NY: 1957.

Meyer, Blakeman Qunitard. *Views of Rye, New York*. New York: Corlies Macy and Company, 1917.

Moxhay, Charles. *Rye on the Water, A History of Rye and Its Waters*. Rye, NY: Rye Historical Society, 1994.

Rheingold, Paul D., ed. *Views of Rye, 1917–2007*. Rye, NY: Rye Historical Society, 2008.

Sanchis, Frank E. *Westchester County, New York, American Architecture*. New York: North River Press, 1977.

Stanley, Barbara W. *Century One: A Centennial History of the Rye Free Reading Room, 1884–1984*. New York: Ganis and Harris, 1984.

The First Hundred Years of the American Yacht Club (1883–1983). Rye, NY.

Zwerger, Mark R., Janet M. Malang, and Andrew F. Horn. *The Osborn*. Charleston, SC: Arcadia Publishing, 2007.

INDEX

www.arcadiapublishing.com

Discover books about the town where you grew up, the cities where your friends and families live, the town where your parents met, or even that retirement spot you've been dreaming about. Our Web site provides history lovers with exclusive deals, advanced notification about new titles, e-mail alerts of author events, and much more.

MADE IN THE USA

Arcadia Publishing, the leading local history publisher in the United States, is committed to making history accessible and meaningful through publishing books that celebrate and preserve the heritage of America's people and places. Consistent with our mission to preserve history on a local level, this book was printed in South Carolina on American-made paper and manufactured entirely in the United States.

This book carries the accredited Forest Stewardship Council (FSC) label and is printed on 100 percent FSC-certified paper. Products carrying the FSC label are independently certified to assure consumers that they come from forests that are managed to meet the social, economic, and ecological needs of present and future generations.

FSC
Mixed Sources
Product group from well-managed forests and other controlled sources

Cert no. SW-COC-001530
www.fsc.org
© 1996 Forest Stewardship Council

Find Your Place in History.